Wildlife
Photographer
of the Year
Portfolio 26

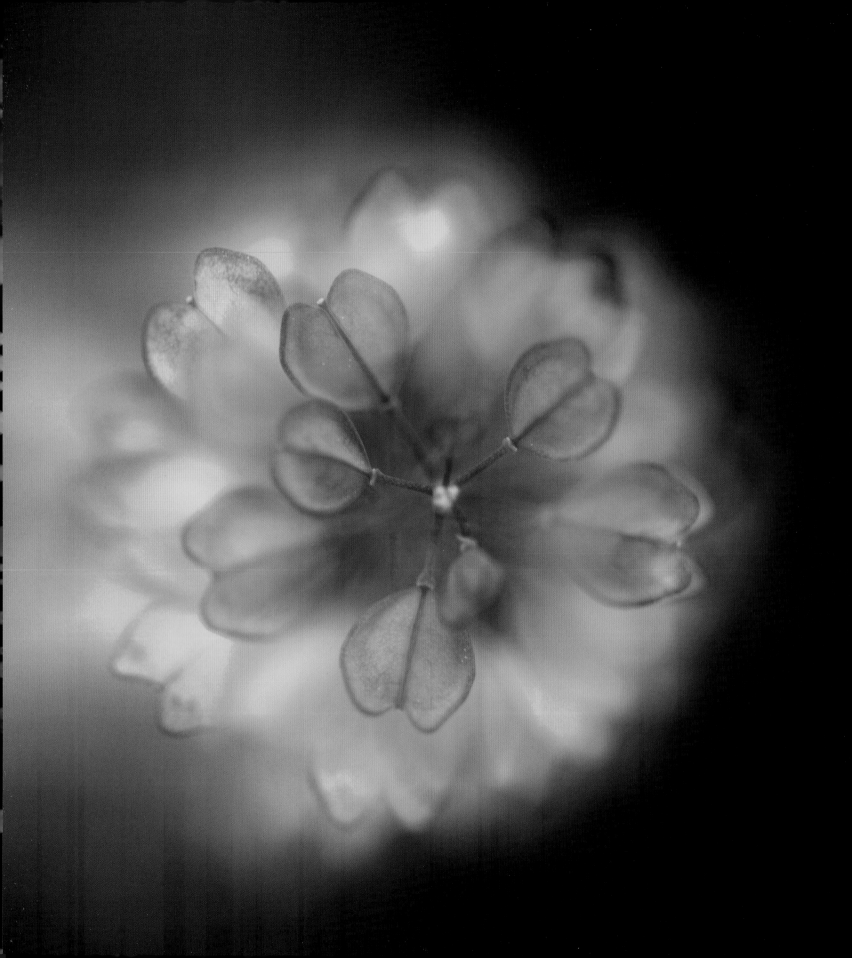

Wildlife Photographer of the Year

Portfolio 26

Published by the Natural History Museum, London

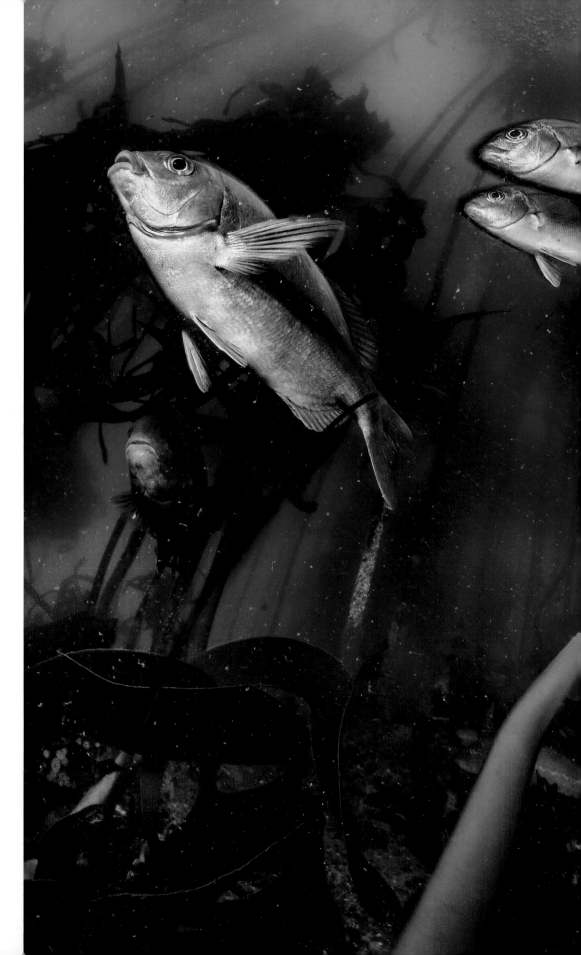

First published by the Natural History Museum,
Cromwell Road, London SW7 5BD
© The Trustees of the Natural History Museum,
London, 2016
Photography © the individual photographers 2016

ISBN 978 0 565 0 93952

A catalogue record for this book is available from the
British Library.

Editor: Rosamund Kidman Cox
Designer: Bobby Birchall, Bobby&Co Design
Caption writers: Tamsin Constable and Jane Wisbey
Image grading: Stephen Johnson
www.copyrightimage.com
Colour proofing: Saxon Digital Services
Printing: Printer Trento Srl, Italy

opposite: Joris van Alphen
previous page: Sandra Bartocha
foreword page: Audun Rikardsen
competition page: Stefano Unterthiner

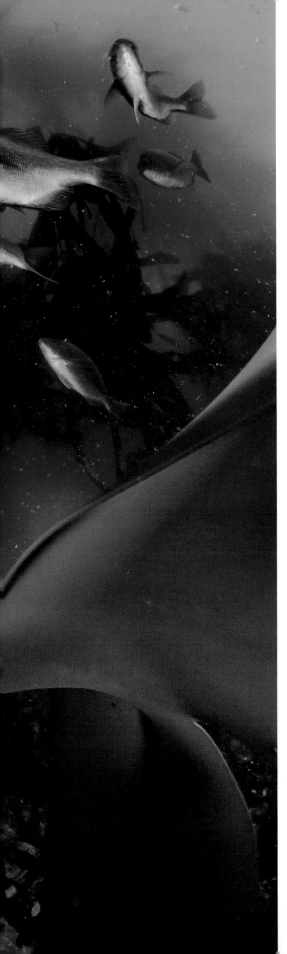

Contents

Foreword

The Wildlife Photographer of the Year competition has the highest standards, and it is a great privilege to chair the jury. However, as you have probably sneaked a peek at the fantastic images, you know this already. My job now is to plant a thought or two to take you on a journey around the photography... and perhaps to prompt action.

So bear with me while I make a curious comparison. At first glance, the images in the book are nothing like 'selfies'. These intense, original and inspiring views of the world around us seem like the polar opposite to the repetitive self-portraits found in social media, the type of photo that many people create and see most often but forget almost instantly. Unlike those solipsistic reflections, you might think that wildlife photography looks outward at all other species and places. It would seem to be entirely not about ourselves. It is beyond us, something other.

But reconsider: you could say that these are selfies, too, of an altogether more interesting kind. That is because we humans are the creatures that take the pictures, enter them into the Wildlife Photographer of the Year competition, judge them and view them. From the millions of images originally shot by photographers, to the many tens of thousands entered into the 2016 competition, to the 100 selected for the exhibition, the book in your hands is the result of an intense filtering and assessment carried out by *Homo sapiens* for *Homo sapiens*. It presents a time capsule of what we think now about wildlife.

While these pictures may not have our faces in shot, they have our fingerprints on the cameras and the files, and our thoughts are in the frame, along with our reflections as we look at them.

Most of the world's species have not been featured this year or any year in the competition. Those that make the cut tend to combine being impactful on the eye with being part of a narrative – they are icons of nature as an experience and as history. In some way they illustrate our story. Tendencies and trends are apparent. Big cats never get far away from the lenses of the world, while the once-strange landscapes of Iceland are increasingly familiar. We find new stories in each, of course – from the drama of leopards prowling the alleys of Indian towns at night to the environmental-art appeal of dramatic volcanic landscapes.

Meanwhile, for example, beetles – which are said to make up 25 per cent of the planet's animal species – struggle to find great photographers to tell their story powerfully. Insects and plants are the workers on our planet, the recyclers that make life sustainable, but it is the large predators and the grand exotic locations which tend to draw the lenses. Sometimes a species breaks out as a new iconic subject: last year, a stunning portrait of a pangolin is followed this year by a shocking image of the genocidal wasting of pangolins. The orangutan continues to have fame for mostly the wrong reasons, touching our sense of guilt while living ever more precariously on the edge of extinction. Can the emotional grab of a photograph help change this?

I believe so. Great photography and image-led stories can move us to action. I hope future entrants will keep pushing out the boundaries of what we photograph and what we represent in this competition. We need both photographers and viewers to care that great wildlife photography can foster and conserve values in wildlife.

To do that the pictures must be made with emotional impact while also holding an absolute concern for truthfulness to the experience. What matters is to show the world as it is and how it changes, and to help us understand it better and inspire us to care. For our small part, the jury endeavoured to select only images that were made in the right way, ethically sourced and ethically produced.

Such photography accurately and inspiringly documents wildlife in ways that can help understanding and conservation. Such work may also demonstrate the better side of our nature. It is one selfie worth creating.

Lewis Blackwell
Chair of the Jury, Wildlife Photographer of the Year 2016

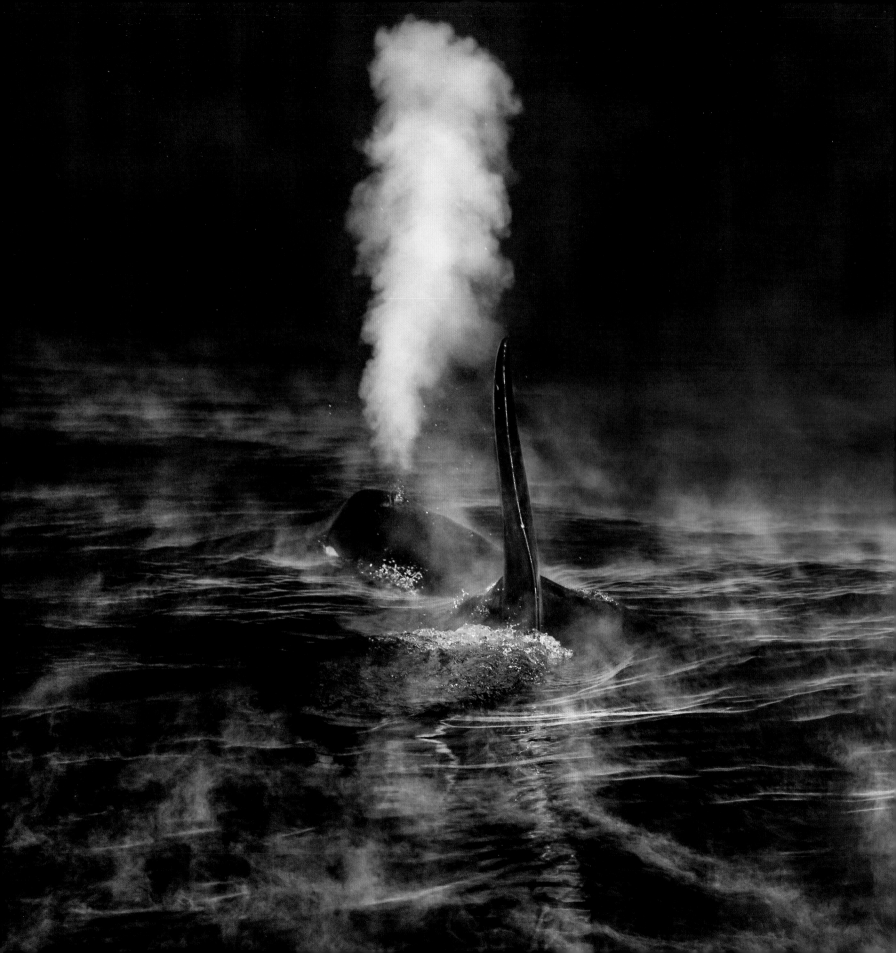

The Competition

Wildlife Photographer of the Year is more than a competition. It's an international and influential showcase of the most memorable, beautiful and sometimes challenging images of wild creatures and wild places. Entry is open to everyone – all ages, all nationalities – but invariably, the finalists have one thing in common: they are passionate about the natural world and want others to marvel at and think about what they see or witness.

This year, there were nearly 50,000 entries from 95 countries. These were judged (without the identities of the photographers being known) over a number of weeks by an international jury, which selected the final 100 pictures. These are displayed in categories that try to encompass a large range of subject matter, including lesser-known groups of animals, but also encourage different styles, including documentary reportage and storytelling. There are strict rules (and checks) to avoid digital manipulation beyond in-camera settings and digital processing – the aim is to be truthful to nature. But the judges are also looking for artistry and new ways of seeing nature. Being true to nature has to mean being true to the natural behaviour of an animal. Not only must the subjects be wild and free – unless an ethical or conservation issue is being reported on – but the welfare of the subjects remains paramount, and pictures are disqualified if there is a suspicion that animals have been manipulated.

There are significant financial rewards for the winners, but for all the finalists, 79 this year, the reward is the prestige and exposure. They are showcased in a competition that has a 50-year history of championing the very best photographers of wildlife and wild places. The collection of 100 images is seen worldwide, not only in this book but also through a major travelling exhibition. This opens in London at the Natural History Museum, where it is displayed for more than six months, but also goes to Europe, the Americas, Australasia and the Far East. And through international publicity via the internet, the winning images are also seen by many more millions.

This year, no portfolio collection was awarded, but two awards were given for photojournalism stories – collections that profile two major environmental issues, gaining them more international exposure. Though no Rising Star Award was given, a new range of young talent is represented in this year's categories for young photographers. Indeed, while the winners include some of the world's leading professionals, all of them started their careers young, and one of them is a past winner of the Young Wildlife Photographer of the Year Award, and he is now at the top of his profession.

This hugely varied collection will end up being seen through a range of media, by an audience of more than 50 million. Through the artistry of the work displayed, it will surely make that audience marvel about the health and the value of this truly wonderful natural world and inspire a new generation of photographers to champion it.

The next competition opens on 24 October and closes on 15 December 2016. See the new categories at www.wildlifephotographeroftheyear.com

Judges

Bruno D'Amicis (Italy), nature and fine art photographer

Orsolya Haarberg (Hungary/Norway), nature photographer

Rosamund 'Roz' Kidman Cox (UK), writer and editor

Piotr Naskrecki (Poland/USA), biologist and photographer

Klaus Nigge (Germany), wildlife photographer

CHAIR
Lewis Blackwell (UK), author and creative director

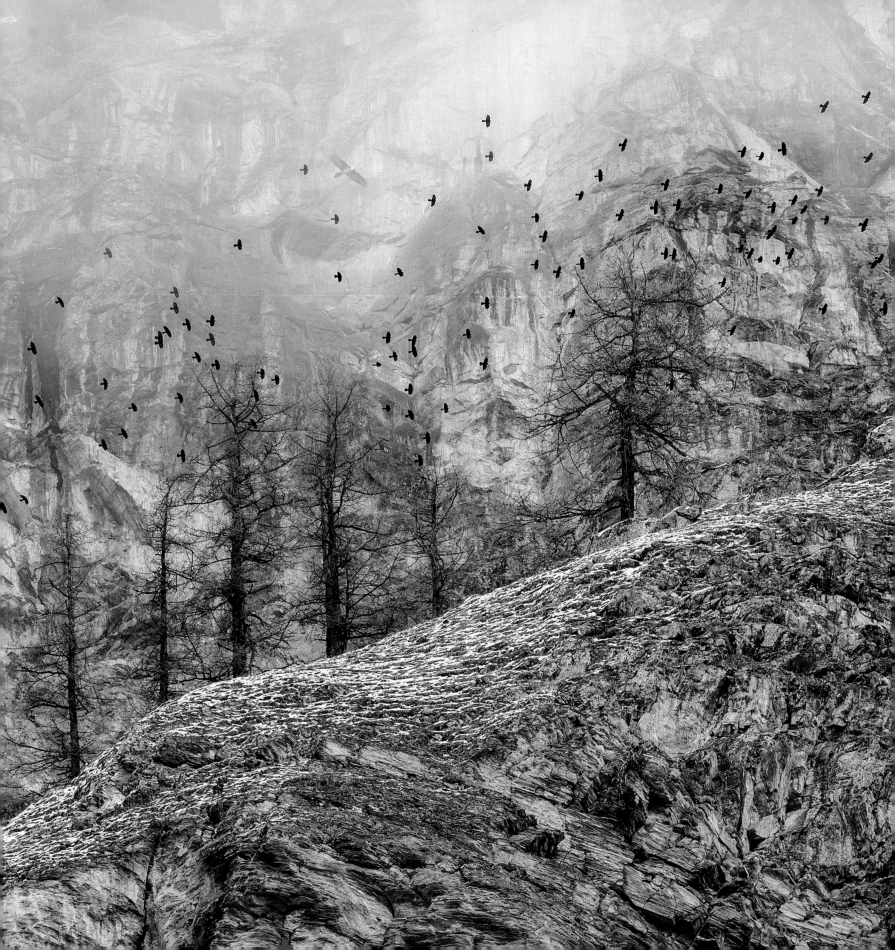

The Wildlife Photographer of the Year 2016

The Wildlife Photographer of the Year 2016 is **Tim Laman**, whose picture has been chosen as the most striking and memorable of all the entries in the competition.

Tim Laman

USA

A field biologist and photojournalist and a past award-winner in this competition, Tim Laman believes that promoting awareness through photography can make a real difference for conservation. Long-term projects

include his birds-of-paradise study, using both stills and video, and documentation of orangutans in the wild, in collaboration with his wife Cheryl Knott and her Gunung Palung Orangutan Program. Tim is a *National Geographic* contributor, with more than 20 features to his credit, most of them on rainforest subjects.

WINNER

Entwined lives

A young male orangutan makes the 30-metre (100-foot) climb up the thickest root of the strangler fig that has entwined itself around a tree emerging high above the canopy. The backdrop is the rich rainforest of the Gunung Palung National Park, in West Kalimantan, one of the few protected orangutan strongholds in Indonesian Borneo. The orangutan has returned to feast on the crop of figs. He has a mental map of the likely fruiting trees in his huge range, and he has already feasted here. Tim knew he would return and, more important, that there was no way to reach the top – no route through the canopy – other than up the tree. But he had to do three days of climbing up and down himself, by rope, to place in position several GoPro cameras that he could trigger remotely to give him a chance of not only a wide-angle view of the forest below but also a view of the orangutan's face from above. This shot was the one he had long visualized, looking down on the orangutan within its forest home.

GoPro HERO4 Black; 1/30 sec at f2.8; ISO 231.

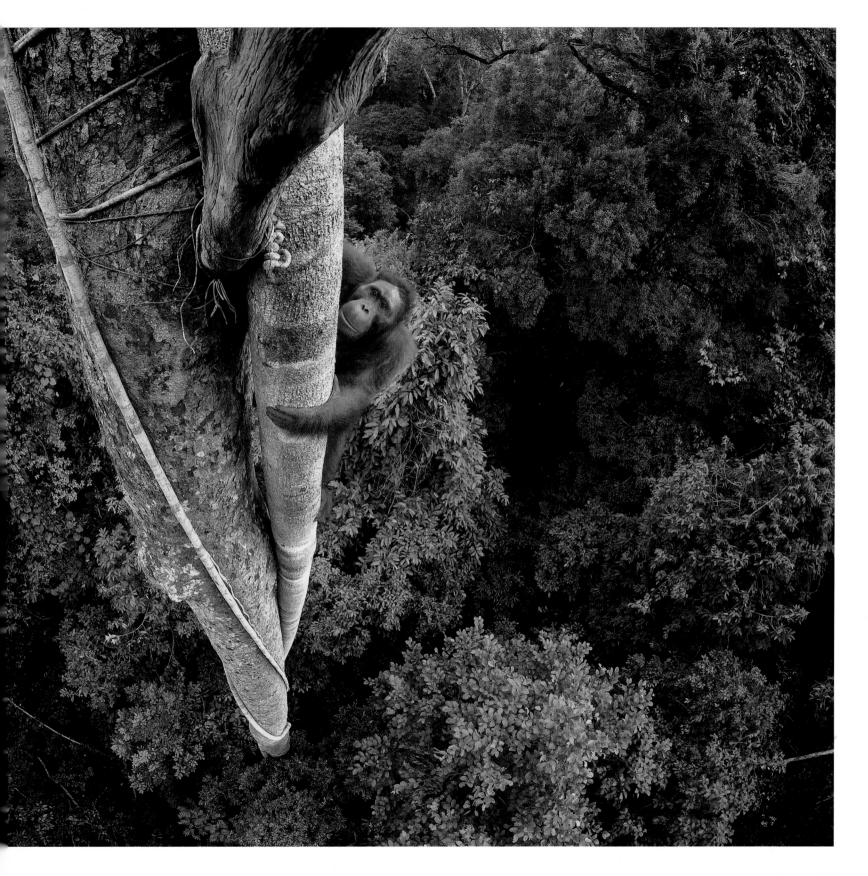

Reptiles, Amphibians and Fish

Little treasure

Marco Colombo

ITALY

The summer heat on the Italian island of Sardinia had reduced the mountain river to a series of small pools, but undeterred, Marco eased himself into the turbid water. His quest – part of a project to highlight the biodiversity of freshwater environments – was the shy European pond turtle. Despite its wide distribution in central and southern Europe and beyond, many populations are declining, threatened by water pollution, habitat loss and the introduction of competing American red-eared terrapins. Individuals that have a speckling of yellow or gold across their dark shells and skin are also caught illegally for the pet trade. When Marco was forced to rely on natural light (his strobes failed), his challenge was to stay focused on the turtle as it moved across the shadows, stirring up mud and debris. 'Conveying a sense of place was essential,' explains Marco. So he kept the shot wide, embracing the drama of the sunbeams falling through gaps in the riverside vegetation to illuminate his atmospheric portrait.

Nikon D90 + Tokina 10–17mm f3.5–4.5 lens at 10mm; 1/60 sec at f11; ISO 400; Isotta housing.

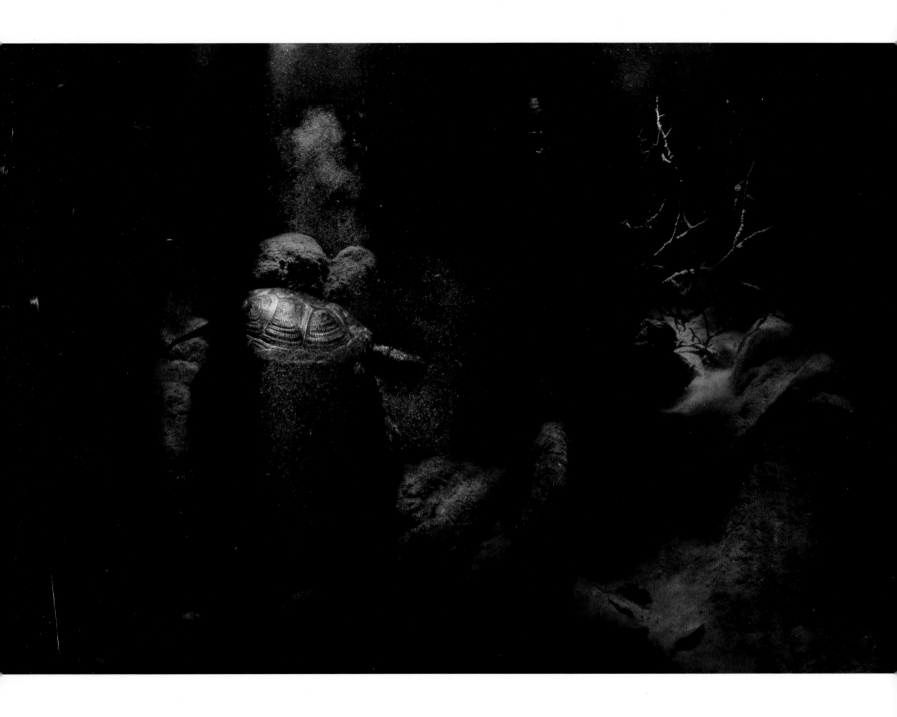

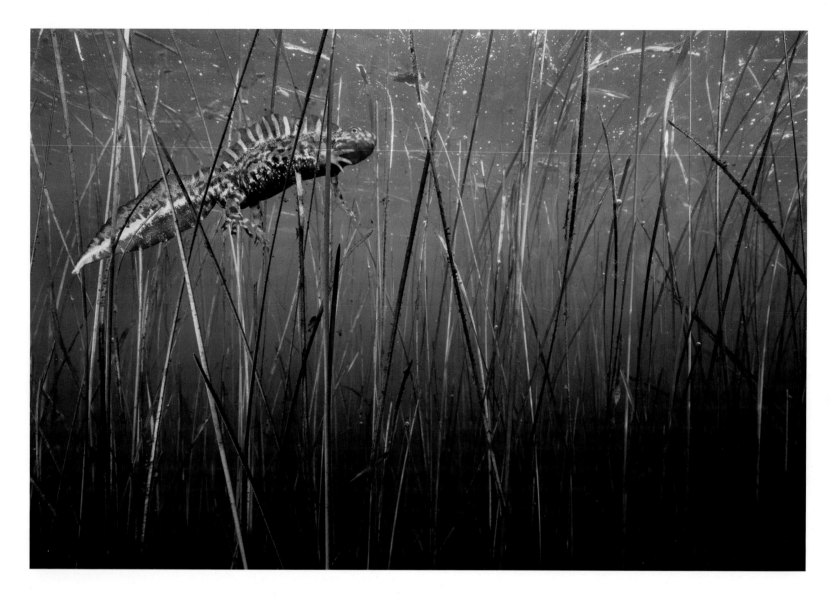

Newt style
Cyril Ruoso

FRANCE

Cyril was in heaven when he found five different species of newt in the same small pond in central France, on a spring day with good light and clear water. Better still, one of them was a marbled newt – the rarest amphibian in the region, at the northeastern limit of its range. From time to time, a male nearly 17 centimetres (7 inches) long would surface to breathe. It was wearing a 'wonderful courtship costume', its striped crest standing tall and smooth along its mottled length. Cyril positioned his camera carefully in the water, hoping that the newt might enter the frame among the pattern of criss-crossed stems that were catching the light. It did, just once, hanging below the surface – 'like a dinosaur in a meadow' – before it snatched a breath and dived down in search of a female.

Canon EOS 5D + 14mm f2.8 lens; 1/13 sec at f18; ISO 100; Ikelite housing; two Ikelite DS160 strobes; remote shutter release.

Puddle of procreation
Cyril Ruoso
FRANCE

By the end of February, near Cyril's home in central France, every ditch and hollow was full of water. In a shallow forest puddle – tinted by tannin from rotting leaves – a gang of male common frogs was poised for action. 'As soon as a female jumped in,' says Cyril, 'they went crazy, desperate to be the one to embrace her.' There were about 20 frogs in the puddle and hundreds more in a nearby pond (they may have overwintered in the bottom or returned there following scents). With five males to every female, competition was fierce. Once a male had clasped a female, he would hang on (using thumb pads) until she released her hundreds of jelly-cased eggs for him to fertilize. Cyril had modified his underwater housing so that he could adjust the settings remotely. As light glowed through the eggs, he caught a moment in this puddle of procreation as the males awaited the next arrival.

Canon EOS 5D + 14mm f2.8 lens; 1/20 sec at f16; ISO 200; Ikelite housing; two Ikelite DS160 strobes; remote shutter release.

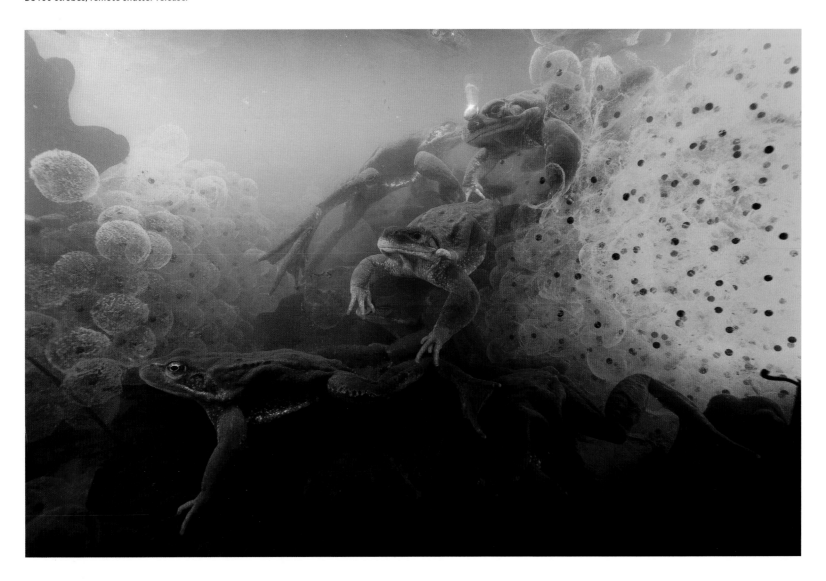

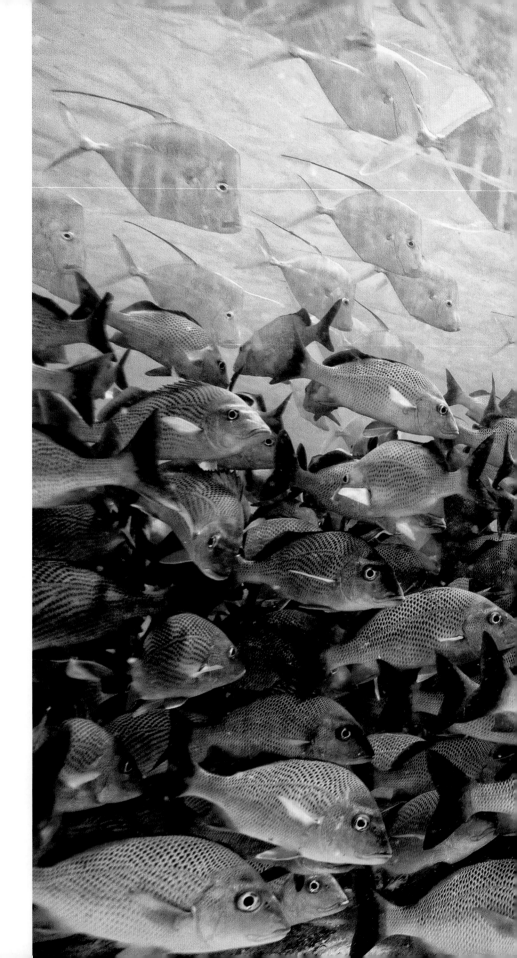

The disappearing fish
Iago Leonardo
SPAIN

In the open ocean, there's nowhere to hide, but the lookdown fish – a name it probably gets from the steep profile of its head, with mouth set low and large eyes high – is a master of camouflage. Recent research suggests that it uses special platelets in its skin cells to reflect polarized light (light moving in a single plane), making itself almost invisible to predators and potential prey. The platelets scatter polarized light, depending on the angle of the sun relative to the fish, and so do a more effective job than simply reflecting it like a mirror. This clever camouflage works particularly well when viewed from positions of likely attack or pursuit. What is not yet clear is whether the fish can increase its camouflage by moving the platelets or its body for maximum effect in the ocean's fluctuating light. The lookdowns' disappearing act impressed Iago, who was free-diving with special permission around Contoy Island, near Cancun, Mexico. Using only natural light, he framed them against a shoal of grey grunt to highlight the contrast between them.

Canon EOS 5D + 20mm f2.8 lens; 1/320 sec at f11; ISO 400; Ikelite housing.

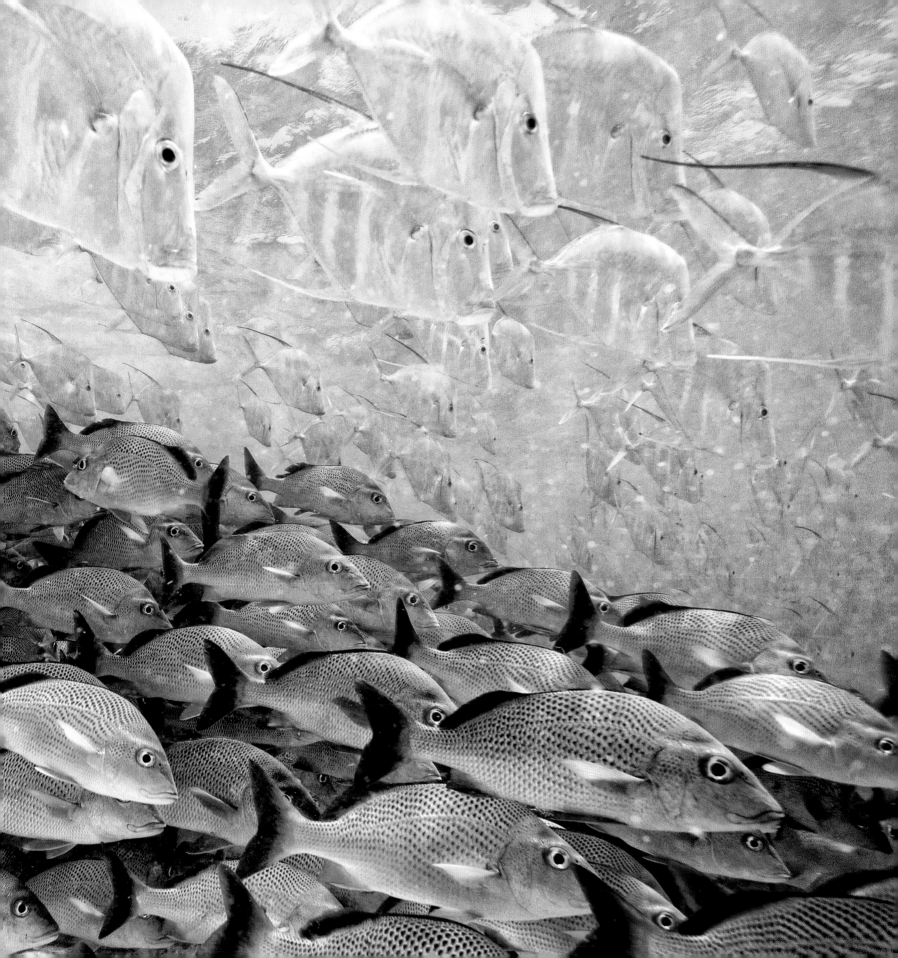

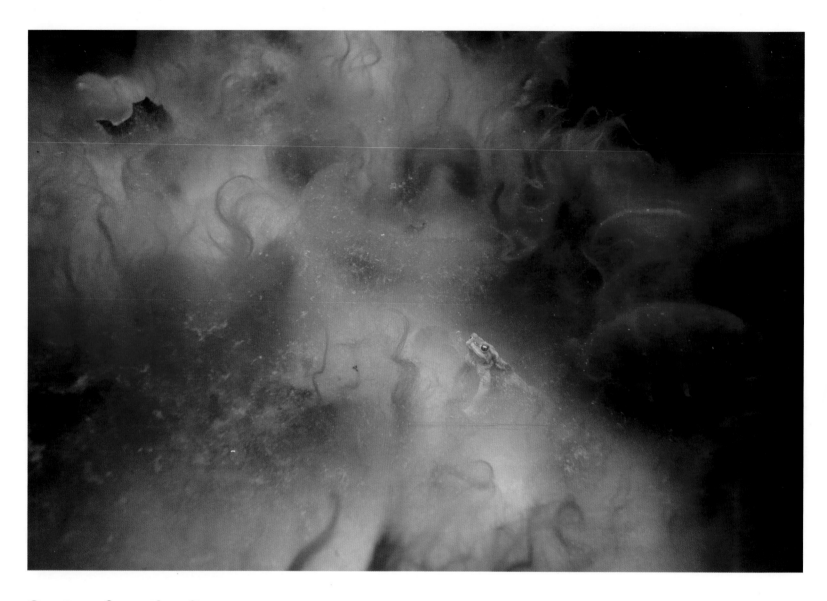

Creature from the slime
Christophe Salin

FRANCE

Christophe visited the fountain every day for a week to catch the toads arriving.
It was early spring in northwestern France, when common toads were on the
move, migrating along traditional routes from their overwintering sites in the forest
(among logs and under leaves) to their breeding ponds. The males often start first,
waiting at the ponds for potential mates to arrive. The fountain overflowed into a
series of pools 'beautiful with algae', where a few toads hung around before joining
the throng in the nearby spawning pond. Constant rain for days made the water
too murky to take pictures. Finally the water cleared a little and Christophe set up
his shot with the subdued light he needed to create cool shades. By angling his
camera down to enhance the mysterious atmosphere, he captured the moment
a toad rose up – copper-coloured eyes glinting – 'like a creature from the abyss'.

Canon EOS 5D Mark III + 17–40mm f4 lens; 1/500 sec at f5; ISO 3200; Ewa Marine housing.

Snappy attitude
Mac Stone

USA

'Finding these turtles is always a treat,' says Mac, who spotted this one while free-diving along the spring-fed Rainbow River in Florida, USA. The common snapping turtle has a reputation for being aggressive and able to inflict a nasty bite (the upper jaw is hooked). It will eat almost anything, from plants to prey – including crabs, snakes and birds – as well as carrion. It either ambushes prey that swims past or stalks it, rapidly extending its head and neck to snap it up. With a shell almost half a metre (20 inches) long, this was an imposing individual, but Mac was more concerned with approaching slowly enough through the tangled vegetation so as not to spook it or stir up clouds of mud. The turtle continued feeding for a while, then shuffled its feet, kicking up a plume of sediment, raising its head to offer Mac a striking head-on view before calmly swimming away.

Canon EOS 5D Mark III + Sigma 15mm f2.8 lens; 1/80 sec at f9; Aquatica housing; Sea & Sea YS-D1 strobes.

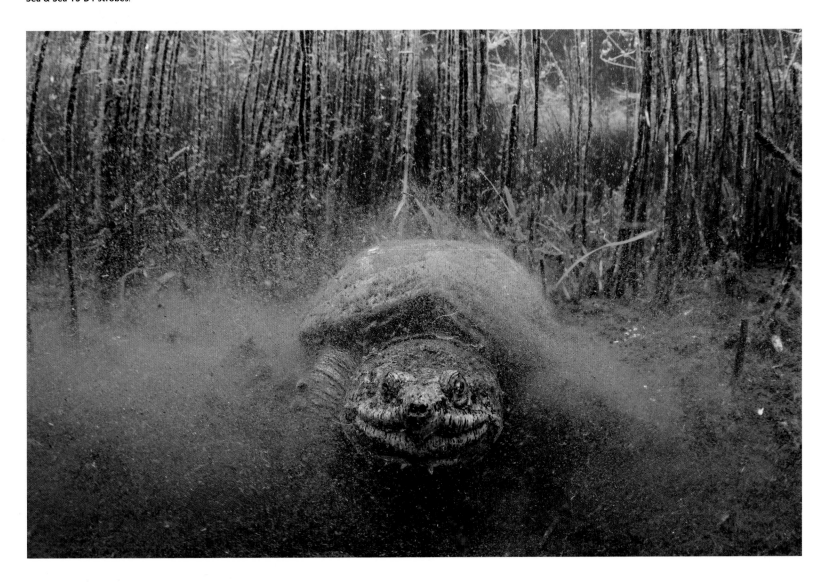

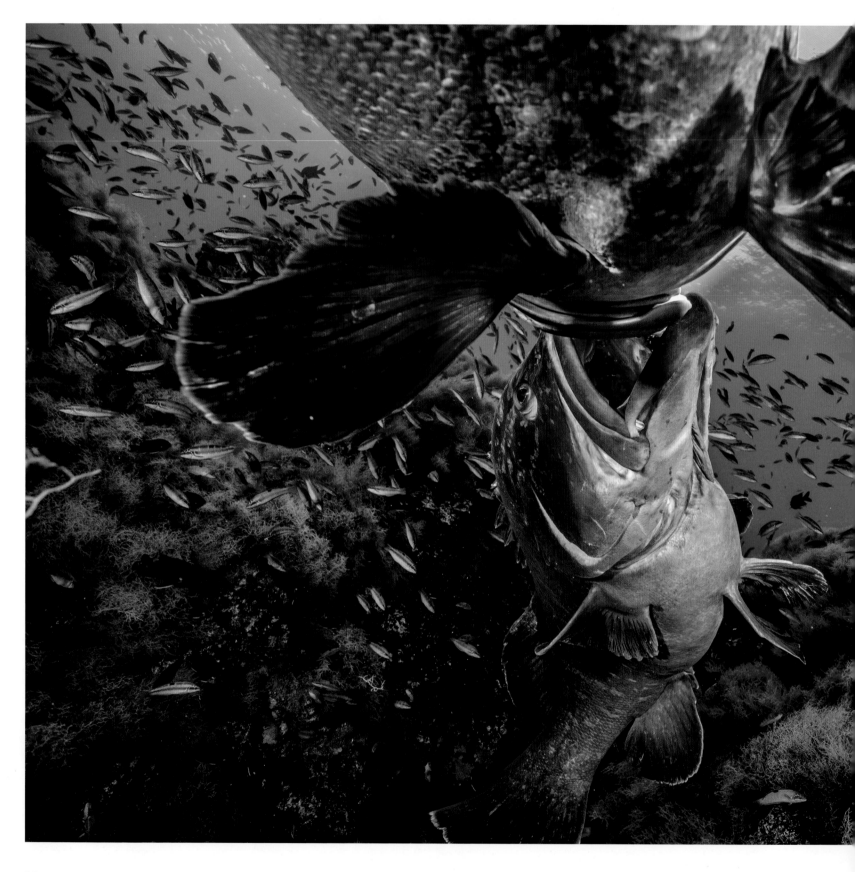

Battle of the big fish
Jordi Chias Pujol
SPAIN

The fight began gently, two male dusky groupers touching cheek to cheek, but gradually it escalated into a violent attack, each biting the other viciously in a full-on territorial battle. In the Azores, at the start of the mating season these huge fish – up to 1.5 metres (nearly 5-foot) long and weighing up to 60 kilos (132 pounds) – vie for territories, where they attract females to spawn. Though all individuals develop initially as females, some turn into males as they grow larger and older (usually around the age of 12). Jordi's challenge was to find several large individuals, anticipate a fight and manoeuvre into the right position to capture the five-minute drama. These rivals were so absorbed in each other that they ignored Jordi, who was able to approach and frame his shot against the reef and the shoal of peaceful ornate wrasse. That he was able to get so close is because, in this protected area, the groupers are unafraid of divers. Elsewhere, they have more reason to be wary – in recent decades, commercial fishing and spearfishing has caused dramatic declines, and the species is now endangered, its slow growth-rate and complex reproductive habits making it particularly vulnerable.

Canon EOS 5D Mark III + 17–40mm f4 lens at 17mm; 1/125 sec at f11; ISO 320; Isotta housing; two Seacam 150D strobes.

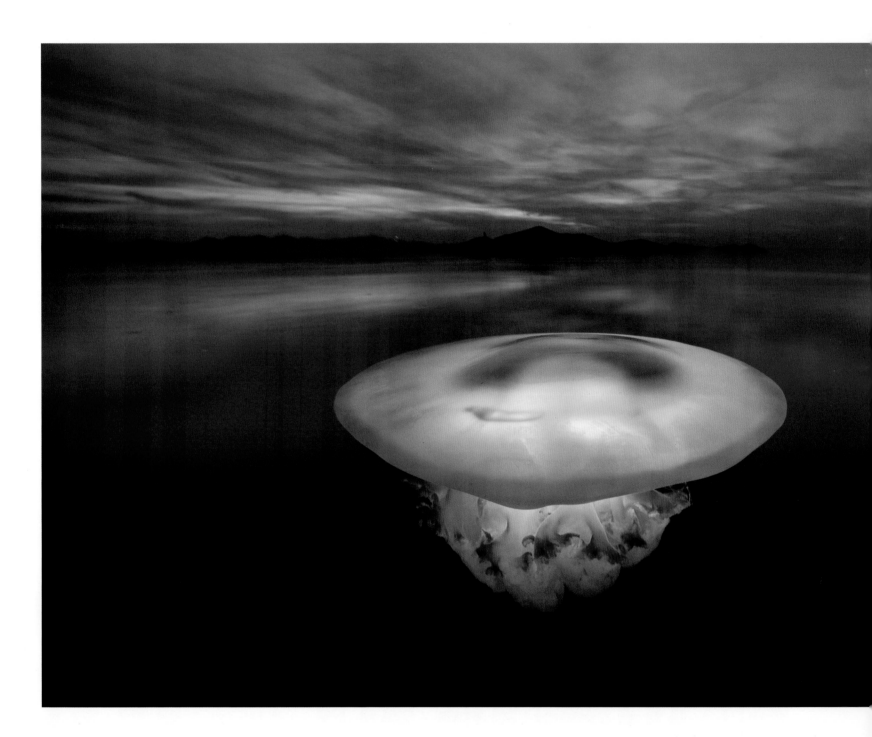

Invertebrates

The dying of the light
Angel Fitor

SPAIN

As the season turns in southeastern Spain, cooling water and autumnal winds blowing across the shallow coastal lagoon of Mar Menor wipe out most of the barrel jellyfish that swim in to feed on the summer plankton bloom. Struck by how unique each one is – 'like a living island' – and the imminence of its death, Angel set out to create a contemplative portrait. He waited three seasons for the right conditions, tracking the sun to see exactly when it would set over the island of Baron. Then he waited for a jelly to turn up in the right place, on a calm night, and the two 'islands' to align. One perfect evening, this solitary individual, about 40 centimetres (16 inches) across, rested motionless just below the surface. With a bubble of air trapped under its umbrella from being flipped in the wind, it was no longer able to dive and would not survive for long. Taking care not to disturb the still water or the animal, Angel manoeuvred waist-deep across the muddy bed, positioned his tripod so the camera was just above the surface and used a strobe to backlight the jelly. As the light faded, he finally captured his magical image of the dying jellyfish. It is also a picture symbolic of the fate of the lagoon itself. Since the picture was taken, continuing fertilizer and pesticide run-off from intensive agriculture has finally resulted in a huge algal bloom that is threatening to destroy the fragile ecosystem of this Specially Protected Area.

Nikon D800 + Sigma 14mm f2.8 lens; 1 sec at f18; ISO 50; Nexus housing; Inon Z-240 strobe; Retra uTrigger; Manfrotto tripod.

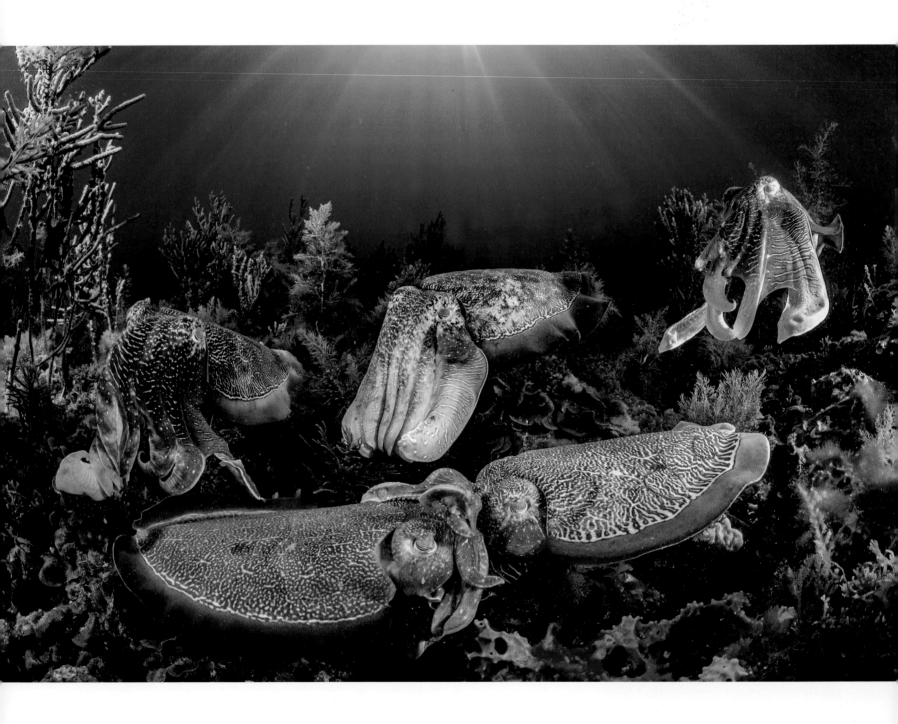

Collective courtship
Scott Portelli
AUSTRALIA

Thousands of giant cuttlefish gather each winter in the shallow waters of South Australia's Upper Spencer Gulf for their once-in-a-lifetime spawning. Males compete for territories that have the best crevices for egg-laying and then attract females with mesmerizing displays of changing skin colour, texture and pattern. Rivalry among the world's largest cuttlefish – up to a metre (3 feet) long – is fierce, as males outnumber females by up to eleven to one. A successful, usually large, male grabs the smaller female with his tentacles, turns her to face him (as here) and uses a specialized tentacle to insert sperm sacs into an opening near her mouth. He then guards her until she lays the eggs. The preoccupied cuttlefish (the male on the right) completely ignored Scott, allowing him to get close. A line of suitors was poised in the background, waiting for a chance to mate with the female (sometimes smaller males camouflage themselves as females to sneak past the male). Scott's hours in the cold water were finally rewarded when the onlookers momentarily faced the same way, and he framed the ideal composition.

Canon EOS 5D Mark III + 15mm f2.8 lens; 1/200 sec at f18; ISO 320; Seacam housing; two Ikelite DS161 strobes.

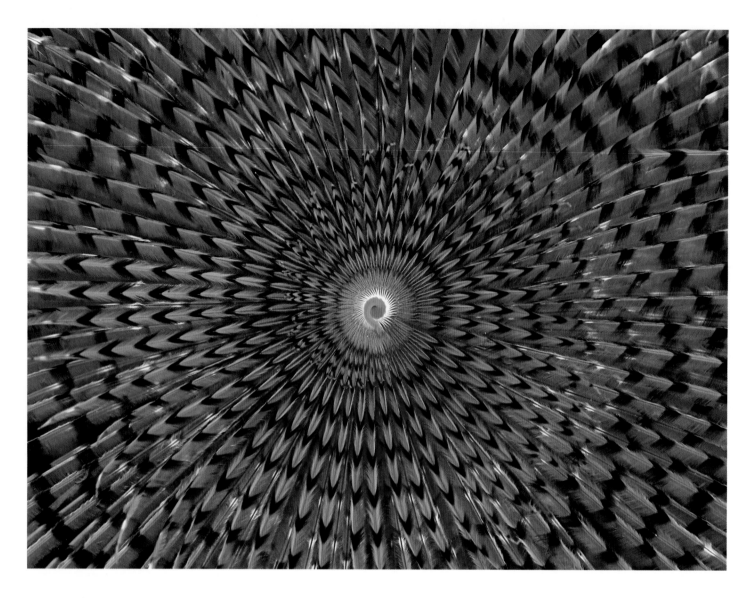

Worm hypnosis
Walter Bassi
ITALY

At the slightest disturbance, the European fan worm would disappear inside its leathery tube. Diving off the coast of Italy, Walter was trying to approach slowly, without his bubbles disturbing it, and to position himself to use strobes without spooking it. The tube – constructed by the worm from mucus, sand and detritus – stood 20 centimetres (8 inches) tall on the seabed, and from its opening extended the worm's spiralling fan of modified tentacles, used to filter organic particles from the water. Walter had long admired the 'mesmerizing dances' of the fans, common in sheltered, nutrient-rich water in the Mediterranean. He finally got close enough to this feeding individual to fill the frame. 'It's hypnotic,' he says. 'The eye is drawn to the centre, and then the image seems to start moving.'

Olympus E-PL1 + 60mm lens; 1/100 sec at f14; ISO 100; Olympus housing; two Sea & Sea YS-110α strobes.

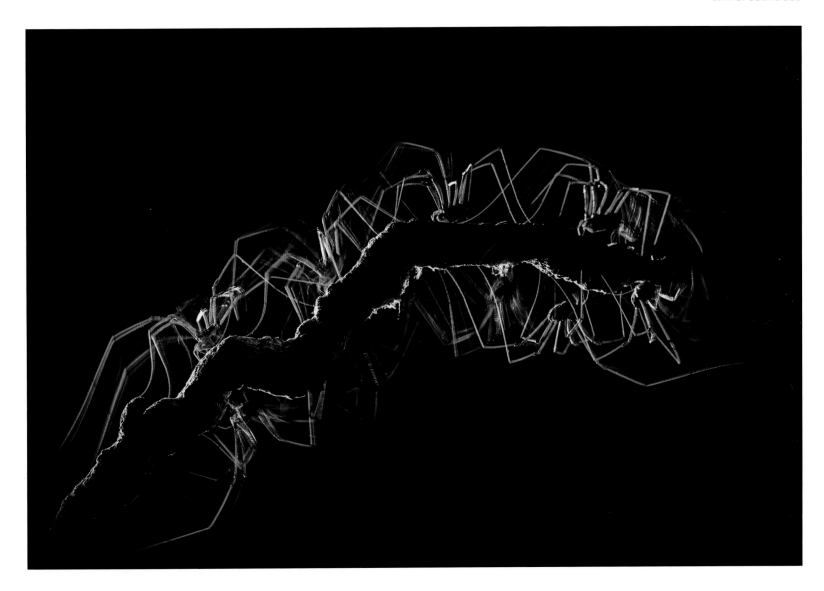

The harvestman walk

Juan Jesús González Ahumada

SPAIN

There were lots of harvestmen about that night in the Andalusian pine forest in southern Spain. Juan was there to capture the character of these strange spider-like arachnids. They hunt at night, walking raised up on their eight slender, seven-jointed legs, catching insects and other invertebrates, but also scavenging. They have a pair of eyes, but in the dark, their second pair of legs – slightly longer and loaded with sense organs – act as antennae to guide them. Juan homed in on a harvestman on a tree root. Lighting it from behind with a flashlight, he isolated its leggy silhouette. By turning the light on and off during a single long exposure, he recorded an impression of the animal's navigation, its legs in constant motion. He couldn't see the camera display from his position and so was delighted to find the harvestman's movements had filled the frame.

Canon EOS 6D + 100mm f2.8 lens; 133 sec at f8; ISO 100; flashlight; remote control; tripod.

Crabzilla

Thomas P Peschak

GERMANY/SOUTH AFRICA

The remote, uninhabited Seychelles atoll of Aldabra is one of the last island bastions of the coconut crab in the Indian Ocean. Elsewhere, on many islands in the Indian and Pacific oceans, the world's largest terrestrial arthropod (with a penchant for coconuts, which it can crack open with its powerful claws) has been eaten by humans almost to extinction. One evening, as a ranger was measuring a large crab – they can span a metre (3 feet) across and weigh up to 3 kilos (6½ pounds) – Tom caught sight of the shadow cast by the ranger's headlamp. He was so impressed by the science-fiction silhouette that he knew he had to incorporate it into an image. Walking back, he noticed a big crab outside an old building. He lowered his torch to crab eye-level and was thrilled with the formidable shadow cast on the wall. The elements of his composition started coming together – the torch projecting the silhouette of the out-of-frame crab, a remotely controlled flash lighting the interior of the building and biologist Otto Whitehead crouching in the doorway – but he felt something was still missing. 'As I was thinking about what to do, another crab scuttled into view,' says Tom. Lit by Otto's headlamp from the doorway, 'it was the last piece of this photographic puzzle.'

Nikon D3S + 17–35mm f2.8 lens at 20mm; 2 sec at f6.3; ISO 3200; LED flashlight + head torch + Profoto B1 flash; remote release.

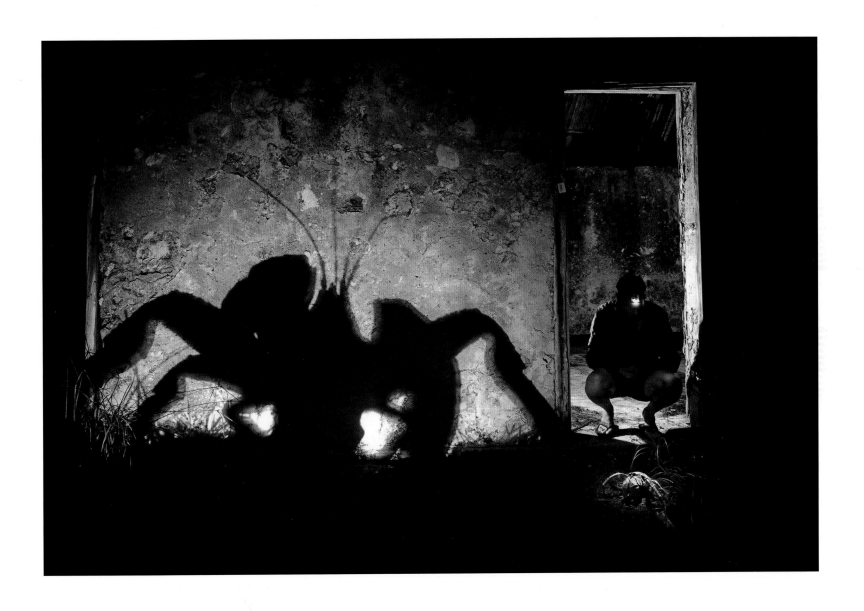

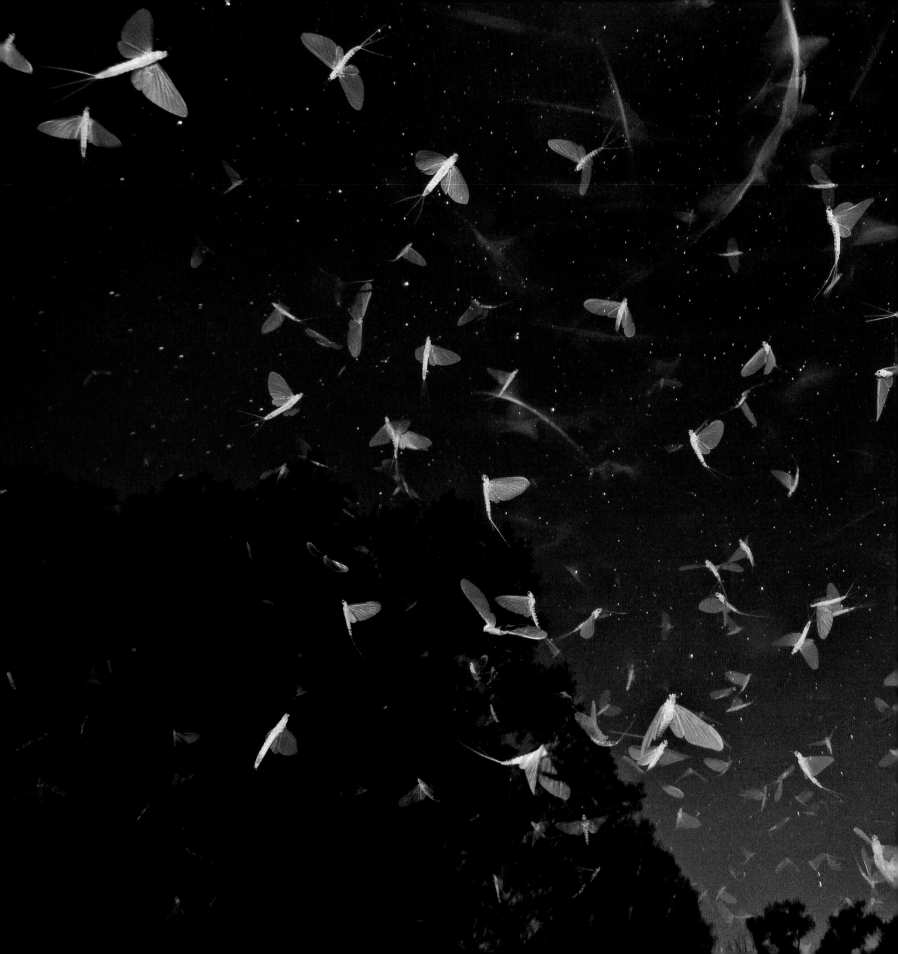

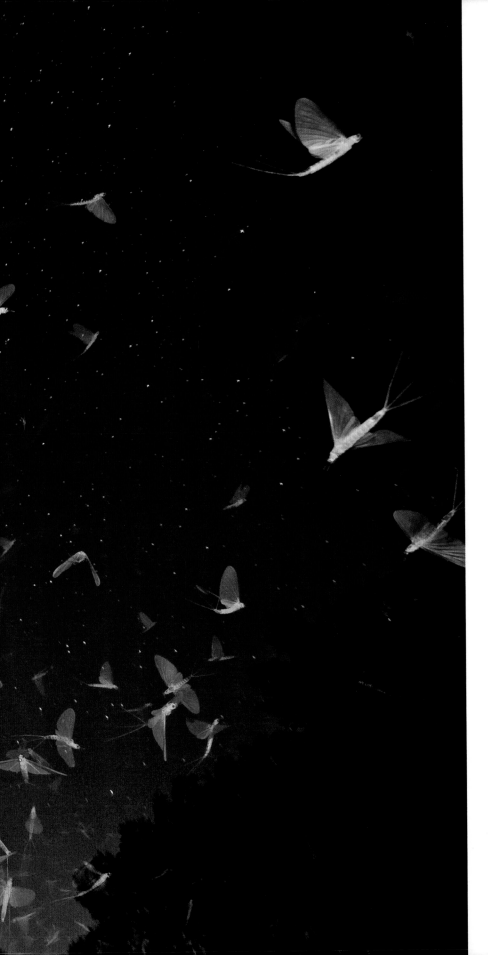

Swarming under the stars
Imre Potyó

HUNGARY

Imre was captivated by the chaotic swarming of mayflies on Hungary's River Rába and dreamt of photographing the spectacle beneath a starlit sky. For a few days each year (at the end of July or beginning of August), vast numbers of the adult insects emerge from the Danube tributary, where they developed as larvae. On this occasion, the insects emerged just after sunset. At first, they stayed close to the water, but once they had mated, the females gained altitude. They filled the air with millions of silken wings, smothering Imre and his equipment in their race upstream to lay their eggs on the water's surface. Then they died, exhausted, after just a few hours. This 'compensatory flight' – sometimes as far as several kilometres upstream – is crucial to make up for the subsequent downstream drift of the eggs and nymphs, and luckily for Imre, it was happening under a clear sky. To capture both the mayflies and the stars, he created an in-camera double exposure, adjusting the settings as the exposure happened. A flashlight added the finishing touch, tracing the movement of the females on their frantic mission.

Nikon D90 + Sigma 17–70mm f2.8–4.5 lens at 17mm; double exposure 1.3 sec at f14 and 30 sec at f3.2; ISO 800; in-camera flash; flashlight; Manfrotto tripod + Uniqball head.

Mammals

The aftermath
Simon Stafford
UK

Eerie silence and a mound of lifeless bodies: the contrast with the mayhem of the previous day couldn't have been starker. And the stench was already dreadful. The day before, thousands of wildebeest on migration through Kenya's Maasai Mara National Reserve had massed at the Mara River, nervous of the crossing ahead and of the huge Nile crocodiles lying in wait. Once one made the leap, they all surged forward and the river became a maelstrom of flailing hooves and crocodiles. In their frantic efforts to get out, they carved gullies in the riverbank, and in over an hour, as the gullies became deeper and deeper, more and more wildebeest slipped back down and died under the hooves of the ones coming out of the river. Simon returned at first light, knowing that scavengers would gather at the site of the carnage. 'It was a sinister scene,' he says. 'There must have been 50 or more carcasses, piled two or three deep.' Spotted hyenas were already feeding, and hippos and crocodiles had gathered in the river below. As Simon watched from the other side of the wide river, one hyena left the feast and stood, as if standing sentry, at the river's edge watching the gathering of crocodiles in the water below.

Nikon D810 + 800mm f5.6 lens; 1/500 sec at f5.6; ISO 400; beanbag.

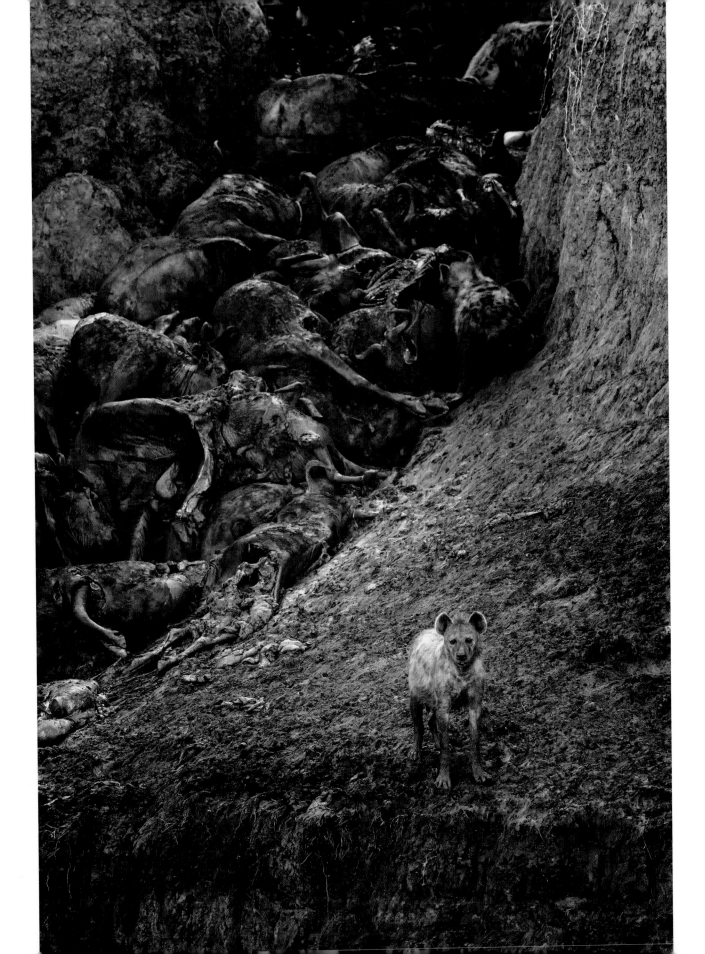

Dawn of the bison

Jasper Doest
THE NETHERLANDS

Following their reintroduction to the Netherlands in 2007, Jasper has been photographing European bison in the Kraansvlak reserve – part of the Dutch Zuid-Kennemerland National Park. But locating the now totally wild, free-ranging herd is not easy. The other challenge is finding the best light. On this summer morning, accompanied by the reserve's forester, he located most of the bison in the dunes and anticipated they would make their way to a lake in the dunes to drink. Setting up on the opposite bank, he waited. Conditions couldn't have been better, with a third of the herd in view, surrounded by a dancing swarm of male midges sparkling in the dawn light. 'With that wonderful backlight, I was able to convey the tranquillity of the scene and the beauty of these magnificent animals,' says Jasper. Bison are Europe's largest land mammal, once widespread across most of the continent, their grazing and browsing habits helping to maintain a mosaic of ecologically rich forests and grasslands. But by 1927 they had been hunted to extinction in the wild. Just 54 remained in captivity. A slow but successful captive-breeding and rewilding programme began in central and eastern Europe, and the population is now around 5,550, of which more than half live in free herds. In Kraansvlak, since the first six bison were reintroduced, more than 20 calves have been born.

Canon EOS 7D Mark II + 70–200mm 2.8 lens at 145mm; 1/640 sec at f8; ISO 400.

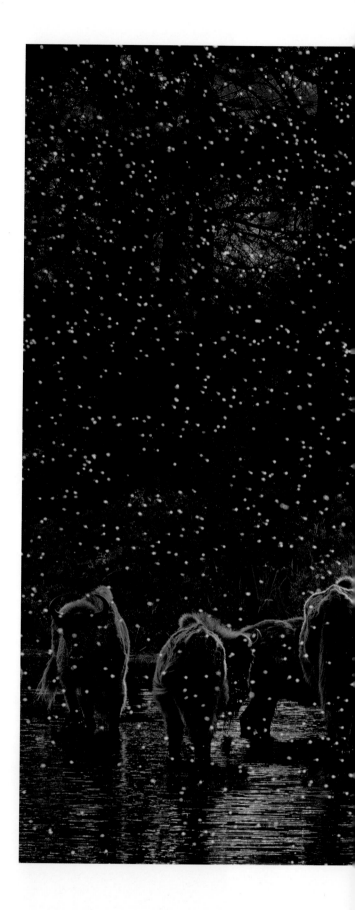

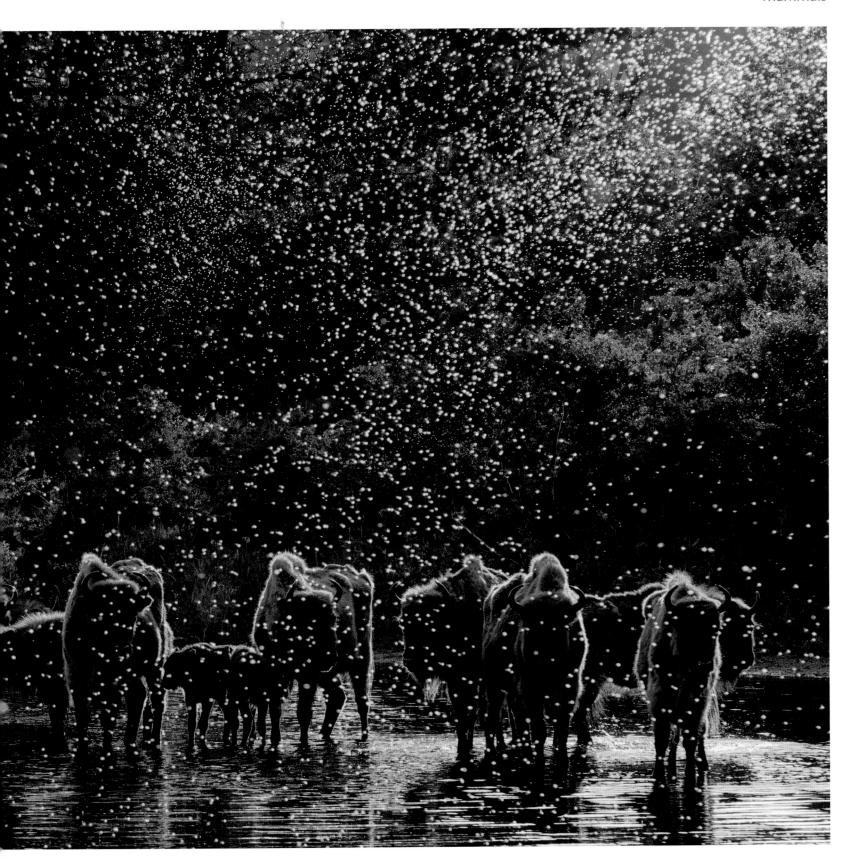

Wild West stand-off
Charlie Hamilton James
UK

A grizzly bear charges at ravens trying to grab a piece of the feast. The bison is a road-kill that rangers have moved to a spot they use for carrion to avoid contact between predators and tourists. The location is Grand Teton National Park, part of the Greater Yellowstone ecosystem in the western US, where grizzlies still roam. 'Approaching a bear's lunch is a dangerous thing to do,' says Charlie. So there were strict protocols for getting out of his vehicle every time he went to check his camera trap. Over nearly five months, he had thousands of images of ravens and vultures, but only a few of wolves or bears, and none were up to the high standards he set himself, until this one. 'The moment I saw it, I was so excited. It had taken nearly five months to get a decent image out of the set-up. It's rare that I like my images, but I really like this one – though I still get annoyed that the top raven is positioned right over the Grand Teton mountain.' The Yellowstone grizzly population has been protected since the 1970s, but now that numbers are recovering, it is proposed that the population is removed from the federal list of protected species, allowing hunting outside the two parks. This has raised concerns not only about the grizzlies' fate but also about the knock-on effect on the ecology.

Nikon D7100 + 10–24mm lens at 24mm; 1/2500 sec at f5.6; ISO 1600; Trailmaster TM550 passive infrared monitor.

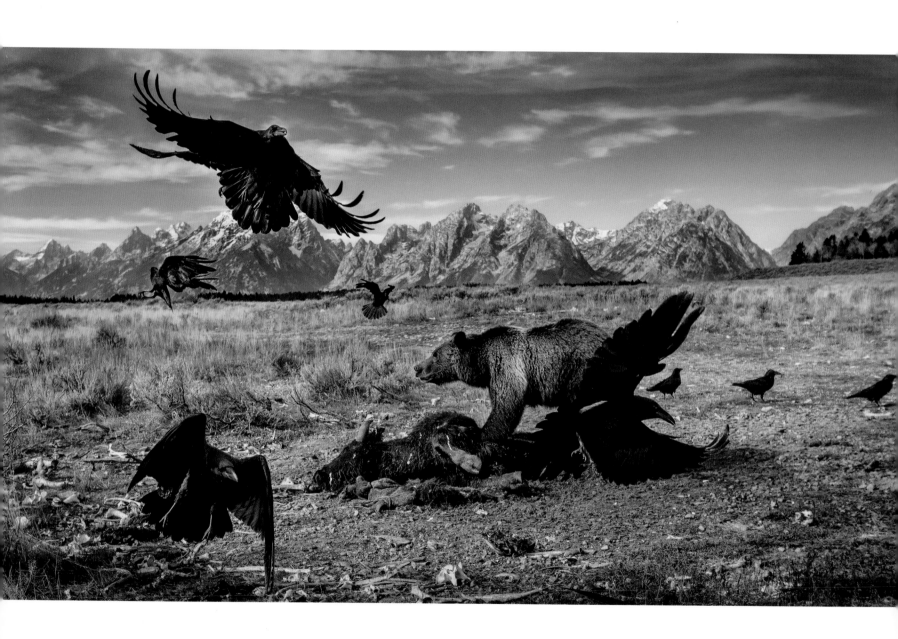

Night blow

Audun Rikardsen

NORWAY

It was the polar winter, and the sun was below the horizon, but there was just enough light for Audun to see from his window a fishing boat dragging its net into the harbour with the herring catch of the day. Suddenly he realized that behind it were the shapes of killer whales. They had come into the fjords outside Tromsø in northern Norway tracking the shoals of migrating herring, but now these whales were following the boat in the hope of an easier meal. Grabbing his gear and his warmest clothes, Audun rushed to his boat. Extreme cold and high humidity created a magical frost mist over the water but also ice crystals that froze to his face and camera. Following the whales by the sound of their blows, and adjusting his settings and flash by instinct (in the rush, he'd forgotten his torch), he hung over the side of the boat and pointed his camera in the direction of the blows or the occasional glimpse of a fin. After six freezing hours, this was the shot that finally made it all worthwhile – an image of a killer whale at the interface between the two worlds marine mammals depend on – air and ocean.

Canon EOS-1D X + 24–70mm lens at 42mm; 1/40 sec at f5.6; ISO 4000; two Canon 600 flashes.

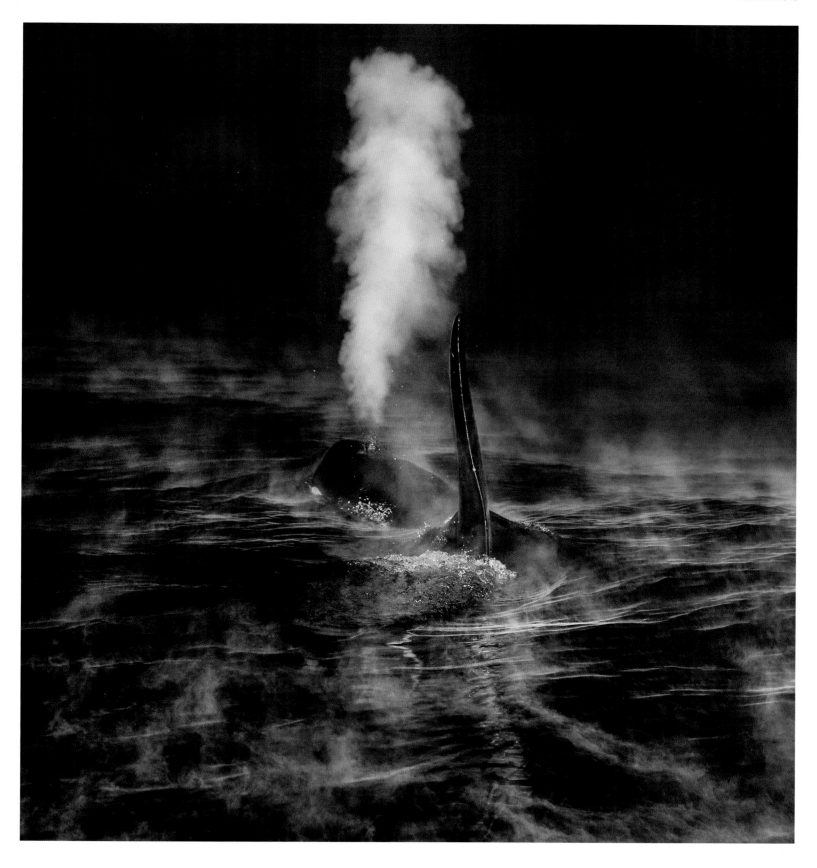

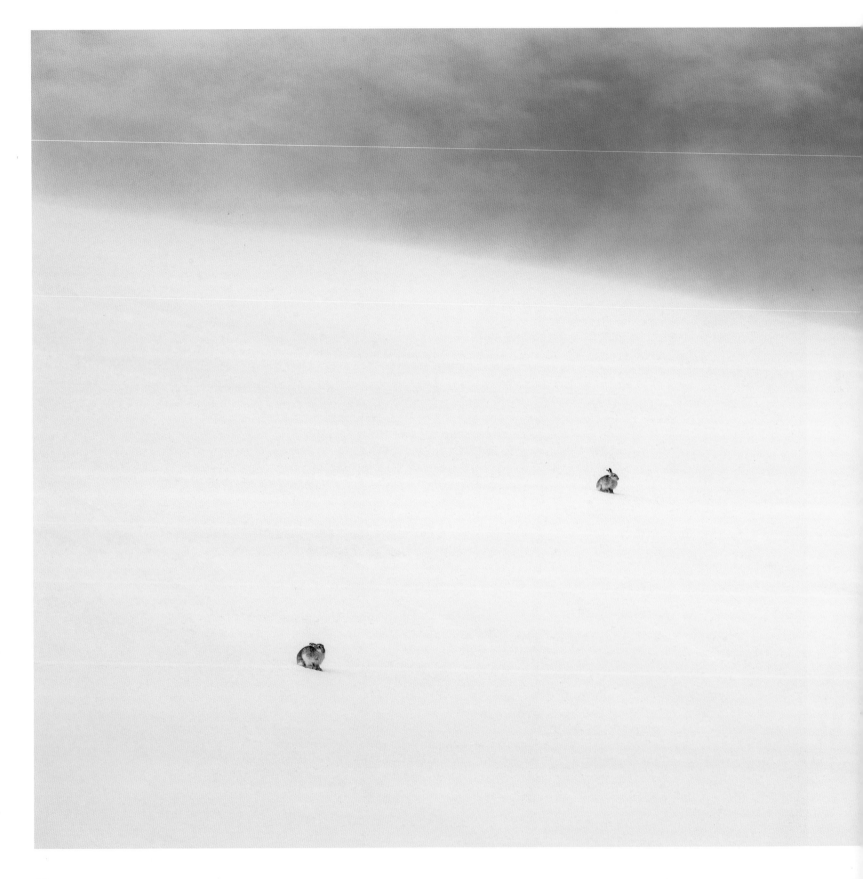

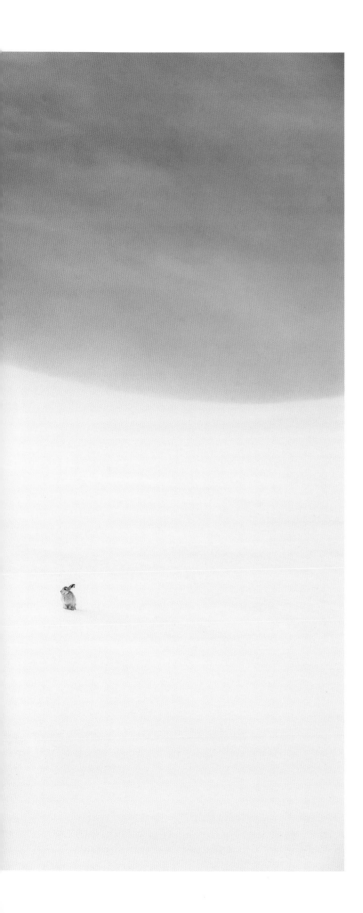

A sporting shot
Andrew Parkinson
UK

Andrew's stakeout location was just below an icefield on the highest slopes of Scotland's Cairngorms National Park. His aim was to photograph mountain hares as a natural part of the harsh mountain environment at the most unforgiving time of the year. It was late February, and the challenge was to keep a low profile while not freezing, which required regular press-ups in addition to the seven layers of upper clothing and four of trousers. He had no idea what his chances were of a hare moving into view, though in this area of the Cairngorms, they are relatively trusting. Elsewhere they are far more nervous, partly because they are routinely – and controversially – killed, blamed by grouse-shooting concerns for transmitting a virus that affects numbers of red grouse (though this is disputed) and for competing with grouse (they eat heather). On this day, after six hours, he got lucky. 'We can possess all of the technology and invest time and effort,' he says, 'but we still have to rely on luck.' Certainly, he never imagined that three courting hares (two males and a female) would appear and arrange themselves in front of him. He hopes that his image will convey their astonishing adaptability and 'give value to these miracles of nature, which can be so thoughtlessly exterminated in the name of sport'.

Nikon D3S + 200–400mm f4 lens at 240mm; 1/400 sec at f13; ISO 800.

Mara mama calls

Darío Podestá

ARGENTINA

At the whistling of a mother Patagonian mara, pups of different ages and sizes start to emerge from their communal nursery den on the Chubut plains of southern Argentina. Only two of them belong to her, and they are the only ones she will nurse, recognizing them by smell. The father of her pups is nearby, keeping watch (maras mate for life, and the male follows the female wherever she goes). Also nearby is Darío, with a remote-control trigger for his camera, which he's placed close to the burrow. This was the fourth day of his stakeout, and only on this morning was there a stormy sky, giving ideal overcast lighting. In this area of Patagonia, a number of pairs of mara – sometimes more than 20 – use a communal nursery den, dug by the females, who give birth outside and then leave their youngsters to hide in the burrow, out of sight of both land and aerial predators. Then the parents go off to feed, often a long distance away. Only one pair at a time will come to feed their offspring, though the youngsters will usually all come out when an adult calls. For a number of years, Darío has been trying to photograph the behaviour of these rodents – found only in Argentina. Though they are relatively common, they feed over huge areas and are very shy. This breeding burrow was one of the few he had discovered where the entrance wasn't obscured by bushes and where he could show their social interactions against a backdrop of the Patagonian plains.

Canon EOS 5D Mark II + 17–40mm f4 lens at 17mm; 1/400 sec at f14; ISO 1000; Hähnel Giga T Pro II wireless-timer remote.

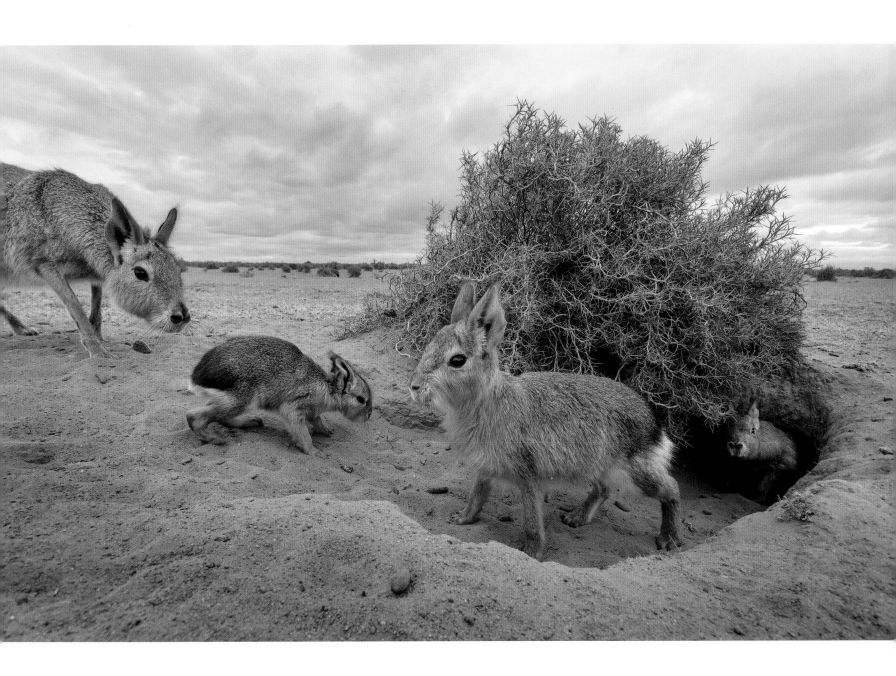

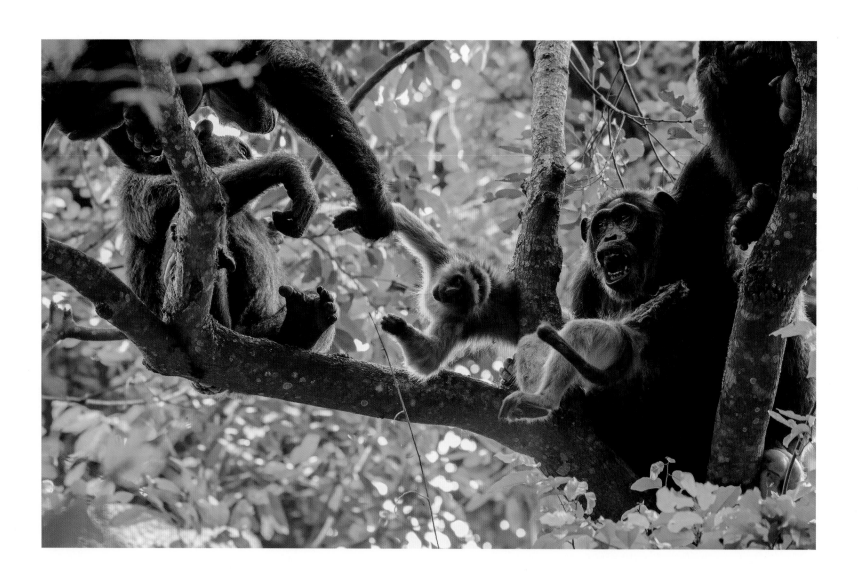

Spoils of the hunt
Ronan Donovan

USA

The forest erupted with noise: the booming barks and pant-hoots of male chimpanzees and the terrified squeaks of red colobus monkeys. A grisly scene awaited Ronan when he caught up with the large group of eastern chimpanzees he'd been following in Uganda's Kibale National Park. The males were huddled in a tight circle over a red colobus. As Ronan watched, the dominant male eviscerated the monkey, pulling out the nutrient-rich digestive organs as the still-live animal flailed around in shock. Once the males had taken the choice meat, they let the waiting females have the rest and left. Here two high-ranking females argue over the body, pulling it back and forth; gathered round are younger ones waiting their turn for scraps of the nutritionally valuable meat. Who gets what will depend on hierarchy and relationships. The hunt had caused the levels of aggression and social stress to surge, and it was a 'loud, gory and difficult event to witness', says Ronan. 'I wanted to capture all those tensions.' To freeze the movement and catch the all-important facial expressions in the low light of the forest, he had to use a high speed and a higher-than-normal ISO. At first glance, it's not clear from the picture whether the interaction involves play, curiosity or anger, but once you see the protruding spine, the magnitude of the situation becomes clear. Hunts are rare – and in this case, opportunistic – and in the year he spent with the chimps, Ronan only witnessed three.

Canon EOS 5D Mark II + 100–400mm f4.5–5.6 lens; 1/400 sec at f8 (+1 e/v); ISO 4000.

Birds

Eviction attempt

Ganesh H Shankar

INDIA

These Indian rose-ringed parakeets were not happy. They had returned to their roosting and nesting hole high up in a tree in India's Keoladeo National Park (also known as Bharatpur Bird Sanctuary) to find that a Bengal monitor lizard had taken up residence. The birds immediately set about trying to evict the squatter. They bit the monitor lizard's tail, hanging on for a couple of seconds at a time, until it retreated into the hole. They would then harass it when it tried to come out to bask. This went on for two days. But the action only lasted a couple of seconds at a time and was fast-moving. The branch was also high up, and Ganesh had to shoot against the light. Eventually the parakeets gave up and left, presumably to try to find another place to rear their young. These Indian birds are highly adaptable, and escaped captive parakeets have founded populations in many countries. In Europe, where they are known as ring-necked parakeets, they are accused of competing for nest holes with some native species, such as nuthatches, and even bats, but in turn, other birds such as starlings are quite capable of evicting the parakeets from their nest holes.

Nikon D810 + 200mm f2 lens; 1/500 sec at f5; ISO 400; Gitzo 5540LS tripod + Sachtler 0707 FSB-8 fluid head.

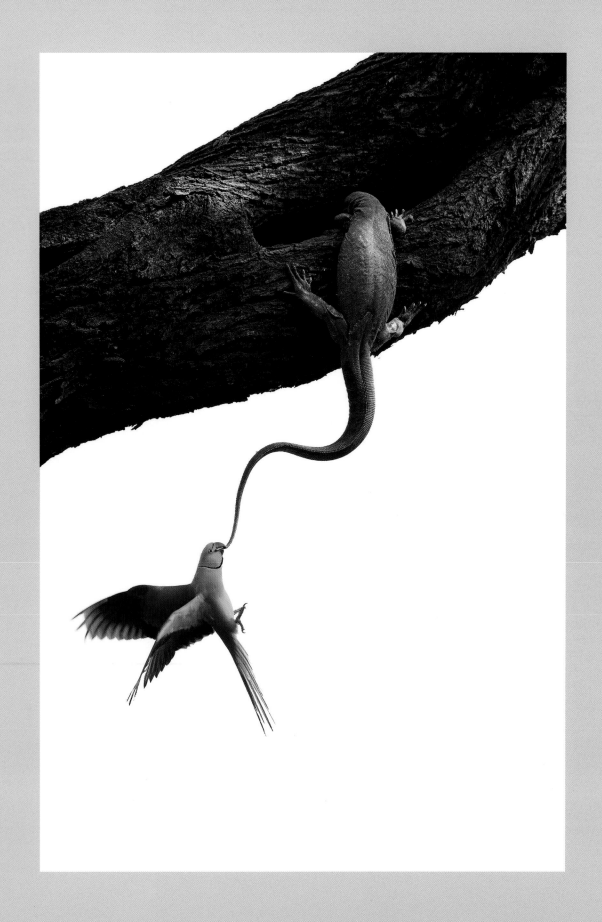

Rig diver

Alexander Mustard

UK

The irony wasn't lost on Alex: drilling for oil is not generally beneficial for wildlife, and yet rigs can offer both shelter for fishes (and protection from fishing) and a hunting ground for their predators. The Eureka Oil Rig, off Long Beach, California, is a favourite spot for local Brandt's cormorants, with both a ready supply of fish and an above-water structure for roosting and wing-drying. Unusually, the rig also allows divers to explore underneath. But the light there is low, and so the only way Alex could show the vast stage as well as the drama with a wide-angle lens (a land lens rather than a fish-eye, so the rig legs would appear straight) was to add a special underwater corrector lens allowing a wide enough aperture. What he set out to show was a cormorant hunting. But the birds would dive up and down using the legs as cover, and the swell and the current were constantly changing. So it took many attempts to get in the right position and catch the moment the shoal of Pacific chub mackerel opened and a cormorant swept through, silhouetted against the blue.

Nikon D4 + 20mm f2.8 lens; 1/250 sec at f10; ISO 800; Carl Zeiss underwater corrector lens; Subal housing; two Seacam 150 Seaflashes.

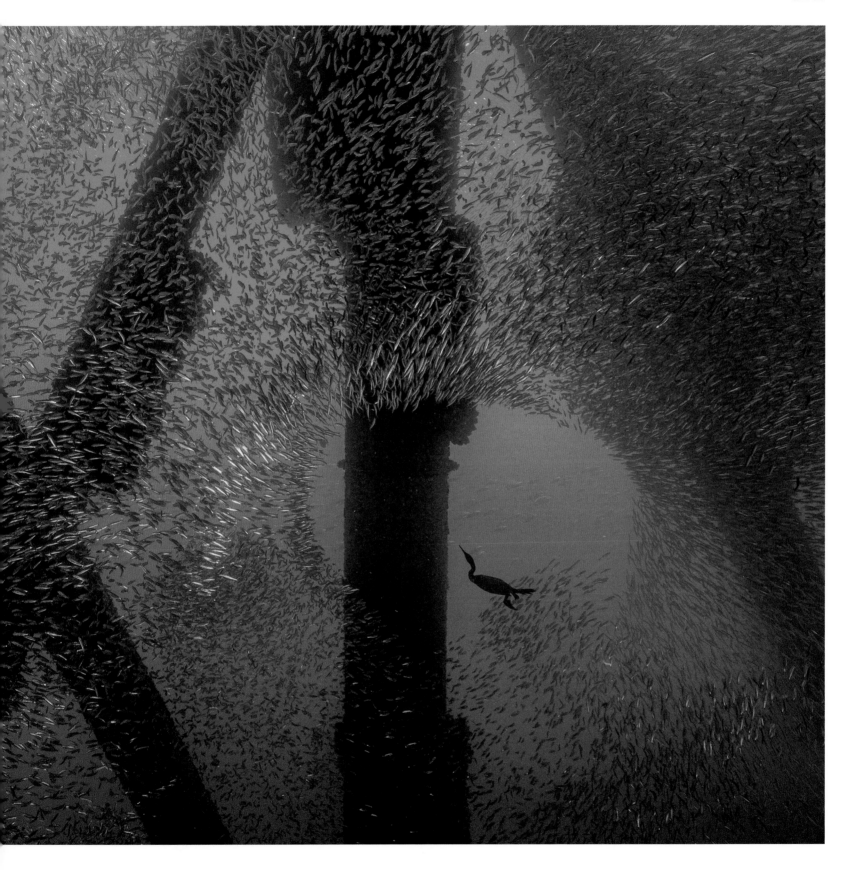

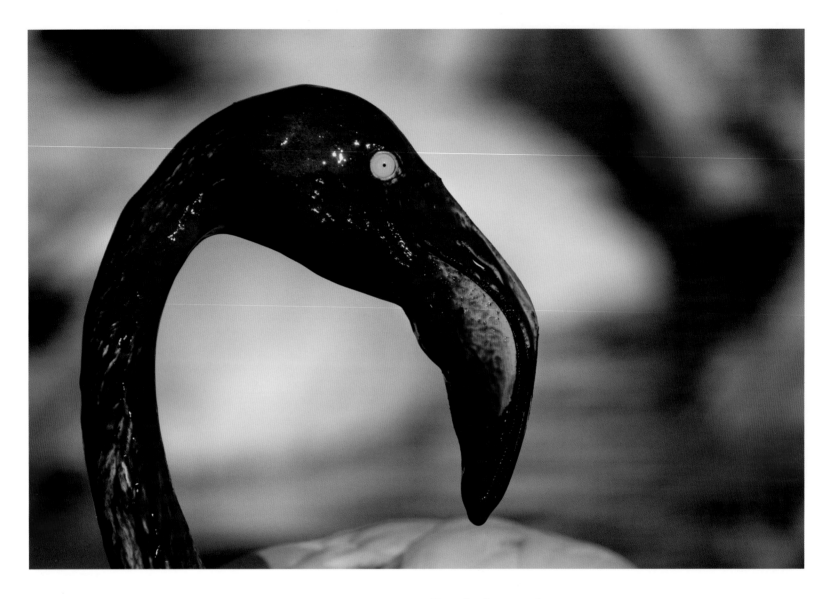

Study in mud
Laurent Chagnard

FRANCE

The greater flamingo lifted its head from feeding to take a breath and posed for a moment, its head and neck lacquered in thick, rich mud. It then put its head upside down again and walked on, swinging it from side to side, pumping water through the comb-like plates in its beak to filter out tiny morsels including insect larvae, worms and brine shrimps. Laurent was watching from behind reeds at the edge of a small lagoon in the French Camargue. This huge delta, with its briny lagoons, lakes and marshes, attracts more than 350 bird species and boasts the most important Mediterranean colony of greater flamingos – around 10,000 pairs. Laurent's photo was planned, symbolizing the richness and value of the mud in which these magnificent birds feed – though much of it contains agricultural fertilizers, pesticides and even PCBs.

Canon 7D + 100–400mm f4.5–5.6 lens at 400mm; 1/1250 sec at f6.3; ISO 100.

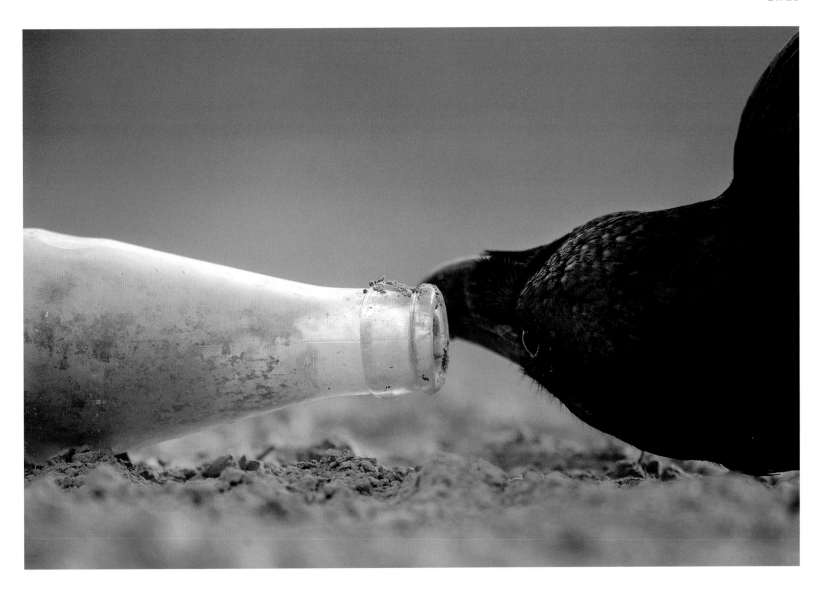

I spy with my raven eye

José Juan Hernández Martínez

SPAIN

José was in position before dawn, his lens trained along the ground from a hide that he had partially buried in a field in Fuerteventura in the Canary Islands. Ravens were flying over, pinching food from a nearby feeding station for Egyptian vultures, but they couldn't resist stopping off at the field to peek inside the glass bottles tossed there by passers-by. These bottles are death traps for creatures such as lizards and shrews, offering carrion for ravens. 'They would peer into the bottle openings,' says José, 'then pick them up, placing them in different positions – even upright – to inspect the contents' to see if there was something worth trying to extract with their bills. José spent several days in the hide to capture this image, which sums up a raven's curious and clever character.

Nikon D3S + 500mm f4 lens + 1.4x extender; 1/1250 sec at f5.6; ISO 800; Manfrotto tripod + Wimberley head; hide.

Remains of the day
Saud Alenezi

KUWAIT

The polka-dot feathers immediately identified the victim: a guinea-fowl —
a common bird in Kenya's Maasai Mara National Reserve. A tourist vehicle
positioned too close had scared away the killer, a martial eagle. But Saud knew
that the eagle was very likely to return to its food, and after the tourists had
left, he set up his shot. It is forbidden to get out of your vehicle in the reserve
(because of lions), but Saud had a solution: a specially created robotic car that
could position his camera close to the carcass. The difficulty was setting it up
in the right position, as he wouldn't be able to move it if the eagle returned.
The gamble paid off. Towards the end of the day, the martial eagle flew back
to claim its prize, spreading its wings over the corpse, crest slightly raised as it
feasted, looking straight at the camera and giving Saud his shot.

**Canon EOS 5D Mark III + 17–40mm f4 lens at 24mm; 1/640 sec at f5.6; ISO 400;
remote shutter release.**

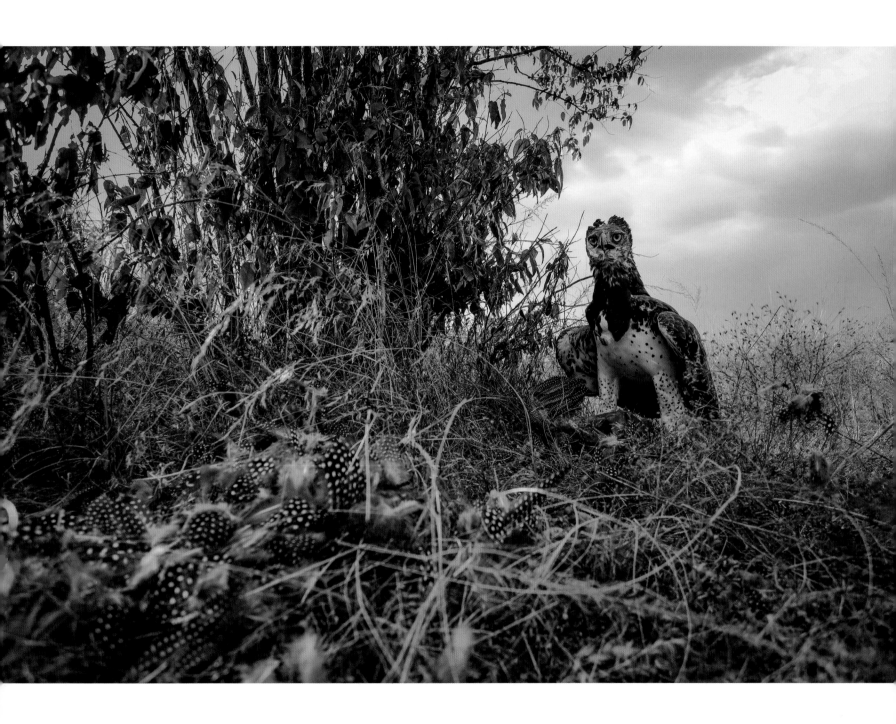

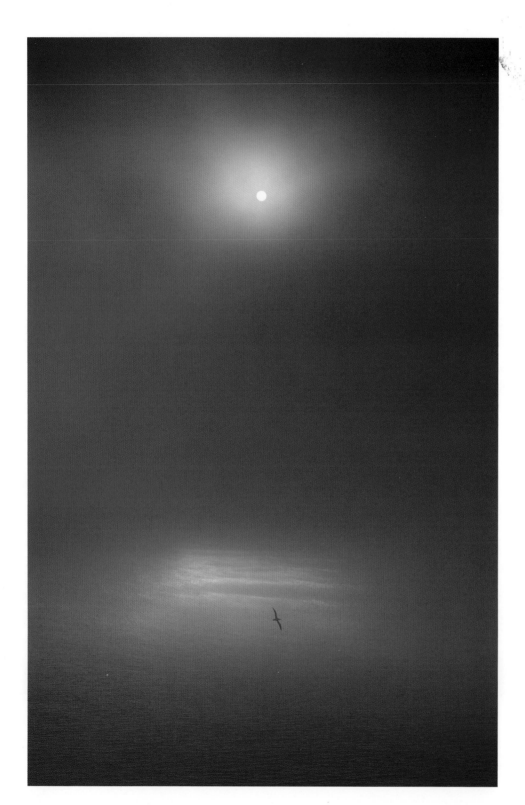

Into the blue

Guillaume Bily

FRANCE

He had seen the same light effect a few days before, but he hadn't got to the cliff edge in time to capture the scene. This time, Guillaume ran to the edge when he saw the light change. The Shetland island of Unst is famous for its diverse colonies of breeding seabirds, with kittiwakes, razorbills, skuas, shags, black guillemots, puffins, northern fulmars and gannets (more than 12,000 pairs of them), but it was also the light and the landscape that had attracted Guillaume to Unst. Now a great bank of fog hung over the sea, partially obscuring the sun. 'The reflection of the sun on the water was the only focal point in that blue immensity,' he says, until a single gannet flew ghost-like into the frame.

Nikon D4 + 50mm f1.4 lens; 1/640 sec at f13 (−1 e/v); ISO 200.

Hunting by ear
Eric Médard
FRANCE

Tipping her head from left to right, the barn owl tunes into the rustling, directing the sound to her ear openings just inside her feather facial disc. Barn owls excel at picking out the high-frequency vocalizations and the sounds of small mammals moving around. Their ear holes are different shapes and positioned at slightly different heights, and so each ear also hears slightly differently, allowing a sound to be pinpointed. This owl spent most of her time hunting in the rough grassland around Eric's home in northwestern France. In winter, however, she not only roosted in Eric's barn but also hunted there – an energy-saving option that is increasingly unavailable to barn owls because of changes in feed storage. Eric used a home-made camera trap, shooting in infrared with an infrared light so the brown rat was unaware of the surveillance by both human and owl.

Nikon D200 + 18–70mm f3.5–f4.5 lens at 25mm + infrared filter; 1/125 sec at f5.6; ISO 640; three Nikon Speedlight SB-24 flashes.

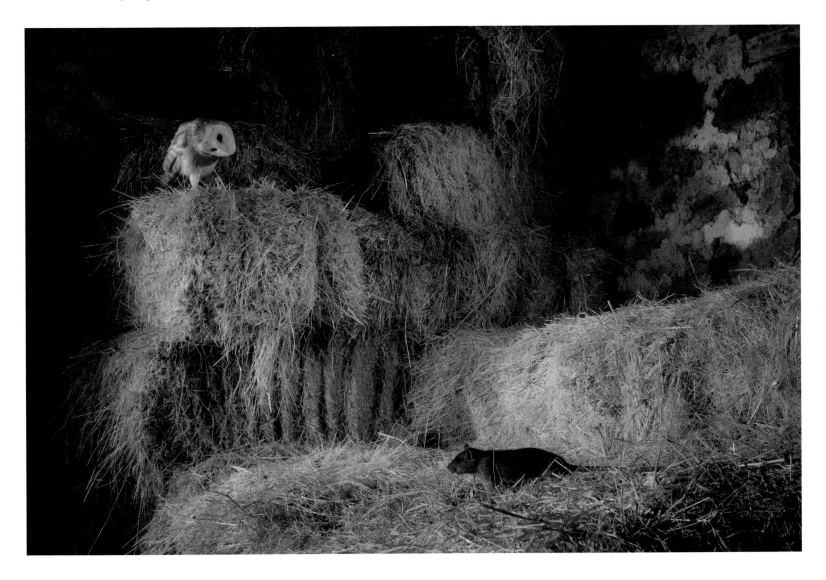

Termite tossing

Willem Kruger

SOUTH AFRICA

Termite after termite after termite – using the tip of its massive beak-like forceps to pick them up, the hornbill would flick them in the air and then swallow them. Foraging beside a track in South Africa's semi-arid Kgalagadi Transfrontier Park, the southern yellow-billed hornbill was so deeply absorbed in termite snacking that it gradually worked its way to within 6 metres (19 feet) of where Willem sat watching from his vehicle. Though widespread, this southern African hornbill can be shy, and as it feeds on the ground – mainly on termites, beetles, grasshoppers and caterpillars – it can be difficult for a photographer to get a clear shot among the scrub. The bird feeds this way because its tongue isn't long enough to pick up insects as, say, a woodpecker might, and though its huge bill restricts its field of vision, it can still see the bill's tip and so can pick up insects with precision. What Willem was after, though, was the hornbill's precision toss, which he caught, after a 40-minute, 40°C (104°F) wait.

Nikon D3S + 600mm f4 lens; 1/5000 at f4; ISO 800; Kirk WM-2 window mount + Benro GH-2 Gimbal tripod head.

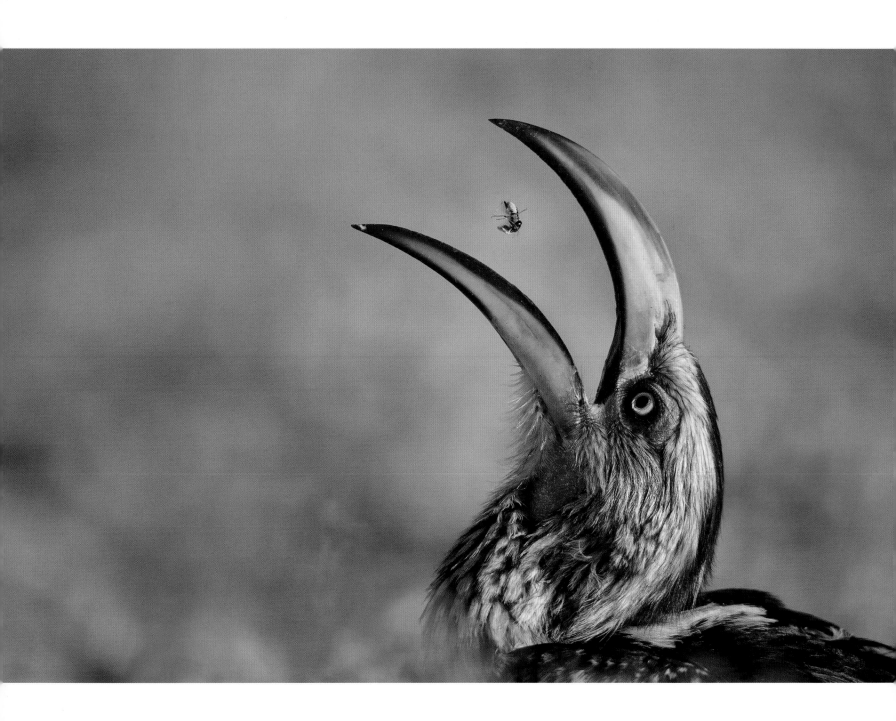

Land

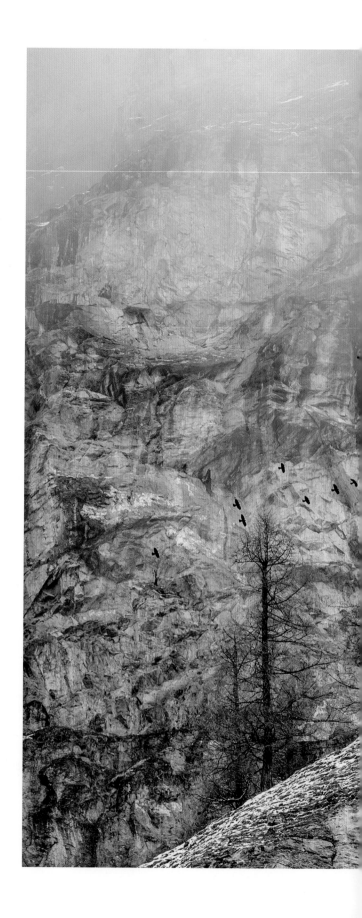

Spirit of the mountains
Stefano Unterthiner
ITALY

For the past two years, Stefano has been photographing the 'wild and challenging environment' around his home in the Aosta Valley in Italy's Gran Paradiso National Park. After several days of rain and snow, he knew the mountains would be swathed in low cloud. So he trekked to this point, where ancient larches, some 250 years old, stand against a dramatic backdrop, merging into the cracks and folds of the lichen-covered metamorphic rock. He was hoping to photograph Alpine ibex (its protection led to the creation of Gran Paradiso as Italy's first national park in 1922). Instead he was rewarded with a glimpse of a lammergeier, or bearded vulture, almost invisible in the low cloud but its form unmistakable – vast black wings, paler underparts and a long, diamond-shaped tail. The species was persecuted to extinction in the Alps a century ago, but a long-term reintroduction project has seen it nesting here again. As he framed his shot, a flock of Alpine choughs appeared, following the curve of the ridge, the vulture looming ghost-like behind them. It was a scene that captured the magic of this 'wild, wonderful region'.

Nikon D3S + 200–400mm f4 lens at 350mm; 1/400 sec at f8; ISO 400.

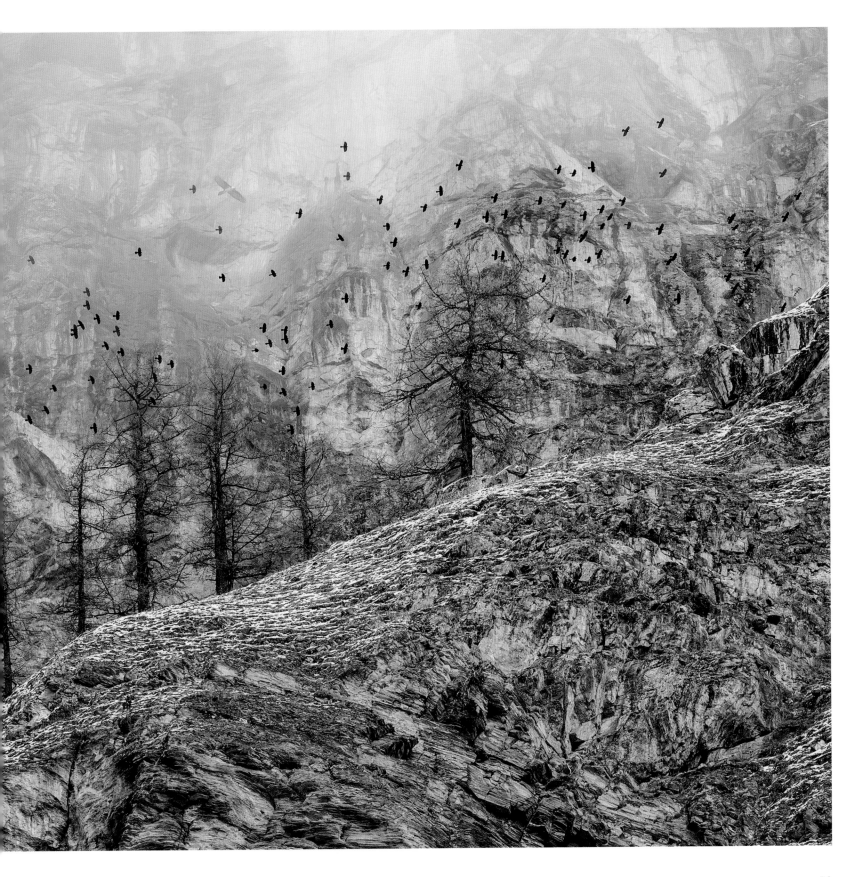

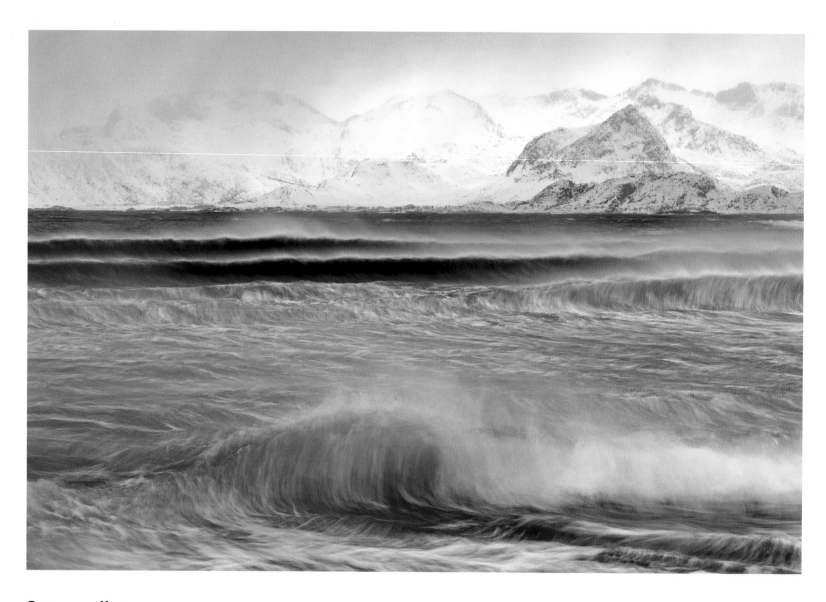

Storm rollers
Sandra Bartocha
GERMANY

Winter conditions on the northern Atlantic coast of Norway's Lofoten islands were fast-changing, and Sandra didn't know what the day would bring when she set out into the storm. Her aim was to portray the wildness of the icy waters and mountainous coast. After hours of shooting incoming waves, at −10°C (14°F), exacerbated by severe wind chill, struggling to keep her tripod steady and the lens free of sea spray and snow, she saw an exceptionally strong gust hit the water. 'A couple of beautiful waves were rolling in very fast,' she says, 'while wind was blowing the crests in the opposite direction.' In one moment, everything came together, colours, alignment and drama. 'I took hundreds of images that day,' she says, 'but just this one conveyed the true feeling of wildness.'

Nikon D3X + 70–200mm f2.8 lens at 100mm + polarizing filter; 0.6 sec at f16; ISO 100; Gitzo tripod + Really Right Stuff ballhead.

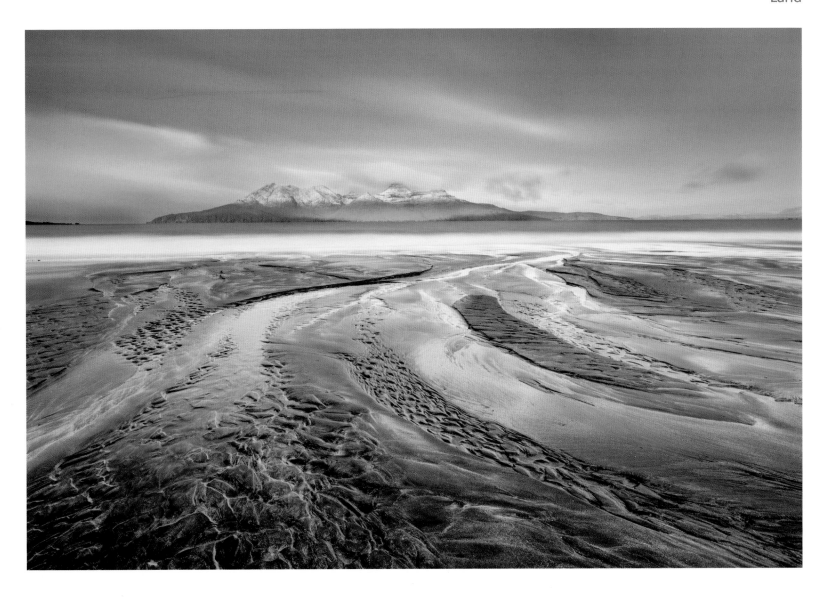

After the storm

Fortunato Gatto

ITALY

Fortunato caught the last ferry to the Isle of Eigg, off the west coast of Scotland, before the storm struck. Severe weather was just what he needed for sand texture. He then checked the forecast for the coincidence of low tide with snow on the Cuillins of Rum and the prospect of a beautiful dawn. Before sunrise, he set out for Laig Bay, which faces the Isle of Rum – a long beach where white shell fragments blend with black basalt grains in constantly shifting patterns. The storm had passed, but the wind was still strong, stinging him with sand and salty spray. He set a long exposure to enhance the contrast between the dynamic clouds and sea and the static rippled sand, its curves leading towards the snow-dusted island. As the first light hit the distant peaks, everything came together in this sublime moment.

Canon EOS 5D Mark III + Zeiss 21mm f2.8 lens + Lee landscape polarizer + ND 1.8 + NDG hard-edge filters; 121 sec at f11; ISO 100; Canon remote control; Manfrotto tripod.

Clouded in mystery

Alexandre Deschaumes

FRANCE

As the storm began to clear, the clouds drew back to reveal jagged granite peaks of the most famous mountains in the Patagonian Andes. Hiking a little higher in the cold and wind, Alexandre found his spot 'where the shapes of the mountains were in equilibrium'. He was glad of the clouds and lack of any strong light, which allowed the mysterious atmosphere to dominate. He wanted to capture the 'soul' of these magnificent peaks – the Cuernos del Paine in Chile's Torres del Paine National Park – and the immensity of the landscape, with spires reaching 2,460 metres (8,070 feet). To achieve the sense of depth and detail that he wanted, he created a panoramic picture (12 frames stitched vertically). By moving the hand-held camera from sharp reality on the left to a more painterly, less sharp view, he managed to combine the powerful landscape with the otherworldly atmosphere that so enthralled him.

Canon EOS 5D Mark III + 300mm f2.8 lens; 1/1250 sec at f2.8; ISO 100; 12 images stitched.

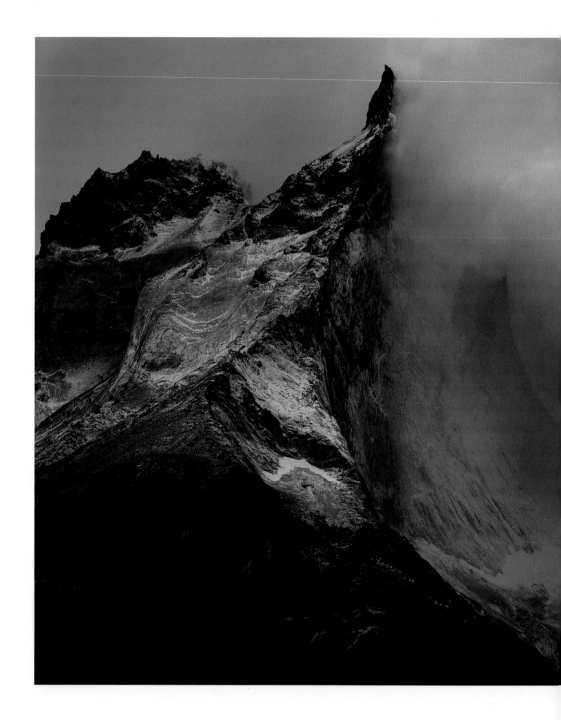

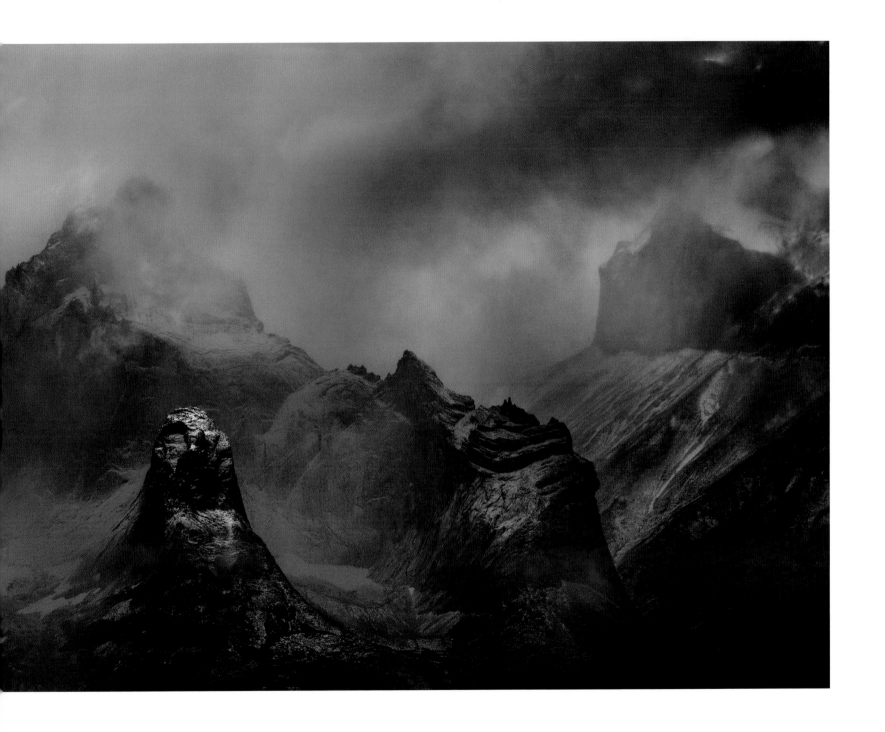

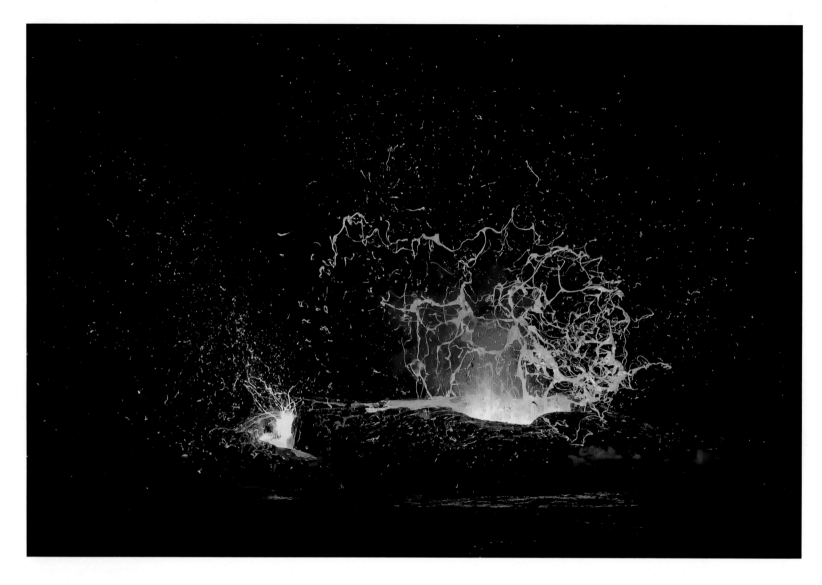

Blast furnace
Alexandre Hec

FRANCE

When the lava flow from Kilauea on Hawaii's Big Island periodically enters the ocean, the sight is spectacular, but on this occasion Alexandre was in for a special treat. Kilauea (meaning 'spewing' or 'much spreading') is one of the world's most active volcanoes, in constant eruption since 1983. As red-hot lava at more than 1,000°C (1,832°F) flows into the sea, vast plumes of steam hiss up, condensing to produce salty, acidic mist or rain. Alexandre witnessed the action and returned in an inflatable the following evening to find that a new crater had formed close to the shore. Capturing the furious action in a rough sea was no easy task. From 100 metres (330 feet) away, he was blasted with heat and noise – 'like a jet taking off'. In a moment of visibility, his perseverance paid off, with a dramatic image of glowing lava being tossed some 30 metres (100 feet) into the air against the night sky.

Nikon D300 + 70–200mm f2.8 lens at 70mm; 1/350 sec at f4; ISO 800.

Kashmir light and shade
Enrique López-Tapia de Inés
SPAIN

The last light of the day illuminated the barren slopes of Nubra Valley, hidden between the Himalayas and the Karakoram mountains in remote Kashmir, India. Enrique had arrived there via Khardung La pass, one of the highest roads in the world – the perfect place to acclimatize before starting a 16-day trek through the Zanskar mountains. What he hadn't expected was a spellbinding show of light and shade. As the clouds scooted past in the breeze, the shadows in the soft evening light leapt from one sharp mountain ridge to the next, across the succession of deep gorges. 'I always kept my camera ready', says Enrique, 'since the mind and body are slower at this altitude.' Without pausing to set up his tripod, he shot multiple frames – each unique – as the clouds shifted and the sun quickly disappeared. In this fleeting moment, he relished the depth created by the light and the drama added by the shadows to the arresting landscape.

Nikon D300 + 80–200mm f2.8 lens at 200mm; 1/640 sec at f5.6 (–1.3 e/v); ISO 200.

Plants

Wind composition
Valter Binotto

ITALY

With every gust of wind, showers of pollen were released, lit up by the winter sunshine. The hazel tree was near Valter's home in northern Italy, and to create the dark background, he positioned himself to backlight the flowers. Hazel has both male and female flowers on the same tree, though the pollen must be transferred between trees for fertilization. Each catkin comprises an average of 240 male flowers, while the female flower is a small bud-like structure with a red-tufted stigma. The pollen-producing catkins open early in the year, before the leaves are out, and release huge amounts of pollen to be carried away by the wind. And now recent research suggests that bees may also play a role. The catkins are an important source of pollen for early bees and have a bee-friendly structure, while the red colour of the female flowers may entice insects to land on them. 'The hardest part was capturing the female flowers motionless while the catkins were moving,' explains Valter. 'I searched for flowers on a short branch that was more stable.' Using a long exposure to capture the pollen's flight and a reflector to highlight the catkins, he took many pictures before the wind finally delivered the composition he had in mind.

Nikon D4 + 200mm f4 lens; 1/80 sec at f10; ISO 200; remote shutter release; Gitzo tripod + Benro head; reflector.

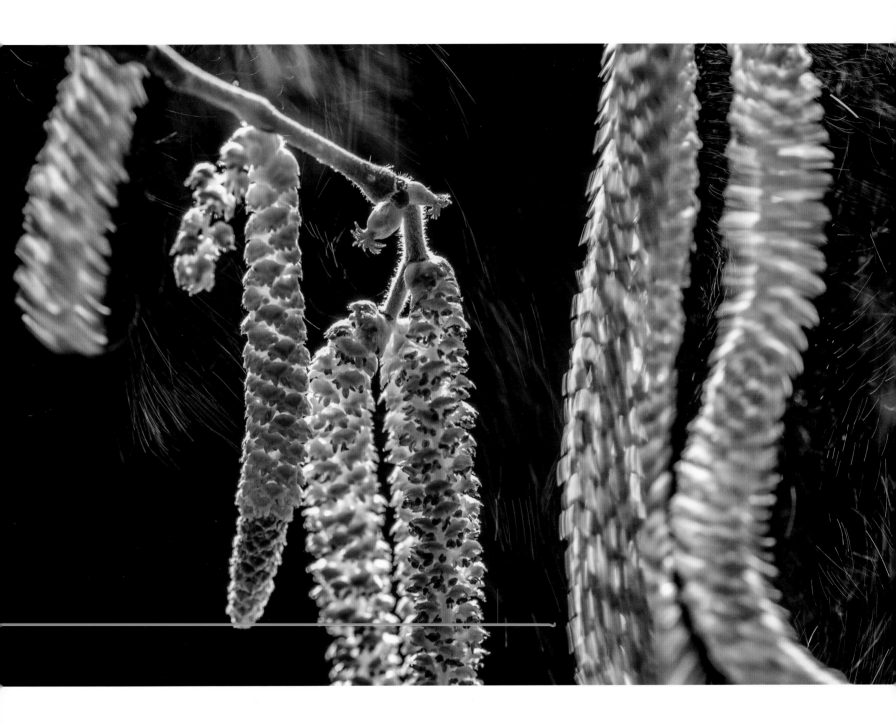

Grass at sunrise
Roberto Bueno
SPAIN

At dawn, as on many other summer mornings, Roberto was in his hide beside a pool in Sierra de Béjar, Spain, hoping to photograph birds. But unusually, after three hours, none had shown up. So he swapped his telephoto lens for a shorter one and went to explore near the creek. What he found was a delicate species of hairgrass, just 10–15 centimetres (4–6 inches) tall, a grass that, for years, he had been trying to photograph in flower in a special way. 'Grasses are among the most widespread groups of plants,' he says 'but are often overlooked because of their simplicity... yet seen close up, their delicate forms can be so beautiful'. He lay down and adjusted his tripod to its minimum height, facing into the low light. 'At last, I saw in the viewfinder the picture I had been looking for.' Using a polarizing filter to enhance the colours and eliminate reflections, he captured the simple, ethereal beauty of the grass in the soft early-morning light.

Nikon D800 + 70–200mm f2.8 lens at 200mm + B+W polarizing filter; 1/125 sec at f7.1; ISO 800; Gitzo tripod + RRS ballhead.

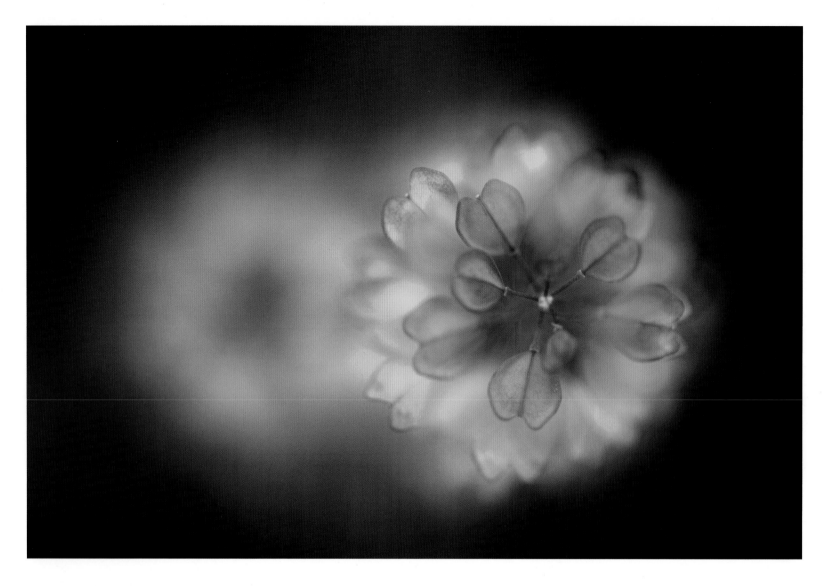

Heart's delight
Sandra Bartocha
GERMANY

A tiny plant absorbed all of Sandra's attention that summer evening on the Swedish island of Öland. The Cotswold pennycress, at home on limestone soils and old walls, is not difficult to find in mainland Europe (though it occurs at only a few sites in the UK, mainly in the Cotswolds). Its clusters of tiny, white flowers produced in spring, ripen into delicate, heart-shaped seedpods. 'Looking from above gave me an interesting perspective,' says Sandra. Shooting macro meant a narrow depth in focus, and so she chose an in-camera double exposure, handholding the camera in position while changing the focus between shots from the upper to the third row of seeds. 'The challenge was balancing', says Sandra, 'and finding that perfect frame.' Relying on just natural light, her image merges colours and multiple layers of sharpness to celebrate the beauty of this less obvious subject.

Nikon D800 + 105mm f2.8 lens; 1/100 sec at f4.2; ISO 100; double exposure.

Little star
Stefano Baglioni
ITALY

Unusually high temperatures and extreme drought had killed many of the agaves in this part of Mexico's Chihuahuan Desert, but their loss was another's gain. Stefano spotted this young bishop's cap cactus, already 20 centimetres (8 inches) across, exploiting the organic matter and the touch of shade afforded by the remains of an agave. The species is a desert survivor, covered with tiny, white hairy scales (trichomes) that are thought to provide some protection from the sun and ribbed sections (typically five) that enable it to shrivel or expand depending on the availability of moisture, with more ribs added as the plant grows to become a stout column up to a metre (3.3 feet) tall. In the searing heat, Stefano carefully framed the cactus among the criss-crossing leaves and, when a temporary cloud softened the light, captured the rich textures and tones of the parched scene.

Nikon D800 + 85mm f2.8 lens; 0.3 sec at f19; ISO 200; Gitzo tripod + Manfrotto head.

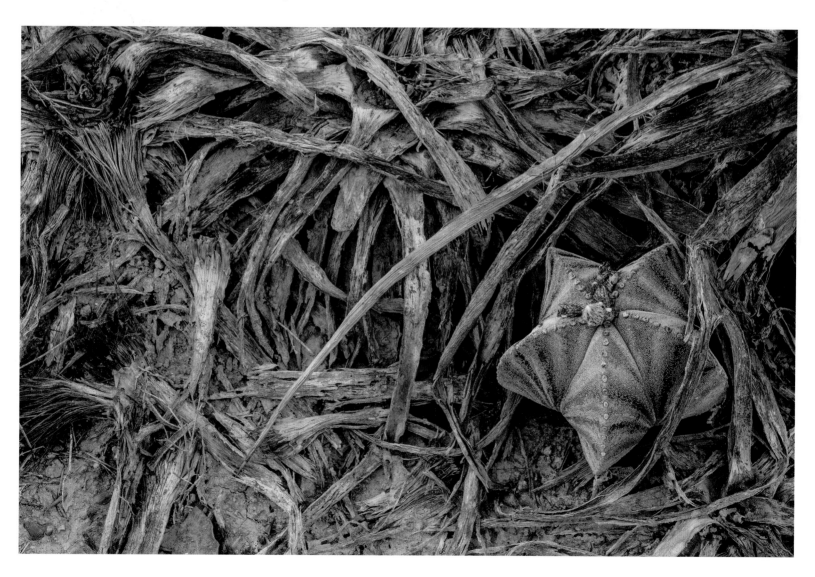

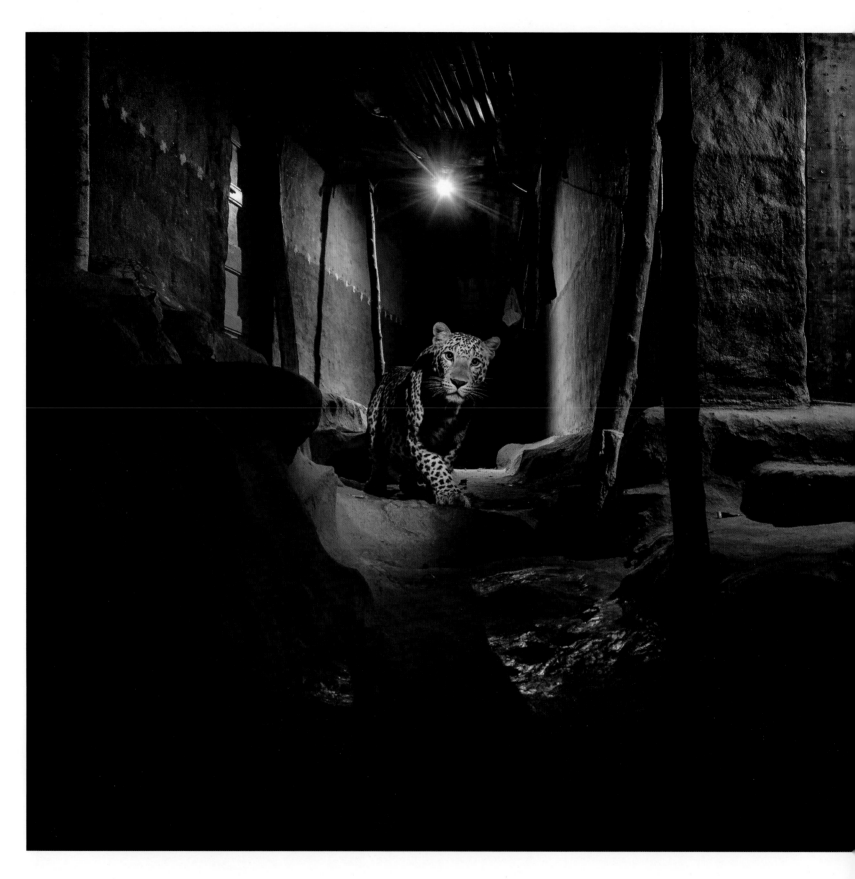

Urban

The alley cat
Nayan Khanolkar
INDIA

At night, in the Aarey Milk Colony in a suburb of Mumbai bordering Sanjay Gandhi National Park, leopards slip ghost-like through the maze of alleys, looking for food (especially stray dogs). The Warli people living in the area respect the big cats. Despite close encounters and occasional attacks (a particular spate coinciding with the relocation of leopards from other areas into the park), the cats are an accepted part of their lives and their culture, seen in the traditional paintings that decorate the walls of their homes. The leopard is not only the most versatile of the world's big cats but possibly the most persecuted. With growing human-leopard conflicts elsewhere grabbing the headlines, Nayan was determined to use his pictures to show how things can be different with tolerance and planning. Once he had convinced the Warli people of his plan, they supplied him with valuable information, as well as keeping an eye on his equipment. Positioning his flashes to mimic the alley's usual lighting and his camera so that a passing cat would not dominate the frame, he finally – after four months – got the shot he wanted. With a fleeting look of enquiry in the direction of the camera click, a leopard went about its business alongside people's homes. Nayan hopes that those living in Mumbai's new high-rise developments now impinging on the park will learn from the Warli how to co-exist with the original inhabitants of the land.

Nikon D7000 + 18–105mm f3.5–5.6 lens at 21mm; 1/20 sec at f7.1; three Nikon flashes; Trailmaster infrared triggers; custom-made housing.

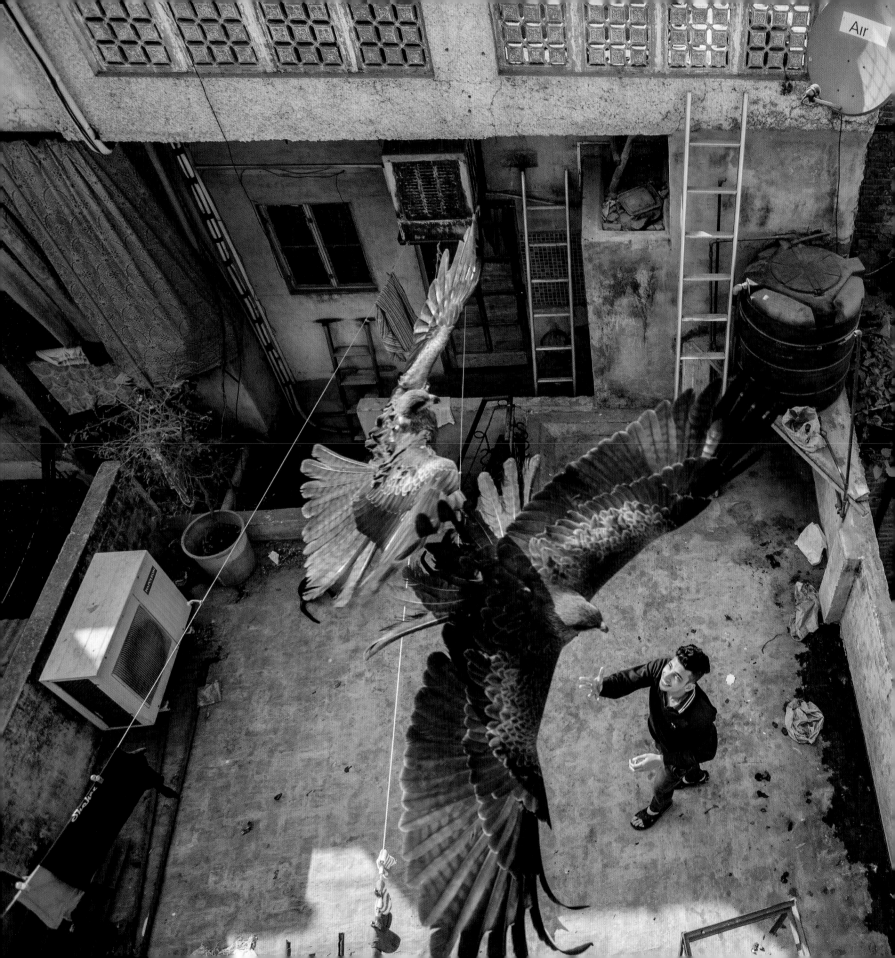

Kite flying
Luke Massey
UK

In the Muslim quarter of Old Delhi, India, people regularly toss leftover scraps of meat to the black kites as an act of kindness to atone for their sins. Luke edged his way through the maze of Chawri Bazar – a market surging with people, animals and vehicles – while whirls of mewing black kites swooped overhead. Sticking with a local guide, he climbed tiny staircases, walked through living rooms and clambered up bamboo ladders until he reached the rooftops. 'The sky was black with kites,' he says. This gregarious species is probably the world's most abundant bird of prey, at home in a range of habitats, though suffering in some areas from pesticides, pollution, poisoning and hunting. In Delhi, there is an added threat: hazardous 'cheese wire' strings of paper kites, which criss-cross the sky every evening. Wires can sever a leg, and festoons of discarded strings hanging from trees also entrap the birds. Once Luke was level with the kites, their wingtips brushing his face, he tried to frame a shot, taking in the rooftop jumble. But with 20 or more sweeping in for every offering, it took hundreds of attempts before he finally got a clear shot, with the meat-thrower's expression and birds in full frame.

Canon EOS-1D X + 17–40mm f4 lens at 40mm; 1/2500 at f7.1; ISO 1600; PocketWizard PlusX remote release; Benro tripod.

Alpine retreat

Hugo Wassermann

ITALY

Hugo was heading up the path to get a good view over the rooftops of the Abbey of Novacella – freshly sprinkled with snow – when he saw the Alpine choughs pecking away at the mortar between the bricks of the chapel. These distinctive birds, with yellow bills and bright red legs, are common in the nearby mountains of northern Italy, feeding largely on insects. In winter, some seek refuge around the monastery, feeding on any fruit remaining in the vineyards and orchards. The mortar provides them with grit, to help them grind up food, and calcium for their eggs. 'The choughs were very nervous, constantly taking flight,' says Hugo, aware that also watching them were their main predators, northern goshawks and peregrine falcons. Hugo grabbed his chance and illustrated the scattering of glossy black birds contrasting with the white-dusted, geometrically patterned roof.

Canon EOS 5D Mark II + 300mm f4 lens; 1/125 sec at f4; ISO 250; Gitzo tripod + Linhof head.

Crystal precision
Mario Cea
SPAIN

Every night, not long after sunset, about 30 common pipistrelle bats emerge from their roost in a derelict house in Salamanca, Spain, to go hunting. Each has an appetite for up to 3,000 insects a night, which it eats on the wing. Its flight is characteristically fast and jerky, as it tunes its orientation with echolocation to detect objects in the dark. The sounds it makes – too high-pitched for most humans to hear – create echoes that allow it to make a sonic map of its surroundings. Mario positioned his camera precisely so that it was level with the bats' exit through a broken window and the exact distance away to capture a head-on shot. The hard part was configuring the flashes to reveal the bat and highlight the edges of the glass shards. His perseverance paid off when he caught the perfect pose as a bat leaves the roost on its night-time foray.

Canon EOS 7D + 100–400mm f4.5–5.6 lens at 160mm; 1/250 sec at f9; ISO 200; Godox V860 flashes; Pixel King Pro remote release; Benro Travel Flat tripod + Benro V3E ballhead.

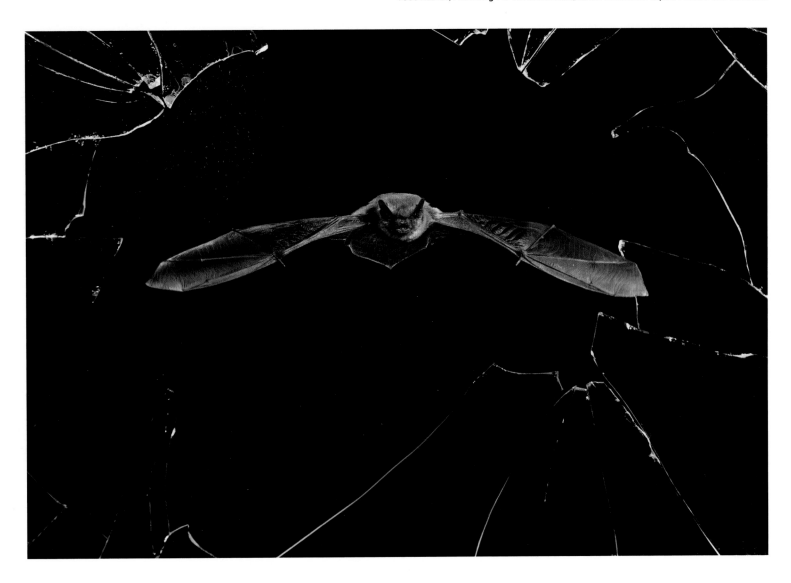

Nosy neighbour
Sam Hobson
UK

Sam knew exactly who to expect when he set his camera on the wall one summer's evening in a suburban street in Bristol, the UK's famous fox city. He wanted to capture the inquisitive nature of the urban red fox in a way that would pique the curiosity of its human neighbours about the wildlife around them. This was the culmination of weeks of scouting for the ideal location – a quiet, well-lit neighbourhood, where the foxes were used to people (several residents fed them regularly) – and the right fox. For several hours every night, Sam sat in one fox family's territory, gradually gaining their trust until they ignored his presence. One of the cubs was always investigating new things – his weeping left eye the result of a scratch from a cat he got too close to. 'I discovered a wall that he liked to sit on in the early evening,' says Sam. 'He would poke his head over for a quick look before hopping up.' Setting his focus very close to the lens, Sam stood back and waited. He was rewarded when the youngster peeked over and, apart from a flick of his ear, stayed motionless for long enough to create this intimate portrait.

Nikon D800 + 17–35mm f2.8 lens at 17mm; 1/6 sec at f4.5; ISO 800; Nikon SB-700 + SB-800 flashes; PocketWizard Plus III remote release; Manfrotto tripod.

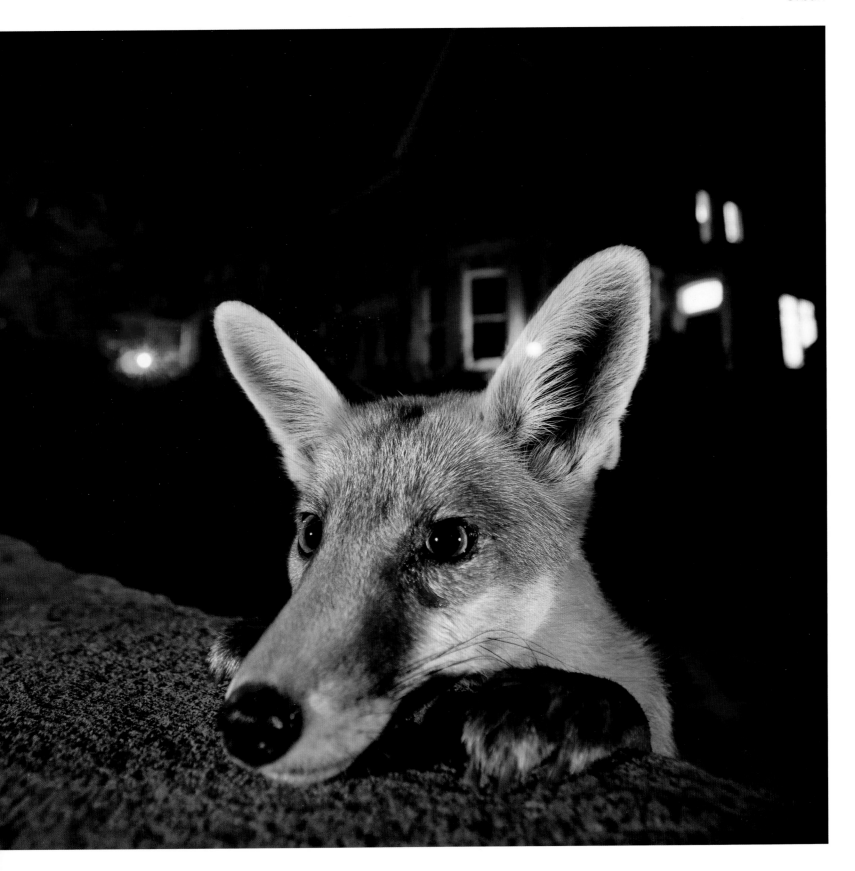

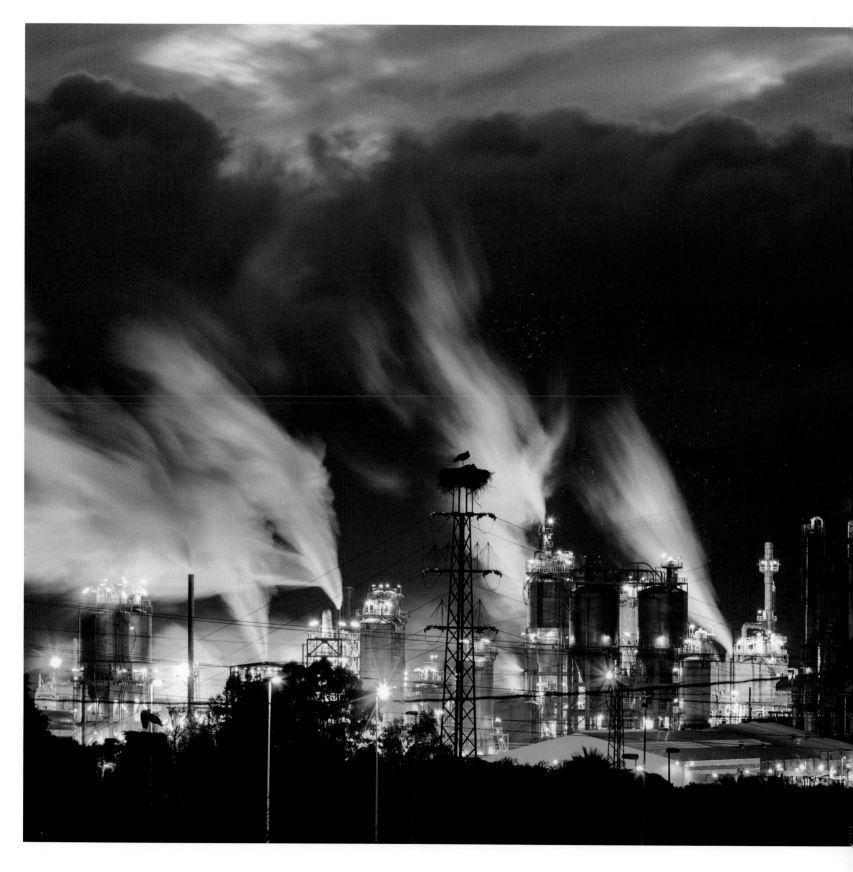

Refinery refuge
Juan Jesús González Ahumada
SPAIN

The oil refinery was noisy, polluted and constantly floodlit, but these white storks saw it as an ideal high-rise nursery. After overwintering in southern Africa, storks often return to the same nest sites, adding sticks to the nests each year, so some get to be more than 2 metres (7 feet) wide. Here the pair had chosen to nest on an electricity pylon next to an oil refinery in southern Spain, risking electrocution from collisions with the power lines – a serious threat. On a nearby hill, Juan found the ideal vantage point for a wide frame of the refinery, with the storks in silhouette, but he needed the right backdrop to transform the scene, which also included a pair of storks nesting lower down (bottom left). He returned several times, until one afternoon, he realized a storm was approaching that might give the dramatic sky he was after. As night fell and the refinery's lights began to blaze, the billowing emissions were highlighted against the dark storm clouds. It was the moment Juan had been waiting for.

Canon EOS 6D + 70–200mm f4 lens + 1.4x extender at 208mm; 10 sec at f7.1; ISO 100; Manfrotto tripod.

Black and White

Requiem for an owl

Mats Andersson

SWEDEN

Every day in early spring, Mats walked in the forest near his home in Bashult, southern Sweden, enjoying the company of a pair of Eurasian pygmy owls – until the night he found one of them lying dead on the forest floor. Pygmy owls, with their distinctive rounded heads and lack of ear tufts, are the smallest owls in Europe, barely 19 centimetres (7½ inches) long, though with large feet that enable them to carry prey almost as big as themselves. They also hunt in the day. Nesting in tree cavities, especially in conifer woodland, they form pair bonds in autumn that last through to spring and sometimes for more than one breeding season. 'The owl's resting posture reflected my sadness for its lost companion,' recalls Mats. Preferring to work in black and white – 'it conveys the feeling better' – he captured the melancholy of the moment, framing the solitary owl within the bare branches, lit by the first light of dawn. Not long after, he found this owl dead, too, and suspects that it and its mate may have been killed by one of the larger owls in the forest, not for food but because, in the breeding season, it didn't tolerate other birds of prey in its territory.

Nikon D4 + 300mm f2.8 lens + 2x extender; 1/160 sec at f5.6; ISO 400.

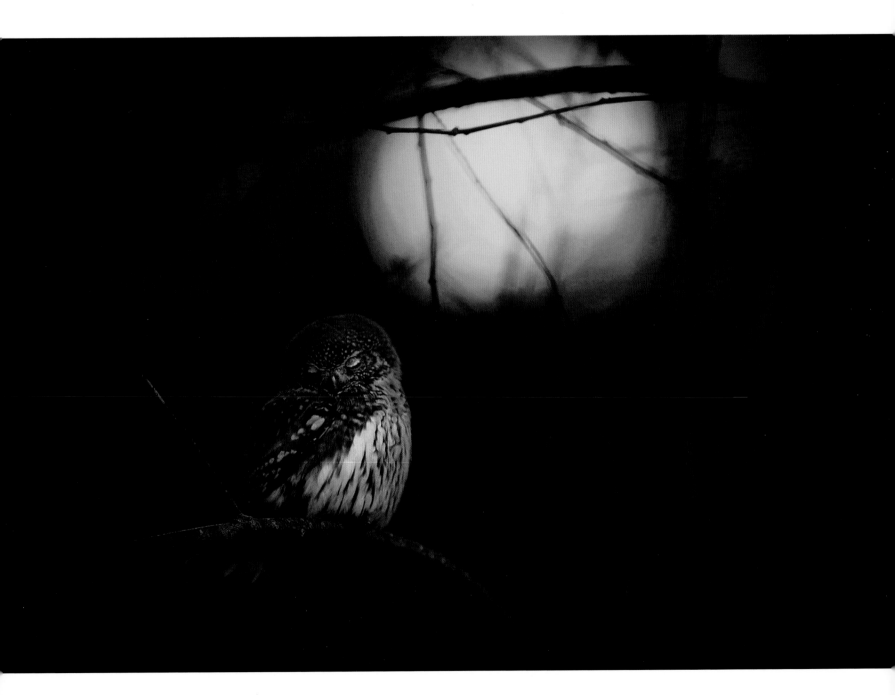

The sardine round-up

Dániel Selmeczi

HUNGARY

In 10 days, Dániel had just one chance to photograph the sardine hunters. Despite the vast scale of the 'sardine run' – when millions migrate along the east coast of South Africa, attracting a host of predators – finding the action is a challenge. And research suggests that, with overfishing and warming waters, the run is becoming less predictable. Day after day, bouncing over huge waves in a dingy, Dániel scanned the horizon for tell-tale diving gannets, racing over to any he spotted. 'Several times I jumped in to find all that was left was scales,' he says. Finally he got lucky, catching the last 10 minutes of speed-feasting, as a family of common dolphins consumed a ball of sardines they had driven to the surface. He caught the moment as the shadowy predators corralled their prey into a swirling backlit composition against a backdrop of overhead clouds.

Nikon D300 + Tokina 10–17mm f3.5–4.5 lens; 1/250 sec at f8; ISO 200; Subal housing; two Ikelite DS161 strobes.

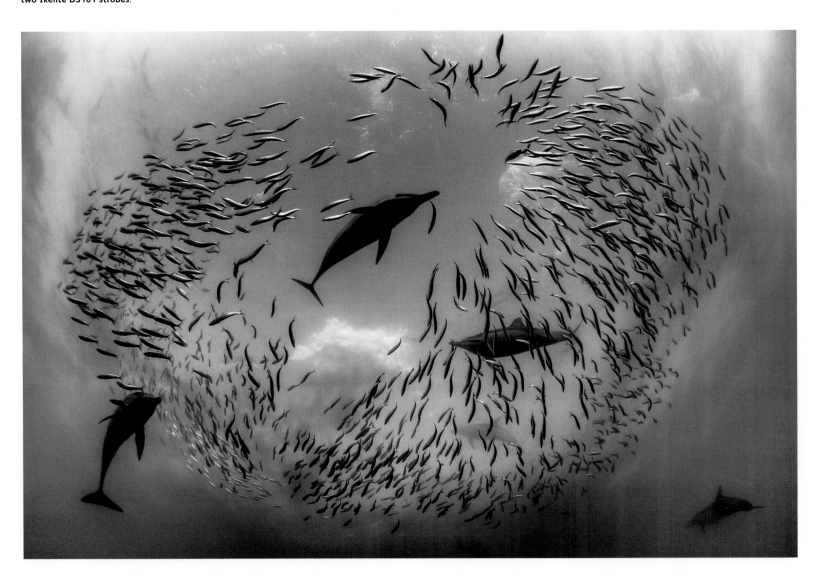

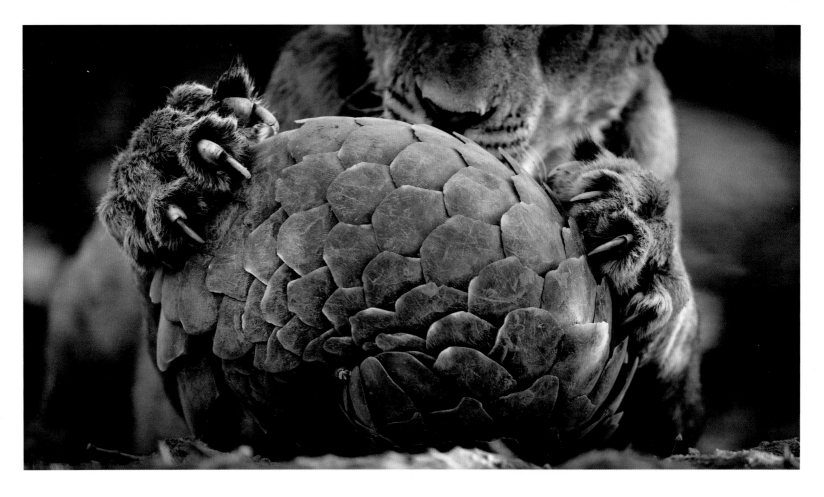

Playing pangolin
Lance van de Vyver
NEW ZEALAND/SOUTH AFRICA

Lance had tracked the pride for several hours before they stopped to rest by a waterhole, but their attention was not on drinking. The lions (in South Africa's Tswalu Kalahari Private Game Reserve) had discovered a Temminck's ground pangolin. This nocturnal, ant-eating mammal is armour-plated with scales made of fused hair, and it curls up into an almost impregnable ball when threatened. Pangolins usually escape unscathed from big cats (though not from humans, whose exploitation of them for the traditional medicine trade is causing their severe decline). But these lions just wouldn't give up. 'They rolled it around like a soccer ball,' says Lance. 'Every time they lost interest, the pangolin uncurled and tried to retreat, attracting their attention again.' Spotting a young lion holding the pangolin ball on a termite mound close to the vehicle, Lance focused in on the lion's claws and the pangolin's scratched scales, choosing black and white to help simplify the composition. It was 14 hours before the pride finally moved off to hunt. The pangolin did not appear to be injured, but it died shortly after, probably not just from the stress of capture but also from being out in the heat all day.

Canon EOS 5DS R + 500mm f4 lens; 1/1600 sec at f4; ISO 1600.

Fairy-tale forest

Agorastos Papatsanis

GREECE

The magic of mushrooms and the tales that surround them inspired Agorastos to create this intriguing picture. He found the surprisingly large group of parasol mushrooms on a cloudy October day in a forest clearing in the Grevena region of northern Greece. Fungi are often admired for their colours, but Agorastos used black and white to celebrate their graceful forms and alignment. The parasols' egg-shaped caps gradually flatten as the mushrooms grow, the stems extending up to 30 centimetres (12 inches), splitting their dark felty coverings into characteristic snake-like markings. Photographing from ground level, using only natural light, Agorastos began experimenting to give the impression of being among the spindly figures that filled his frame. He chose a vintage lens and set it at its widest aperture, to achieve the dreamy background and keep just two mushrooms in focus. 'They stand like a gateway to this elegant family,' he says, 'inviting you to step inside the fairy tale.'

Nikon D600 + Meyer Primoplan 58mm f1.9 lens; 1/250 sec at f1.9; ISO 100.

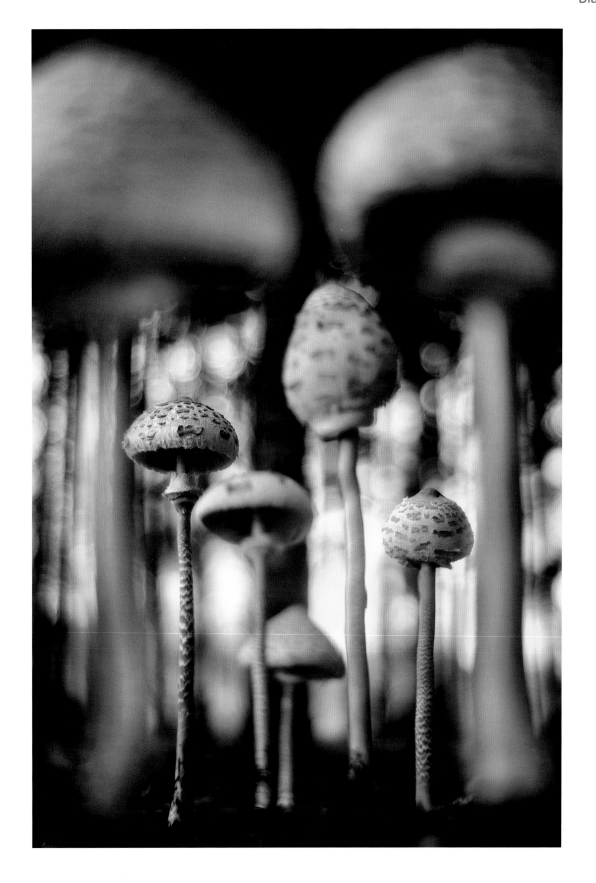

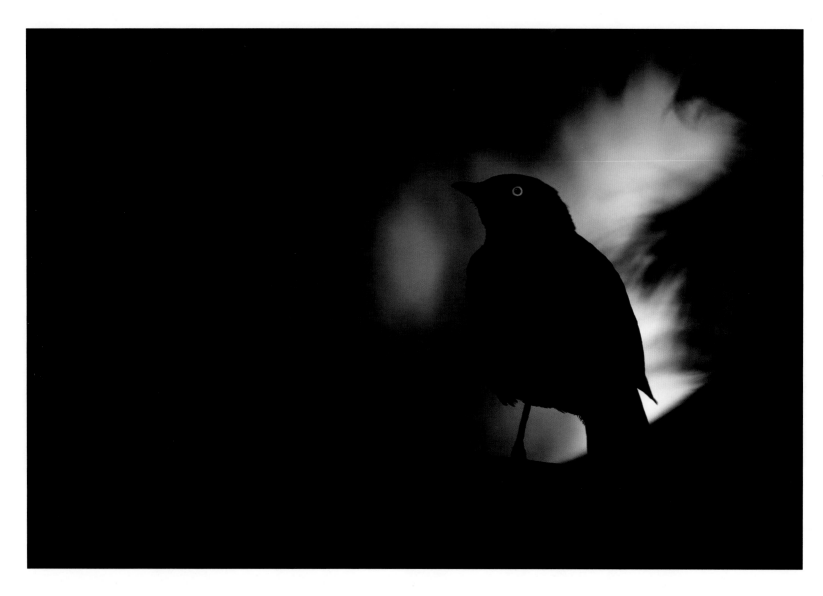

Eye-light
Nicola Di Sario
ITALY

The sun was setting over Ethiopia's Lake Awasa as the starlings returned to roost. Before they settled in the trees for the night, a few crouched on a small, sandy slope with their wings open, absorbing the last rays or possibly socializing. Their behaviour caught Nicola's attention. These lesser blue-eared glossy starlings are a small woodland species, common in many areas of Africa. True to their name, they embellished the lakeside with their iridescent colours, but it was their bright yellow or orange eyes that struck Nicola most. He chose to shoot in black and white to 'get straight to the point'. And while the birds were absorbed in their rituals, he moved to take advantage of the water behind the trees that was reflecting the fading light. Framing an individual against this backdrop, he captured the shadowy atmosphere, letting the bird's eye stand out in the darkness.

Canon EOS 5D Mark II + 500mm f4 lens; 1/500 sec at f4; ISO 1000; Sirui tripod.

Smooth swimmer
Christopher Swann
UK

A short-finned pilot whale surfaces in a silken sea. Its characteristic globular head lifts the water as it glides upwards. This large dolphin, with an appetite mostly for squid, gets it name from an old idea that groups were piloted by leaders. Its highly social nature – super-pods of several hundred have been known – is perhaps why it is susceptible to mass strandings, though it is threatened mainly by being caught in nets. Christopher was looking for whales and dolphins (cetaceans) around the Canary Islands, before he set sail across the Atlantic. Very familiar with the area – he has been travelling the ocean for 35 years – he had a particular picture in mind. 'I knew the angle I wanted of a surfacing pilot whale,' he says, 'but it only suited a silky sea.' On the day he encountered this youngster's pod, he was in luck – the lack of wind made the water perfectly smooth. 'I love the way black and white brings out the texture, the whale's eye and the water rippling over its head,' he says.

Nikon D200 + 70–200mm f2.8 lens at 140mm; 1/1000 sec at f2.8; ISO 200.

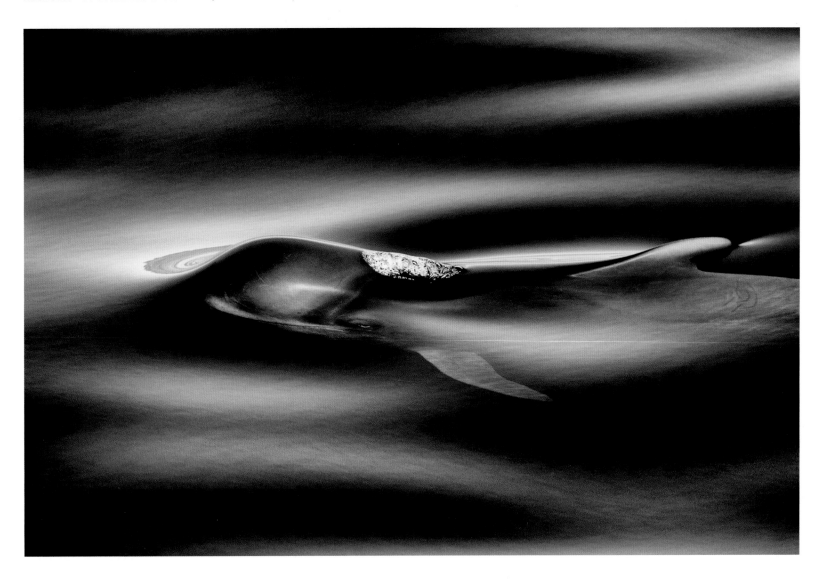

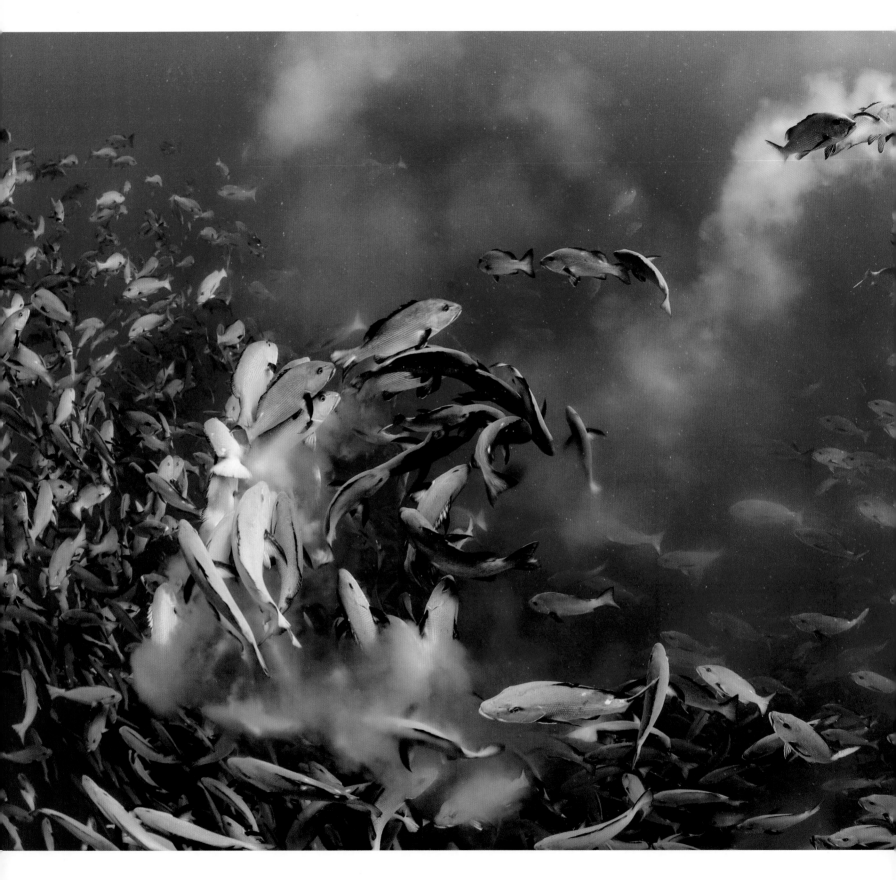

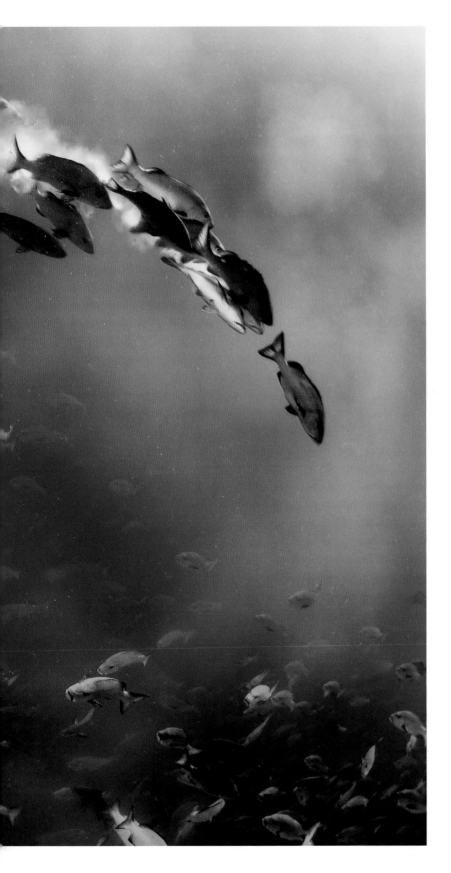

Under Water

Snapper party
Tony Wu
USA

For several days each month (in tandem with the full moon), thousands of two-spot red snappers gather to spawn around Palau in the western Pacific Ocean. The action is intense as the fish fill the water with sperm and eggs, and predators arrive to take advantage of the bounty. Having read about the drama, Tony couldn't understand why there were so few photos of it – until he hit the water there for the first time, in 2012. The currents were unrelenting – ideal for eggs to be swept swiftly away but a struggle for him to keep up with the fast-moving fish. Also, the light was low, and the water was clouded with sperm and eggs. That first attempt failed, but he has returned every year to try to capture the event. Noticing that the spawning ran 'like a chain reaction up and down the mass of fish', his success finally came when he positioned himself so that the action came to him. Rewarded with a grandstand view, he was intrigued to see that the fish rapidly changed colour during mating from their standard red to a multitude of hues and patterns. Even their characteristic two white spots, close to the dorsal fin on their back, seemed to fade and reappear. On this occasion, with perfect anticipation, he managed to capture a dynamic arc of spawning fish amid clouds of eggs in the oblique morning light. Still obsessed by the dynamics and magnitude of this natural wonder, he will be returning to Palau next April to witness once again the spectacular snapper party.

Canon EOS 5D Mark III + 15mm f2.8 lens; 1/200 sec at f9; ISO 640; Zillion housing; Pro One optical dome port.

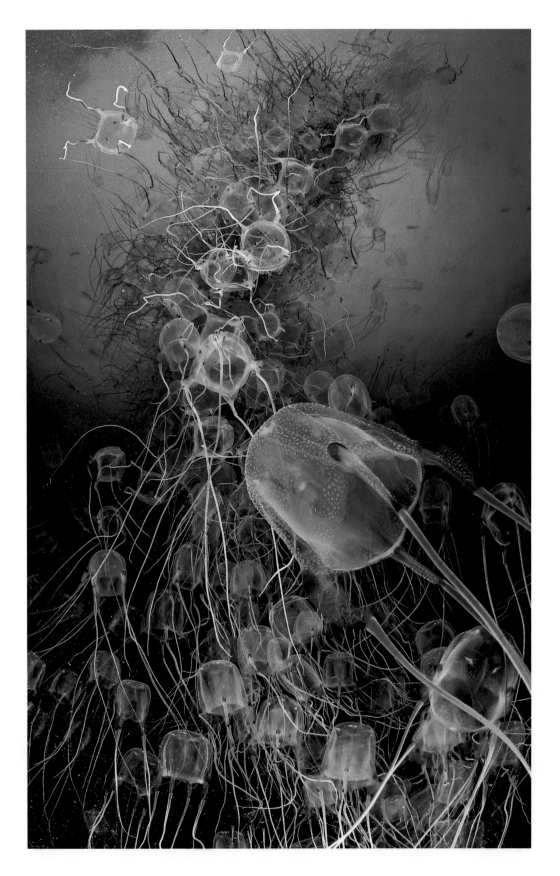

Tentacle tornado
Geo Cloete

SOUTH AFRICA

Though Geo had encountered large smacks of Cape box jellyfish before in the waters off South Africa's Hout Bay, this time numbers were truly astonishing. Not only were there thousands of jellies but they were also tightly packed, forming several columns linked deeper down to a thick swarm. Few have seen such a spectacle and no one knows the reason for such behaviour, but it is probably linked to reproduction. Box jellies are sufficiently distinct from other jellyfish to warrant their own class (Cubozoa). They have four complex eyes, with which they can detect movement of prey and changes in light intensity, and they can actively propel themselves. Some species are also extremely toxic (barbed nematocysts – explosive cells – on the four tentacles of Cape box jellies, used for stunning prey, can inflict painful stings). Some have elaborate courtship and mating behaviours. When they reproduce sexually, the male puts his tentacles into the bell of the female and delivers packets of sperm. 'I was captivated by the rhythmic contractions of their bells as they danced up a storm,' says Geo. For once, the visibility in these plankton-rich cold waters was reasonable, and he was able to capture one of the spectacular columns of transparent jellies against the sunlight.

Nikon D300 + Tokina 10–17mm f3.5–4.5 lens at 10mm; 1/160 sec at f14; ISO 200; Seatool housing; two Sea & Sea YS-250PRO strobes.

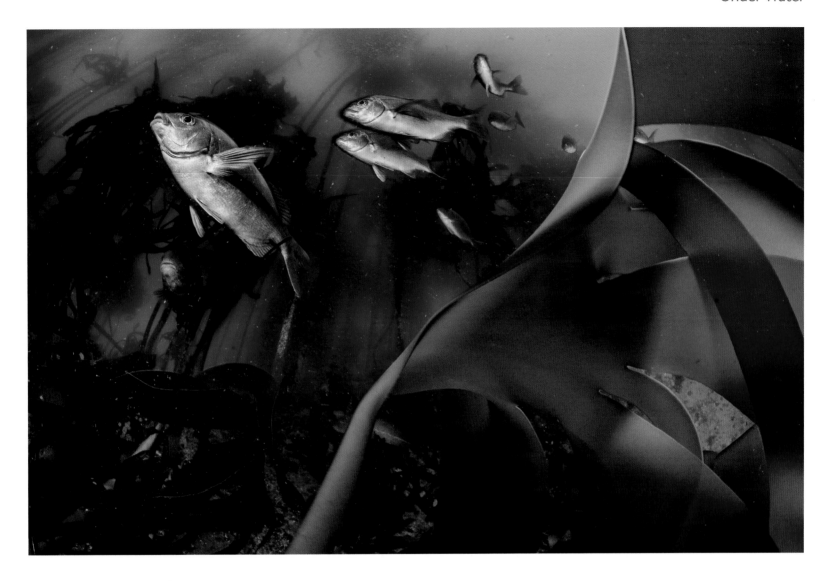

Current riches
Joris van Alphen
THE NETHERLANDS

The strong summer winds blast straight into South Africa's False Bay, making diving difficult, but Joris was committed to revealing the beauty of this seldom-seen boulder-reef community. False Bay is where two formidable currents meet, warm and cold swirling together to create a unique ecosystem. It once teemed with a diversity of fish, but populations have collapsed after years of overexploitation. Hottentot seabream are among the few fish that are still easy to find (many others take years to reach reproductive age making them very vulnerable to overfishing). 'I really liked the shape and colour of the split-fan kelp,' says Joris, setting the scene with sea bamboo reaching up behind, though in the strong surge, it was a struggle to keep the elements lined up. Eventually, a few seabream passed by to complete his composition, their silvery forms set off against the nutrient-rich water.

Canon EOS 5D Mark III + Sigma 15mm f2.8 lens; 1/60 sec at f14; ISO 400; Nauticam housing + dome; two Inon Z-240 strobes.

Arctic showtime

Audun Rikardsen

NORWAY

Above the water, the stage is empty. Below, the show has begun. In February, just before leaving the bays in the fjords of northern Norway to migrate south to mate, male humpback whales begin to play and sing more intensely. From the surface, brief sightings of tail flukes and flippers and the thwack of tails and bodies hitting the surface signal what's going on, but Audun wanted to capture the whole stage, including the interface between ocean and air. But he faced a considerable challenge: the low light at the end of the polar winter. Not only did he have to fashion his own underwater system for the split-level view, but he had to find a male that would stay with him in the water, with the right background above the surface. He also had to be in the water at the right moment and be close enough to the whale and in the right position without disturbing it. So the picture took a huge amount of planning and attempts to get the composition and mood right: peace above, playfulness below. It's thought that the male whales are both serenading the females and communicating with each other ahead of the huge journey to southern latitudes and warmer waters, where they finally mate – a show worth marvelling at.

Canon EOS-1D X + 11–24mm f4 lens at 11mm + 1.2 Lee filter; 1/100 sec at f5.6; ISO 1600; custom-made housing.

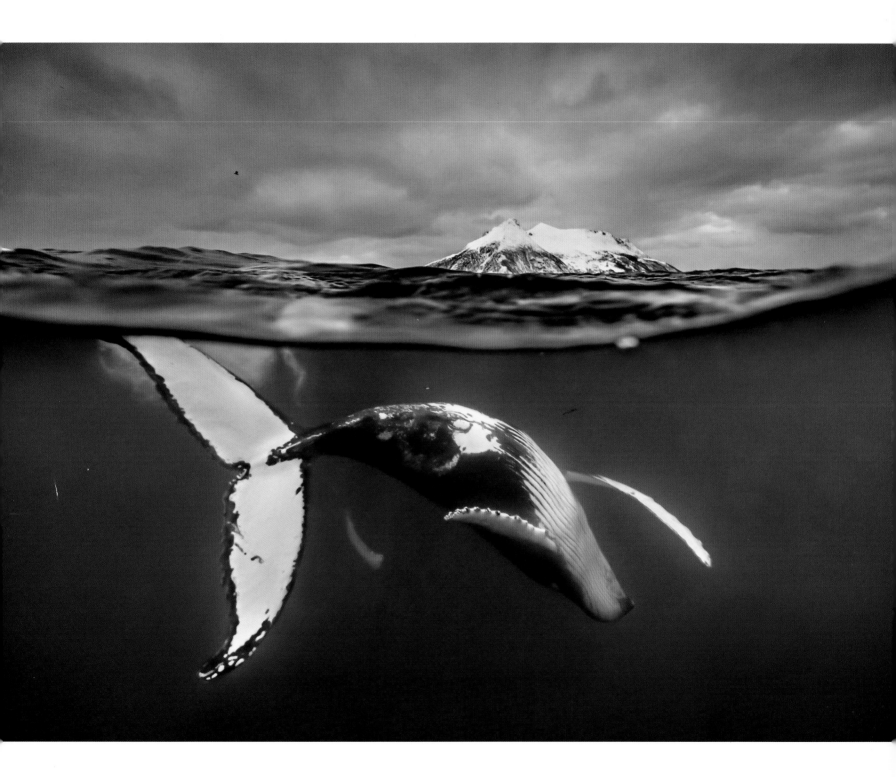

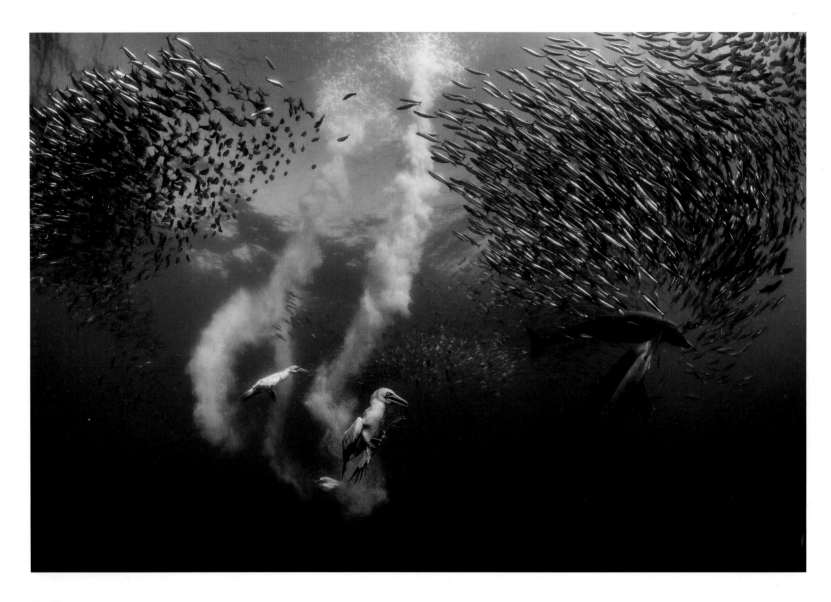

Split moment

Greg Lecoeur

FRANCE

A baitball driven to the surface by common dolphins splits in further panic as Cape gannets plummet down. Wings folded back, they are so streamlined that they barely slow on hitting the water, shooting 10 metres (33 feet) deep before braking. Greg captured the moment one gannet seized a mouthful of fish, a fizzing trail of bubbles in its wake. In two weeks of searching, Greg encountered just two baitballs, one in poor visibility, and this small one, of red-eye round herring – not the sardines he was expecting. The annual 'sardine run', when millions of sardines move up South Africa's east coast, is now less predictable, possibly due to overfishing or warming waters. For Cape gannets, which breed on just six small islands and are vulnerable to extinction, shortage of fish is now a major threat.

Nikon D7000 + Tokina 10–17mm f3.5–4.5 lens at 10mm; 1/200 sec at f9; ISO 200; Nauticam housing; two Ikelite DS160 strobes.

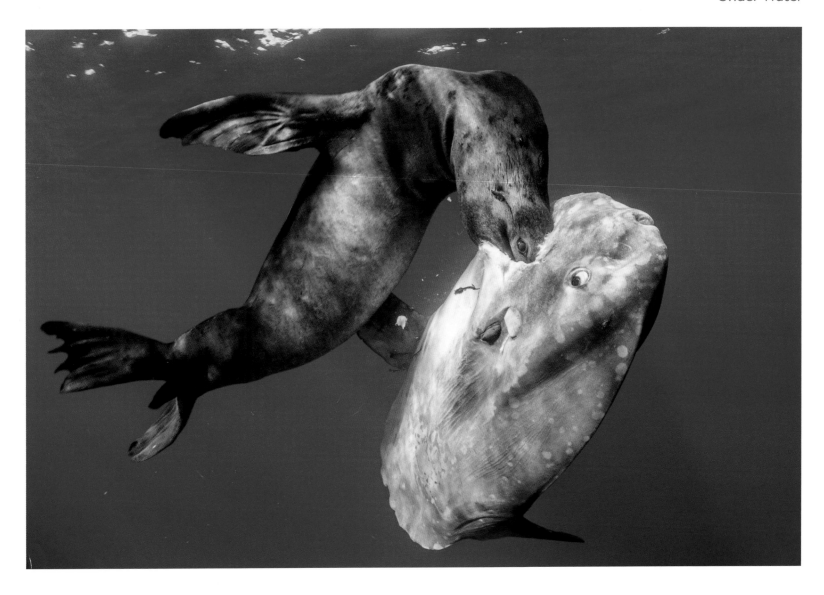

Giant-killer

Ralph Pace

USA

The struggle between California sea lion and ocean sunfish lasted almost an hour. 'The fish would dive to escape,' says Ralph, 'then both would surface further away, thrashing madly.' Ralph was in blue water off San Diego, California, in the hope of seeing just such an encounter. The 2015 extreme El Niño event (warming of sea-surface temperatures in the central-east equatorial Pacific) had driven much of the sea lion's more normal fish prey north to cooler water, leaving the sea lion to take whatever else it could. This young sunfish – the world's heaviest bony fish, up to 4 metres (13 feet) long, with no tail or scales – had lost its pectoral fins, perhaps to a fishing net (many die in nets). Finally the sea lion penetrated its tough skin. 'As they looked eye to eye,' says Ralph, 'the fish seemed almost to plead for its life.'

Canon EOS 5D Mark II + Sigma 15mm f2.8 lens; 1/200 sec at f7.1; ISO 400; Aquatica housing; two Sea & Sea strobes.

Details

The sand canvas
Rudi Sebastian
GERMANY

The pristine white sand of Brazil's Lençóis Maranhenses National Park offers a blank canvas to the rain. In the dry season, sand from the coast is blown by powerful Atlantic winds as far as 50 kilometres (30 miles) inland, sculpting a vast expanse of crescent-shaped dunes up to 40 metres (130 feet) high. With the onset of the rains, the magic begins. An impermeable layer beneath the sand allows water to collect in the dune valleys, forming thousands of transient lagoons, some more than 90 metres (295 feet) long. Bacteria and algae tint the clear water in countless shades of green and blue, while streams carrying sediment from the distant rainforest make their mark with browns and blacks. Patterns appear as the water evaporates, leaving behind organic remains. Rudi learned about the park on a TV programme, and realizing the photographic potential, planned his trip almost two years ahead, to make sure of the season and that he would have time to stay until the water level was right. He waited several days for the perfect light – overhead, to bring out the colours but with clouds obscuring any direct sun 'to get a shadowless purity'. Shooting almost vertically down from a small aircraft with the door removed, avoiding perspective or scale, he created his striking image. A few weeks later, the scene had evaporated.

Canon EOS 5DS R + 24–70mm f4 lens at 70mm; 1/2000 at f5.6 (+0.3 e/v); ISO 320.

Red-hot breakout
Bruce Omori

USA

As the skin of the breakout cooled, it drew a textured black veil across the molten pahoehoe lava flowing beneath. The eruption of Kilauea on Big Island, Hawaii, has since 1983 covered more than 125 square kilometres (48 square miles) with lava. Most of the lava flows through a tube system down to the sea. These tubes (3–4.5 metres, 10–15 feet wide), arise when channel edges build up and arch over or by the cooling of the top and sides of a flow to create walls. From time to time, a new lava flow breaks out at a weak point in a tube. This one was unreachable by foot – 'it meant hovering in a helicopter directly over the apex of the breakout,' says Bruce. Despite the intense heat, making the air very unstable and causing thermal distortion, he captured this abstract design of the surface black web against the flowing red-hot lava.

Canon EOS-1D X + 100–400mm f4.5–5.6 lens at 400mm; 1/1000 sec at f7.1; ISO 2000.

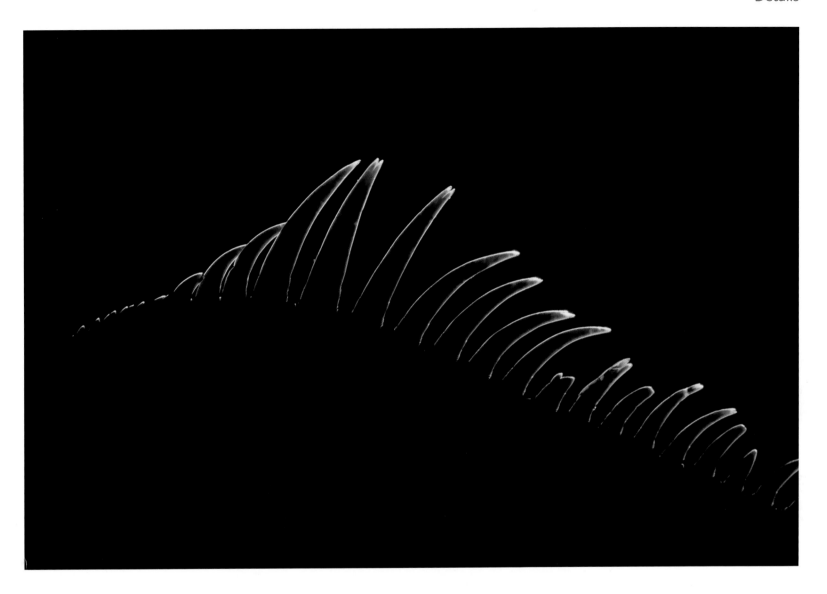

Ridge of thorns
Quentin Martinez

FRANCE

Quentin was out one night with a colleague looking for snakes and amphibians in French Guiana when he came across an old, metre-long (3-foot) green iguana, sleeping on a fence post. The comb of spines running down its back and tail was impressive, especially when silhouetted by his colleague's headlamp. Suggested functions for an iguana's spines include intimidation of rivals or predators, impressing potential mates and body-temperature regulation (spines have a blood supply). They may also act as camouflage, breaking up its outline as it rests in a tree (green iguanas are mainly tree-dwelling and spend most of their time inactive). Using his colleague to backlight the sleeping reptile, Quentin captured its thorny profile – 'like an ancient mountain range in fading light, weathered by the passing of time'.

Canon EOS 7D + 100mm f2.8 lens; 1/50 sec at f8; ISO 800; Fenix LED headlamp.

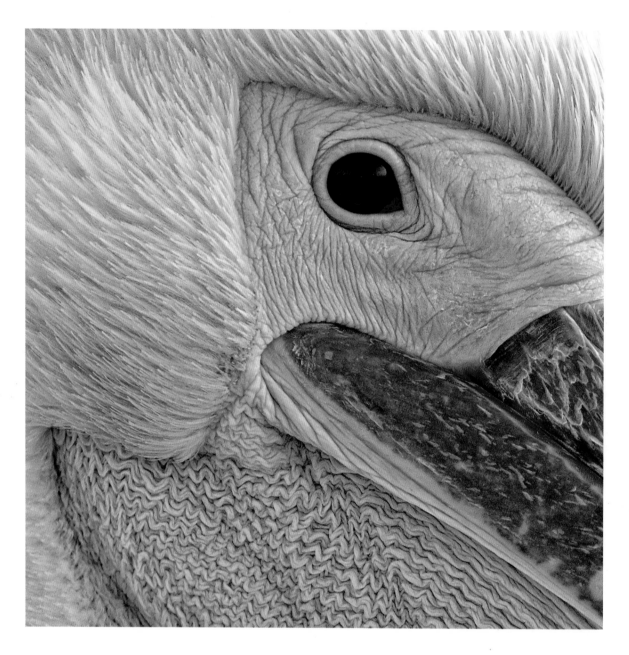

Portrait of a pelican

Bence Máté

HUNGARY

Bence spent 48 hours in his hide on an island in the Romanian region of the Danube Delta. He had built the hide in winter, before the arrival of the great white pelicans – the delta has more than 2,500 pairs, the largest breeding colony outside Africa. Bence's hide was fronted with a one-way mirror overlooking the mudflats, which 20 or more pelicans would cross to feed in the delta. 'They came so close', says Bence, 'that I could make out the tiniest details.' Here he framed the face of a female, her orange-tinted skin and the yellow folds of her pouch contrasting with her blue beak.

Nikon D200 + Sigma 300–800mm f5.6 lens at 800mm; 1/160 sec at f8; ISO 320; Gitzo tripod.

Flamingo veil
Theo Allofs
GERMANY

The track to Lake Logipi in northern Kenya was so rough that, for the last four hours, Theo drove at walking pace, eventually abandoning his car 5 kilometres (3 miles) from the lake. But here was a flat, open spot, clear of big rocks – a place he could fly from and so reach the lake. Next morning, at sunrise (to catch the best light and avoid later thermals), he started his run-up – 50 kilos (110 pounds) on his back, including two cameras – and took off in his powered paraglider. Steering with one hand on the brake, the other holding a camera, he spotted a large flock of lesser flamingos feeding in the shallows. With specialized bills, they filter algae and other plankton from the alkaline-saline lakes of East Africa's Great Rift Valley. Those at the remote Lake Logipi were unused to visitors. 'I had to fly very high so as not to scare them,' says Theo. Leaving trails 'like beautiful veils' in the muddy water, the flamingos gathered into a circle, creating their ephemeral design.

Canon EOS-1Ds Mark III + Zeiss 35mm f2 lens; 1/250 sec at f7.1; ISO 200.

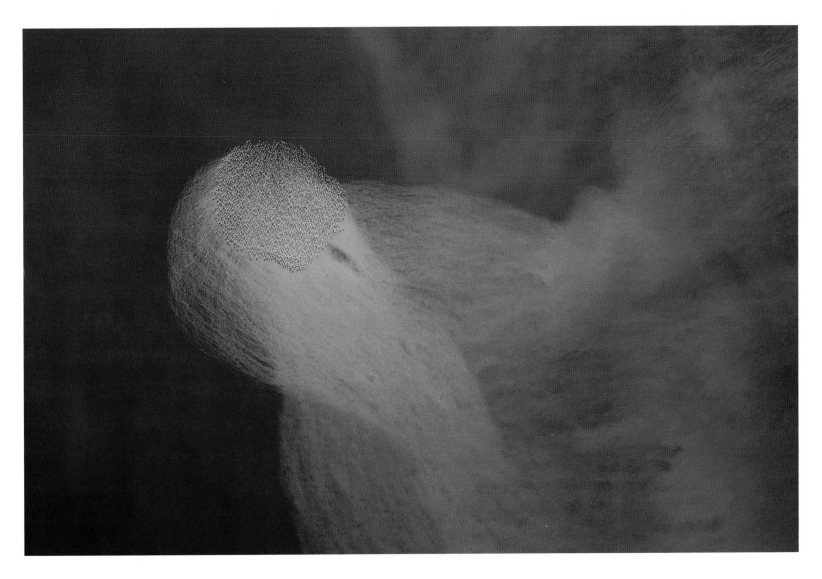

Impressions

Star player

Luis Javier Sandoval

MEXICO

As soon as Luis slipped into the water, the curious young California sea lions came over for a better look. He had arrived the night before at the island of Espíritu Santo in the Gulf of California, sleeping aboard his boat so that he would be ready to dive at sunrise. He had in mind a picture that needed warm light, a slow shutter speed and friendly subjects. One of the pups dived down, swimming gracefully with its strong fore-flippers (sea lions are also remarkably agile on land, since they can control each of their hind-flippers independently). It grabbed a starfish from the bottom and started throwing it to Luis. 'I love the way sea lions interact with divers and how smart they are,' says Luis. The youngsters often use games to hone their skills, especially fishing techniques. As the pup was playing very close to the breaking point of the waves, Luis's timing had to be spot-on to frame it in the right place against the movement of the water. Angling his camera up towards the dawn light – just as the pup offered him the starfish and another youngster slipped by close to the rocks – he created his artistic impression of the sea lion's playful nature.

Nikon D7000 + Tokina 10–17mm f3.5–4.5 lens at 10mm; 1/8 sec at f13; ISO 100; Aquatica housing; two Sea & Sea YS-110 strobes.

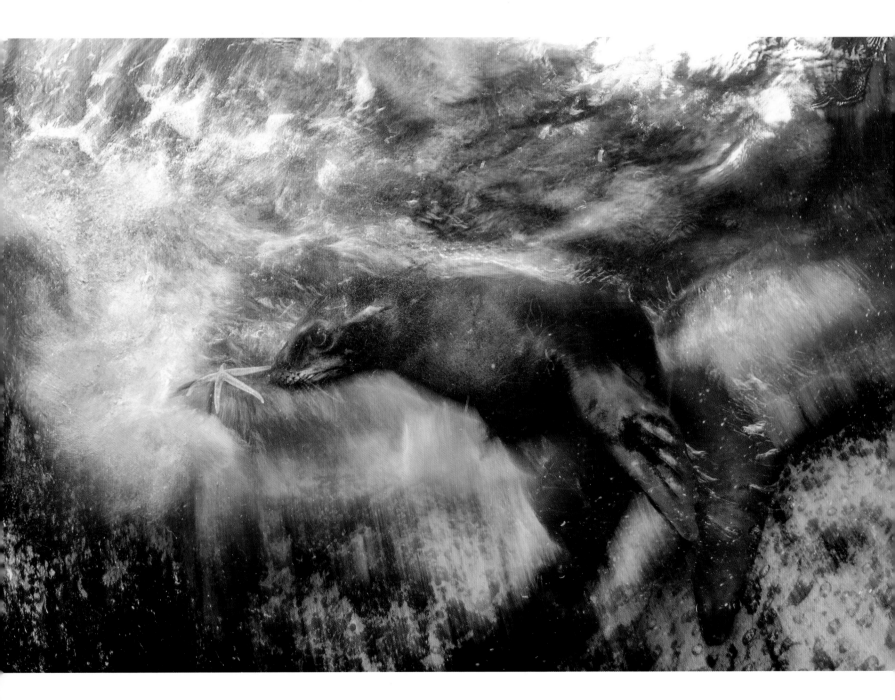

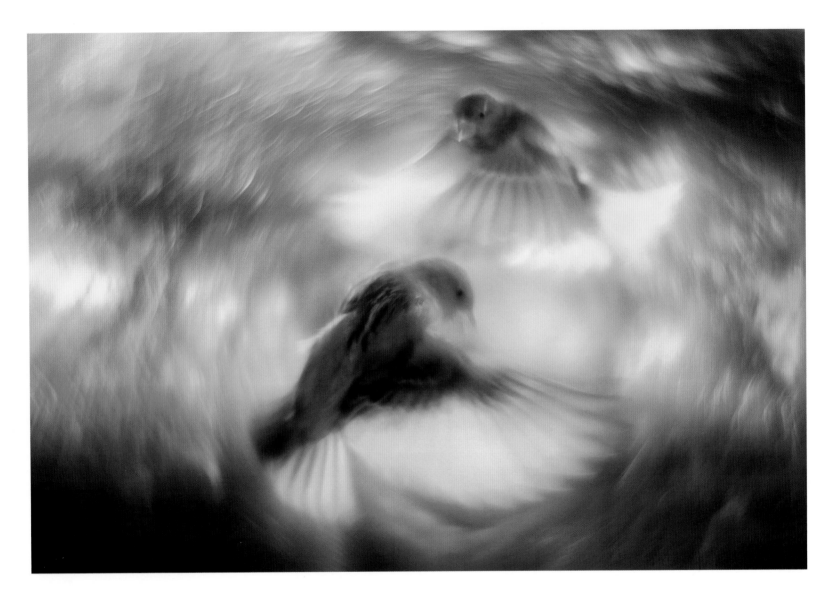

Spiralling sparrows

José Pesquero

SPAIN

Lots of house sparrows regularly visit José's feeder in a wood on the outskirts of Madrid, Spain. They get along fine when there is plenty of food, but as soon as it runs low, the squabbling begins. Here two dominant adults have seen off the others and are now battling it out for the remaining supplies. 'They would throw their legs into the chest of their opponent as if they were eagles,' says José. He wanted to create a memorable image of this once-widespread, sturdy little seed-eater, which in some areas has declined drastically, with likely reasons including reduced food availability and loss of nest sites. Using a vintage lens to produce a soft, swirly background, he prefocused the shot, anticipating where the action might take place, and when the sun filtered through the trees, backlighting their wings, he captured the rhythm of their twisting flight echoed by the spiralling backdrop.

Nikon D810 + Helios 44 58mm f2 lens; 1/250 sec at f2.8; ISO 80; remote shutter release.

Heart's desire
Lars Andreas Dybvik

NORWAY

Lars kept low, sprawled on the clifftop with his camera on the ground, so as not to disturb the birds and to pick up the reflection of the late afternoon sun from the sea behind. The uninhabited Norwegian island of Hornøya hosts tens of thousands of breeding seabirds in summer, including the colony of common guillemots that held his attention. Guillemots usually return each year to the same mate and the same nest site. The female lays a single egg directly on a cliff ledge – its conical shape stops it rolling off. Amid the hectic noise of the colony, the courting couples display – pointing their bills upwards, clashing them together, bowing and preening one another. Lars concentrated on one couple and defocused his lens just enough to capture an impression of their romance. The moment was complete when the birds framed a heart shape between them, filled with golden light.

Nikon D800 + 500mm f4.5 lens; 1/1600 sec at f4.5; ISO 50.

Light fandango

Imre Potyó

HUNGARY

Standing in the dark on the bank of the River Danube in northern Hungary, Imre was covered in buzzing mayflies. 'It was a fantastic feeling', he says, 'to be in the thick of their wonderful dance.' This was the climax – when the females, at the end of their brief lives above water, lay their eggs on the water's surface. The event lasts for just a few days at the end of August, when the adults emerge en masse to mate. As the swarm density peaked, Imre turned on a flashlight and set a long exposure to capture the dynamic scene. For many decades, water pollution drove down mayfly numbers in the Danube. Now they are back up, but with a different threat. Attracted to the lamplight on bridges, many females deposit their eggs in vain on roads, seeing the lamplight reflected from the road surface as moonlight on the river.

Nikon D90 + Sigma 17–70mm f2.8–4.5 lens at 32mm; 1/6 sec at f16; ISO 640; flashlight; Manfrotto tripod + Uniqball head.

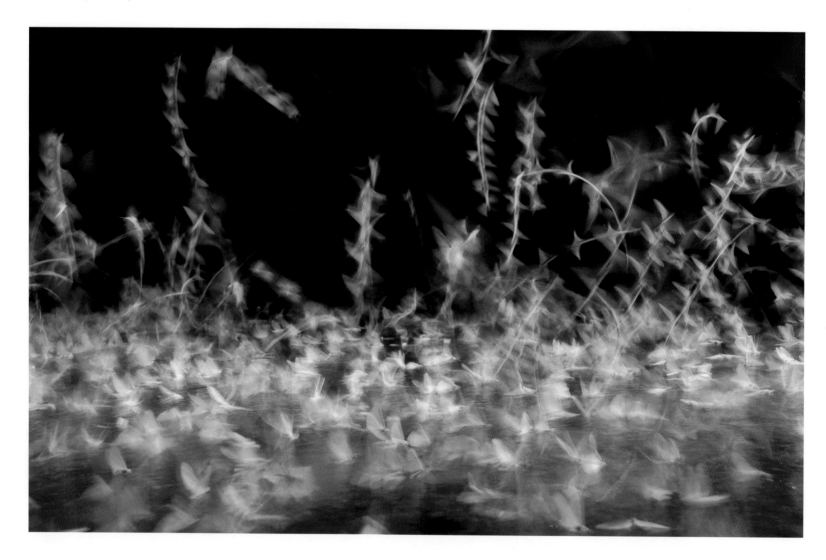

Floe of life
Joanna Lentini
USA

As the ship progressed slowly through the Arctic pack ice north of Svalbard, a bloody scene was unveiled through the fog. A polar bear was feasting on the remains of a seal that it had dragged some distance across the ice. Rushing to change her lens, Joanna lost her position at the bow of the ship but spotted an equally dramatic shot over the starboard side. A narrow ribbon of turquoise cut through the ice – the floes had sheared apart to form a lead. Darker than the adjoining ice, leads can affect the climate in their immediate surroundings (they reflect less light and absorb more solar energy, becoming relatively warm) and speed up the melting of the surrounding ice. They also make good hunting grounds for polar bears. The bears mainly eat ringed seals, sometimes stalking ones hauled out on the ice but more usually waiting for them to surface to breathe, as they must do every 5 to 15 minutes, at a hole they have cut themselves or a natural opening. Quickly framing the trail of hefty footprints, blood-spattered ice and contrasting colours, Joanna seized her graphic composition, devoid of the bear and its prey yet resonant with their presence.

Canon EOS 5D Mark III + 100–400mm f4.5–5.6 lens at 140mm; 1/2500 sec at f6.3; ISO 500.

The Wildlife Photojournalist Award: Single image

The pangolin pit

Paul Hilton

UK/AUSTRALIA

Nothing prepared Paul for what he saw: some 4,000 defrosting pangolins (5 tons) from one of the largest seizures of the animals on record. They were destined for China and Vietnam for the exotic-meat trade or for traditional medicine (their scales are thought, wrongly, to treat a variety of ailments). Pangolins have become the world's most trafficked animals, with all eight species targeted. This illegal trade, along with habitat loss and local hunting, means that the four Asian species are now endangered or critically endangered, and Africa's four species are heading that way. These Asian victims, mostly Sunda pangolins, were part of a huge seizure – a joint operation between Indonesia's police and the World Conservation Society – found hidden in a shipping container behind a façade of frozen fish, ready for export from the major port of Belawan in Sumatra. Also seized were 96 live pangolins (destined to be force-fed to increase their size), along with 100 kilos (220 pounds) of pangolin scales (formed from keratin, the same substance in fingernails and rhino horn) worth some $1.8 million on the black market, and 24 bear paws. All had come from northern Sumatra. The dead pangolins were driven to a specially dug pit and then incinerated. The live ones were taken north and released in the rainforest. 'Wildlife crime is big business,' says Paul. 'It will stop only when the demand stops.'

Canon EOS 5D Mark III + 16–35mm f2.8 lens at 21mm; 1/800 sec at f8; Manfrotto tripod.

Caring for Joey
Douglas Gimesy
AUSTRALIA

In Australia every year, thousands of kangaroos are killed or horribly injured by vehicles, an issue Douglas is trying to highlight. A female's pouch offers some protection, and a joey inside its dead mother's pouch may survive for several days. If rescued, there's a chance that it can be treated and relocated. Dedicated volunteers such as Sandy, Des and Pauline on Kangaroo Island, where collisions are a big problem, are devoted carers. It's no easy task: young joeys, wrapped in artificial pouches, need a special milk formula several times a day. 'I wanted to share the love, care and dedication that these people give to animals,' says Douglas. Awareness campaigns endeavour to educate drivers about speed limits and about stopping to check the pouch of a victim. Females that are not killed outright may limp off into the bush to suffer slow deaths. Their joeys have no second chance.

Nikon D750 + 24–70mm f2.8 lens at 24mm; 1/200 sec at f14; ISO 640; Nikon SB-910 flash + Nikon SB-700 flash; Manfrotto lights + two diffusion umbrellas.

Caring for Missy

Dan Kitwood

UK

Keeper Daouda Keita reaches down to help Missy up onto his back. She is an orphan, one of 50 West African chimpanzees at Guinea's Chimpanzee Conservation Center (CCC). The population of this endangered subspecies is being decimated by deforestation, mining and the illegal trade in wildlife. To obtain babies for the pet trade, whole families may be killed. Those infants confiscated from traffickers are invariably in poor health and traumatized. At the CCC (supported in part by the US-based Project Primate), they begin the slow process of recovery. Here Missy and two other infants are about to go on their daily outing into the bush to learn essential skills. They will gradually be integrated into larger family groups and, when possible, released back into an area around the Haut Niger National Park – a minimum 10-year process of care and compassion.

Canon EOS 5D Mark III + 24mm f1.4 lens; 1/160 sec at f2.2; ISO 1600.

No voice, no choice

Britta Jaschinski

GERMANY/UK

The orangutan steps out of his tiny cage and onto the stage. He is dressed in a costume to accompany the clown. The audience claps and cheers as he shows off his 'talent'. He does this three times a day. The slogan of the Chimelong International Circus is 'Heaven of Animals Brings Happiness to People'. But, says Britta, behind the scenes of many circuses in China and in other parts of the world, it is an unhappy world for wild animals, forced to perform acts that are often painful for species that don't walk on two legs, cycle or do human tricks, and can cause long-term damage. The training of circus animals is intense and often cruel, involving intimidation if not direct physical abuse, including starvation, and trainers will do whatever they can to break animals' spirits. When not performing, these wild animals often live in barren cages and suffer loneliness and crushing boredom. Britta's aim is to raise awareness of the silent suffering of displaced wildlife in animal parks, zoos and circuses around the world and help change attitudes to the use of wild animals in entertainment. 'I try to give dignity to these badly treated sentient beings and restore respect for them,' she says. 'I want my photography to give them a voice. It's the least I can do.'

Nikon F4 + 85mm lens; 1/125 sec at f5.6; Kodak Professional Tri-X-Pan 400 film.

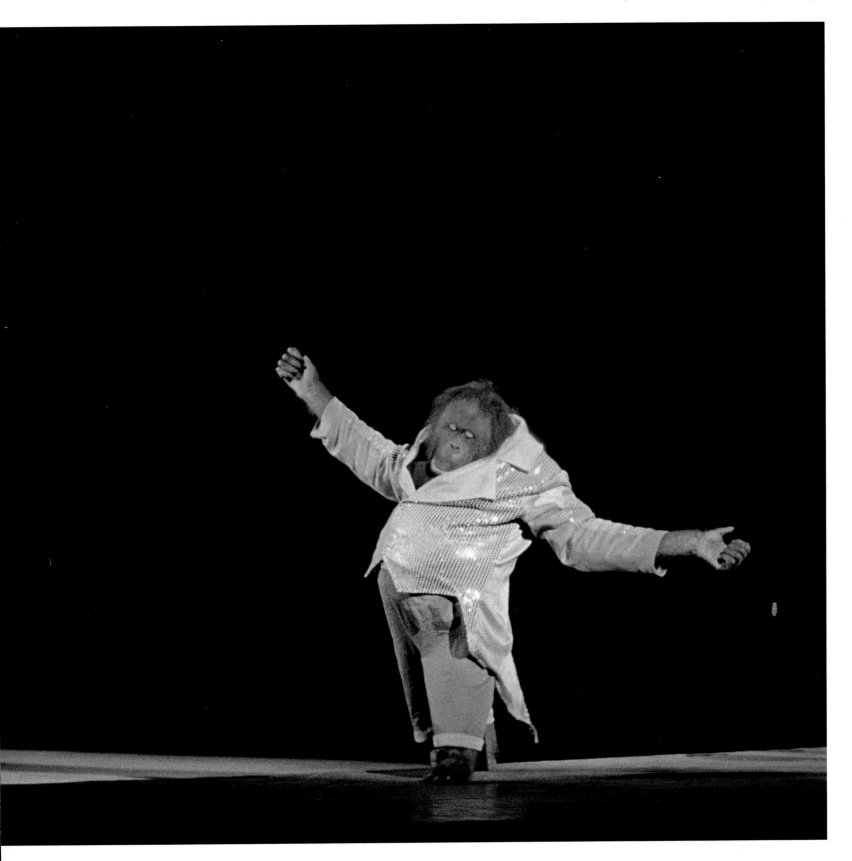

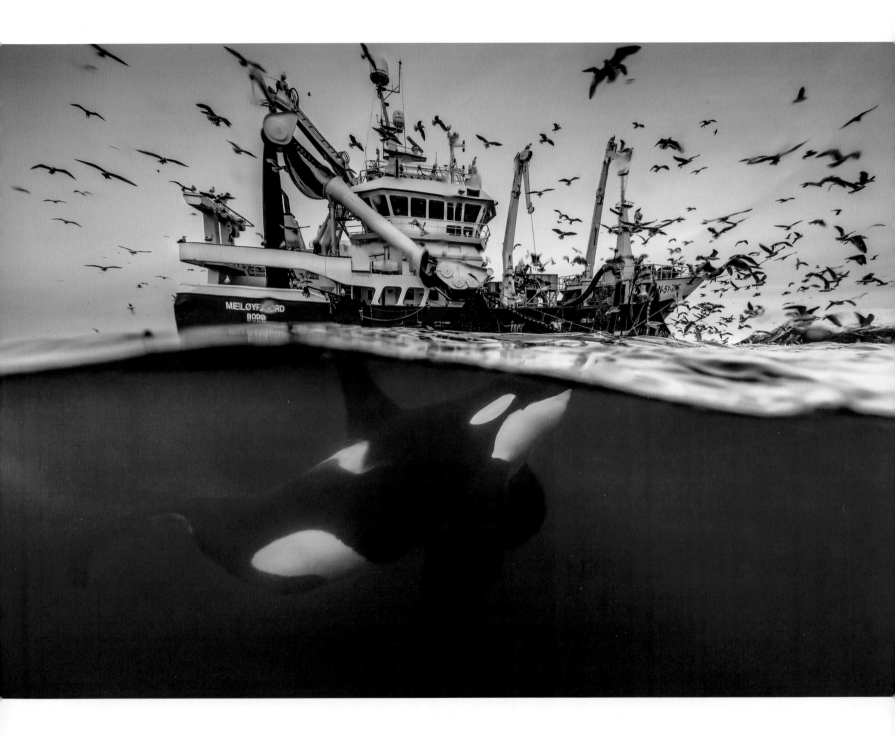

Splitting the catch
Audun Rikardsen
NORWAY

Sometimes it's the fishing boats that look for the killer whales and humpbacks, hoping to locate the shoals of herring that migrate to these Arctic Norwegian waters. But in recent winters, the whales have also started to follow the boats. Here a large male killer whale feeds on herring that have been squeezed out of the boat's closing fishing net. He has learnt the sound that this type of boat makes when it retrieves its gear and homed in on it. The relationship would seem to be a win-win one, but not always. Whales sometimes try to steal the fish, causing damage to the gear, and they can also become entangled in the nets, sometimes fatally, especially in the case of humpbacks. The search for solutions is under-way, including better systems for releasing any whales that get trapped. Having grown up in a small coastal fishing community in northern Norway, Audun has always been fascinated by the relationship between humans and wildlife. And for several years, he has been trying to document the interactions between whales and fishermen. A specially designed, homemade underwater camera housing allows him take split-level pictures in low light. But he needs to get close to a whale, though not close enough to disturb it or be dragged under a boat's side propeller. So having the fishermen's permission to snorkel by their boats has been as important as being tolerated by the whales.

Canon EOS 5D Mark III + 11– 24mm f4 lens at 11mm + 1.2 Lee filter; 1/200 sec at f6.3; ISO 640; custom-made housing.

The shot
Ronan Donovan

USA

It's a moment of fear and anxiety. The alpha male is looking up at the machine bearing down on him, torn between fleeing and being the defender of his pack, and the man is bracing himself, desperate to get a clear shot. The wolf leads one of 10 packs descended from grey wolves reintroduced to Wyoming's Yellowstone National Park in 1995, following their extermination there in the first decades of the 1900s. Today, at least in this US park, it's a conservationist, not a hunter, who is aiming the gun. Doug Smith, the leader the Wolf Restoration Project, is about to shoot a tranquillizing dart to enable the wolf to be fitted with a radio-tracking collar. Ronan is circling above in the spotter plane. 'This was one of the most challenging images I've ever made,' says Ronan. 'The logistics were mind-boggling – weather, plane, helicopter, fuel, and the wolves in the right place... The movement of helicopter, wolf and plane all coincided for this one moment. Then my plane had to peel off and follow the wolf until it collapsed, while the helicopter went on to dart more wolves.' The unique frame that he took tells part of a conservation story that, to date, is a good-news one – for the wolves as keystone predator but also for the health of the Yellowstone ecosystem.

Canon EOS-1D X + 200–400mm f4 lens; 1/8000 sec at f5.6; ISO 400.

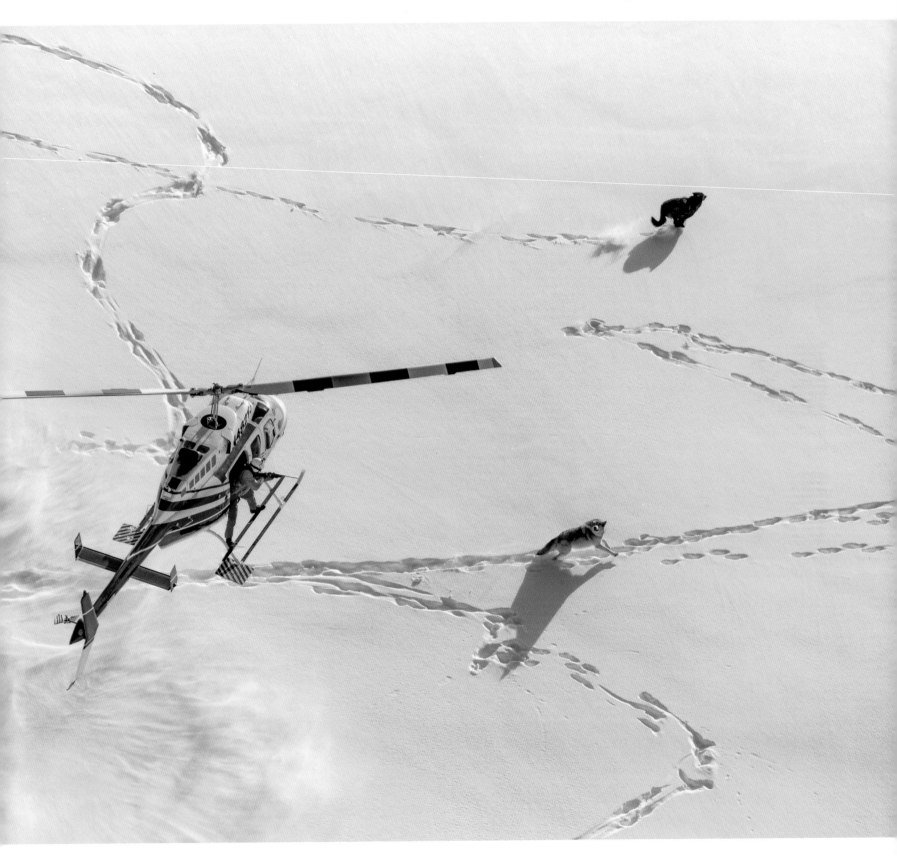

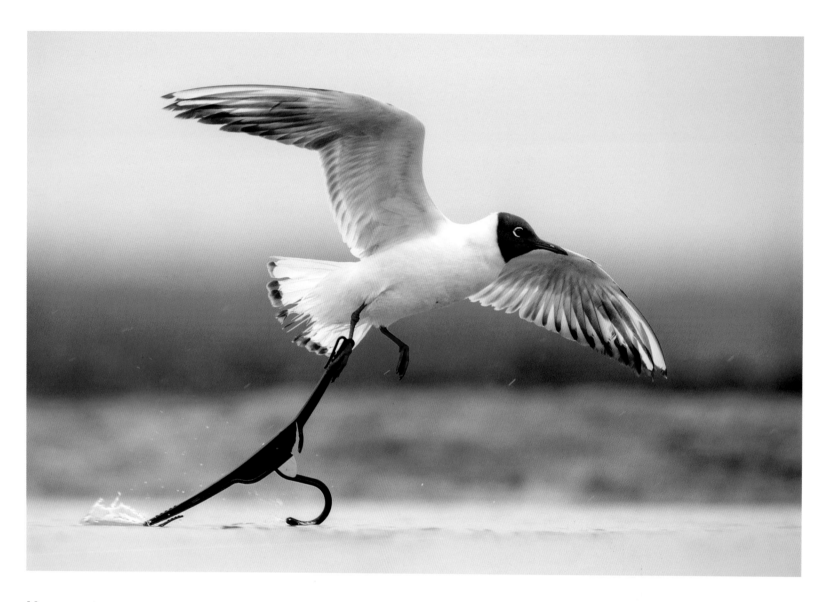

Hanger-trap
Bence Máté

HUNGARY

Bence's first thought was that the black-headed gull was carrying a long piece of reed. It was, after all, the breeding season in Kiskunság National Park, a biosphere reserve in Hungary, home to tens of thousands of migratory birds. Bence was so busy concentrating on adjusting the composition and focus that he failed to notice what the piece of 'reed' really was. It wasn't until he was checking through his images later that he saw that the gull's foot was trapped in a plastic clothes hanger. 'The gulls feed at rubbish dumps outside the national park. I often saw them entangled in bits of rubbish,' he says, 'but mainly they get caught up in fishing line and hooks discarded around the lakes. I saw this poor bird flying around in the area for two more days before it disappeared.'

Nikon D700 + Sigma 300–800mm f5.6 lens at 600mm; 1/800 sec at f8; ISO 1000; Gitzo tripod.

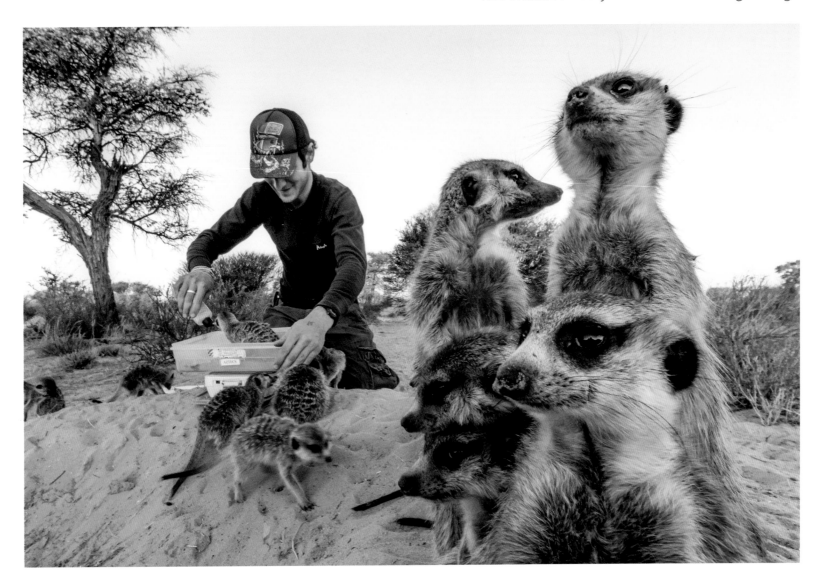

The collaborators

Jennifer Guyton

GERMANY/USA

To study the social behaviour of meerkats in South Africa's Kalahari Desert means getting them so used to certain humans that they ignore them. It takes months, sometimes years. Using a special call to tell them that a non-threatening human is approaching is part of the process. Now when it's time for the twice-daily weigh-in, the meerkats climb onto the scales in return for a drink of water. But for the rest of the time, they carry on with normal life, says Jennifer, pointing out that the subjects of her picture are totally ignoring her presence. Cambridge University researchers know the individual personalities of the meerkats and even the cultures of different groups. Part of the story for Jennifer is the cooperative relationship between researchers and their subjects – 'the joyous part of research'.

Canon EOS Rebel T2i + Sigma 10–20mm f4–5.6 lens at 10mm; 1/60 sec at f16; ISO 800.

The Wildlife Photojournalist Award: Story

The award is given for a story told in just six images, which are judged on their story-telling power as a whole as well as their individual quality.

Charlie Hamilton James
UK

Vultures: circling calamity

Across Africa, vulture populations are in free-fall. The main cause of this catastrophic decline is poisoning, both deliberate and incidental, resulting in countless slow, agonizing deaths. With seven of the continent's eleven species now endangered or critically endangered, vultures are one of the fastest declining groups of animals in the world, their numbers set to fall in Africa by 70–97 per cent in the next 50 years. As nature's clean-up team, playing an indispensable role in complex ecosystems, the impact of their loss will be devastating. Charlie travelled across Africa to tell the unfolding story – a grim tale set to end in ecological disaster if poisoning and poaching continue. But also, says Charlie, 'I love vultures. I think they are wonderful and beautiful, and I wanted to show that to the world.'

The beautiful end

Vultures excel at recycling dead animals. They have powerful beaks and claws to tear open a tough body, featherless heads and necks for hygiene control, and tongues covered in spines to rip flesh off bones. Their ironclad stomachs contain acids that neutralize pathogens, backed up by a robust immune system. This makes vultures 'dead-end' hosts: pathogens such as cholera, rabies and even anthrax go no further (other scavengers carry germs). Vultures also deal with bodies quickly and efficiently, something Charlie observed as he watched the scrum of Rüppell's griffon vultures ripping a wildebeest carcass to shreds on the Ndutu Plain in Tanzania's Serengeti National Park. In just a couple of days, the carcass was little more than a pile of clean bones. But Rüppell's griffon vultures, one of the biggest, are also fast disappearing and are now critically endangered, with around 22,000 remaining in the wild.

Canon EOS-1D Mark IV + 800mm f5.6 lens + 1.4x extender at 1120mm; 1/2500 sec at f8; ISO 1600.

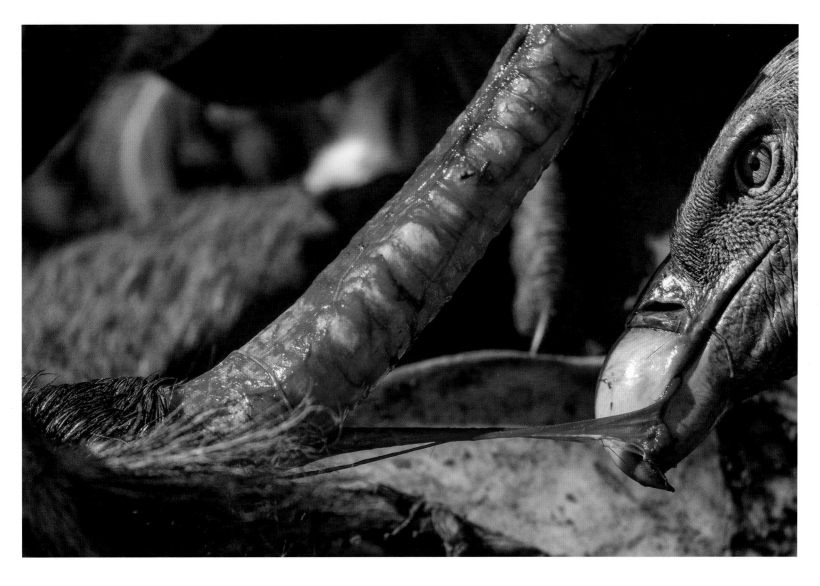

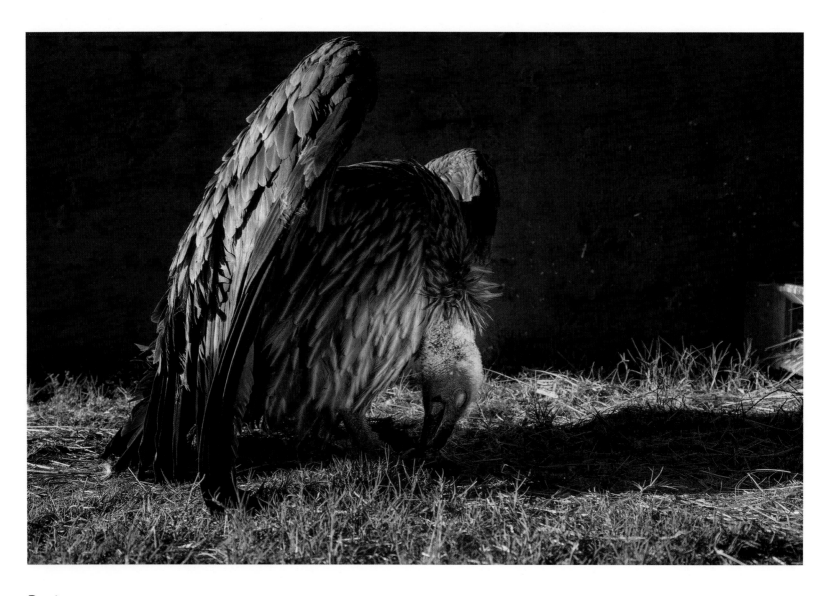

Patient care

Poison is cheap, readily available, and easy to use. More than 60 per cent of vulture deaths are now caused by poisoning. Herders lace carcasses with carbofuran pesticides to kill lions; vultures eat both carcasses and dead predators. Poison is also added to grain, salt-licks and waterholes to kill animals for bushmeat and traditional medicine. Vultures scavenge any bodies they find. A third of vulture poisoning incidents are now related to ivory poaching. Poachers use poison to kill elephants and to kill vultures to stop them kettling in the skies and alerting the authorities. If they're found in time, poisoned vultures can be saved. This endangered white-backed vulture arrived at the VulPro (Vulture Conservation Programme) facility in Magaliesburg, South Africa, with the classic head-droop signs of poisoning. It was treated with atropine and charcoal (hence the black patches on its beak) and slowly recovered. In 1922, the population of white-backed vultures was thought to be around 270,000 in Africa. In 2015, it was 9,400.

Canon EOS-1D X + 24–105mm f4 lens at 50mm; 1/1000 sec at f9; ISO 1600.

Big chick check-up

Vultures develop slowly, reaching sexual maturity at five to seven years. They also breed slowly. Females lay a single egg every year or two. So every new chick is critical to the species' survival. Charlie wanted to photograph desert vultures, and so he joined conservationists from the Namibian Vulture Project, which monitors endangered lappet-faced vultures in one of their last strongholds, Namibia's arid Namib-Naukluft National Park. It's a colossal undertaking. The annual aerial survey lasts four days and covers some 3,000 kilometres (1,865 miles). If active nests are identified, the GPS coordinates are sent to ground crews, who check the nest with a car mirror and ring any chick they find. This fledgling, the flaps of pink skin (lappets) around its face already showing, instinctively flattened itself in defence. Already huge, its wingspan could eventually be up to 3 metres (10 feet) wide, making it the largest vulture in Africa. There are around 8,000 lappet-faced vultures left in Africa. The population is steady in Namibia but falling rapidly overall.

Canon EOS-1D X + 24–105mm f4 lens at 24mm; 1/120 sec at f22; ISO 640.

Vultures as commodities

In southern Africa, vulture body parts feature in traditional medicine, or muthi, and are thought to cure a range of ailments and confer powers such as strength, speed and endurance. Demand is on the rise, particularly for their brains, which are dried, mixed with mud and smoked in the belief that this brings insight into the future. Charlie posed as a tourist to get this image of a market trader selling the body of an endangered lappet-faced vulture at a muthi market in Johannesburg, South Africa. Its wings are being sold separately (left). 'The market was full of bits of elephant, leopard, lion, snakes, owls, eagles and ostrich, as well as lots of plants,' says Charlie. The skin of a pangolin, the most trafficked species in the world, is visible on the bin. Vultures found at the carcasses of poached animals are often headless and footless, suggesting that the poachers are running a side-venture in the muthi business.

Sony DSC-RX 100M3 + 24–70mm f1.8–2.8 lens; 1/640 sec at f5.6; ISO 800.

Vultures as individuals

Conservation concentrates on populations, numbers and species, but what is clear to those who care for them is that vultures as individuals are sociable, intelligent and even playful, with different personalities and moods. One of those who know vultures extremely well is Kerri Wolter, of the conservation organization VulPro, here carrying an injured endangered Cape vulture to a vet near Pretoria, South Africa, after it flew into a power line. The vulture will be treated and, if it's lucky, rehabilitated and released. But if its injuries prove too severe, it will see out the rest of its days (they can live for up to 45 years) in captivity. Amputation is often necessary. 'Lots of Kerri's birds have only got one wing,' says Charlie. Power lines pose a significant threat; others include habitat loss, decrease in numbers of wild ungulates (hoofed animals – meaning less carrion), pollution, persecution, hunting and changes in husbandry and agricultural practices.

Canon EOS-1D X + 24–105mm f4 lens at 24mm; 1/60 sec at f8; ISO 1600.

The last stand

It's a pale imitation of the dizzying heights they're used to, but these rescued Cape vultures are lucky to have the artificial nesting cliffs of the South African VulPro facility at Magaliesburg. Injured, poisoned or disabled, they would have faced certain death in the wild. Those that will never be fit enough to be released back into the wild will play an important role in VulPro's many initiatives, including education, research, campaigning and lobbying. These vultures may never again soar free above the plains and deserts of Africa but, as victims of human action, they can help to explain to those in power how the health of entire ecosystems – and the societies that depend on them – hinges on the survival of Africa's vultures.

Leica M Typ 240 + Summicron-M 35mm f2 lens; 1/750 sec at f16; ISO 800.

The Wildlife Photojournalist Award: Story

The award is given for a story told in just six images, which are judged on their story-telling power as a whole as well as their individual quality.

Tim Laman
USA

While the forest still stands

For orangutans to survive as a wild species – retaining their vast culturally transmitted knowledge of how to survive in the rainforest – the priority is to protect what remains of that forest. But with the majority of orangutans in Indonesian Borneo (Kalimantan) living outside any protected area, and with ever-increasing loss of forest to oil-palm plantations, pulpwood concessions, slash-and-burn farming and huge fires, that's a major challenge. The accelerating loss of orangutans – whole populations with distinct cultures – is part of a bigger story of corporate expansion with lax enforcement of the law and environmental consequences that affect local people. For Tim Laman, the challenge is to reveal glimpses of the lives and culture of truly wild orangutans – something no one else has done – while also reporting on the unfolding tragedy.

Entwined lives

There's usually a fig tree fruiting somewhere, even when other fruit is scarce. This makes figs a vital back-up food for orangutans, which in turn disperse their seeds. Of the more than 50 fig species in West Kalimantan's Gunung Palung National Park, about 20 are 'strangler figs'; these germinate in the canopy of a host tree and wrap their roots downwards. Orangutans make mental maps of where and when to find fruiting trees. But they often travel along interconnecting branches, which can make it difficult to predict where orangutans will be. Unusually, this 30-metre (100-foot) tree had only one access route: the strangler fig 'ladder' around its trunk. Tim spent three days rigging cameras on the tree, guessing that the young male orangutan he'd seen feeding there would return. As the ape shimmied up the root, Tim made an image he'd long dreamed of, combining a unique perspective and a wide-angle view to highlight the relationship between the orangutan and its forest.

GoPro HERO4 Black; 1/30 sec at f2.8; ISO 231.

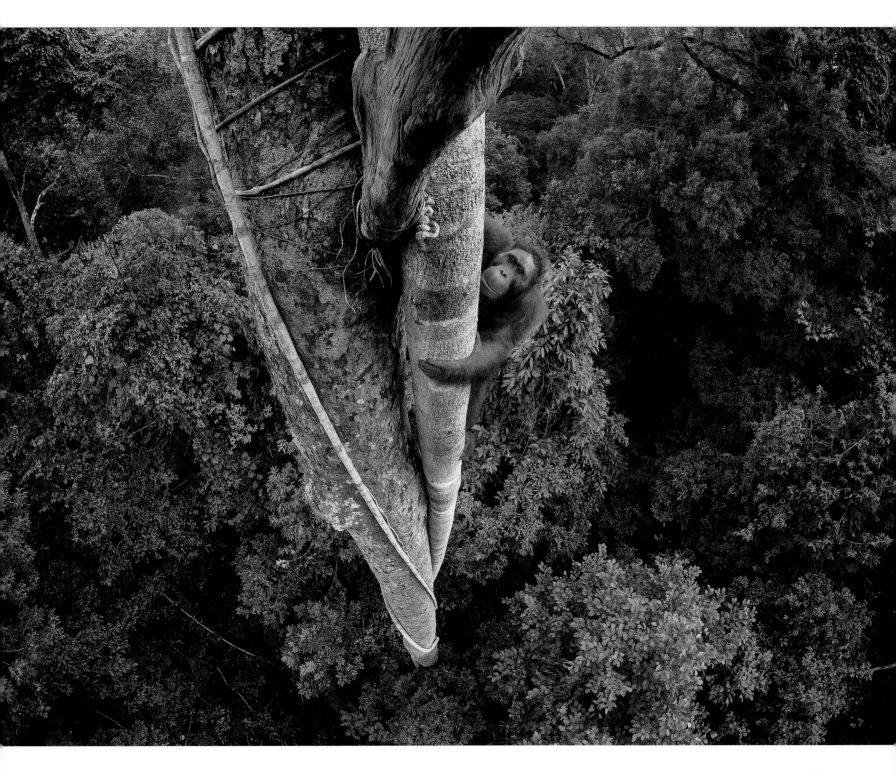

When mother knows best

Generally, orangutans are solitary, but they will spend time together when their paths cross in the rainforest – moments of intense social activity and, possibly, of information exchange. For young ones, it's their mothers who are the main source of knowledge. Tim spent three weeks – all day, every day – following this Bornean orangutan and her month-old baby in Gunung Palung National Park, West Kalimantan. He'd known her since she was a baby herself, and though she was wild, she was also used to being followed. He wanted to show how intensely curious youngsters are – in this case, trying to see the *Fordia* flowers her mother is eating. Youngsters stay with their mothers for more than ten years, and so this infant should have time to pick up the way her mother does things. 'For orangutans to retain their vast knowledge of how to survive in the rainforest, it's vital that the different populations with their different cultures are protected in the wild,' says Tim.

Canon EOS-1D C + 200–400mm f4 lens; 1/30 sec at f5.6; ISO 2500.

Motherless

When forest fires swept through Borneo in 2015, orangutans that were driven from the forest and into oil-palm plantations and settlements came into conflict with people. If females are killed, usually because of forest clearance, their babies are kept illegally as pets or sold on. This month-old orphan, kept as a pet in a village in West Kalimantan, was reported to the authorities. Here it is being confiscated by Dr Ayu, a vet from International Animal Rescue, to be taken to a rehabilitation centre. She is wearing a mask to prevent passing on any disease to the baby, which is trying to latch on to her stethoscope. In the wild, infants suckle for four or five years, and the average time between offspring is seven to eight years – longer than for any other mammal. So though this infant will be cared for, it will be difficult for it to learn all the skills needed to survive in the wild, skills it would normally learn from its mother.

Canon EOS 5D Mark III + 16–35mm f2.8 lens at 16mm; 1/8000 sec at f4; ISO 2500.

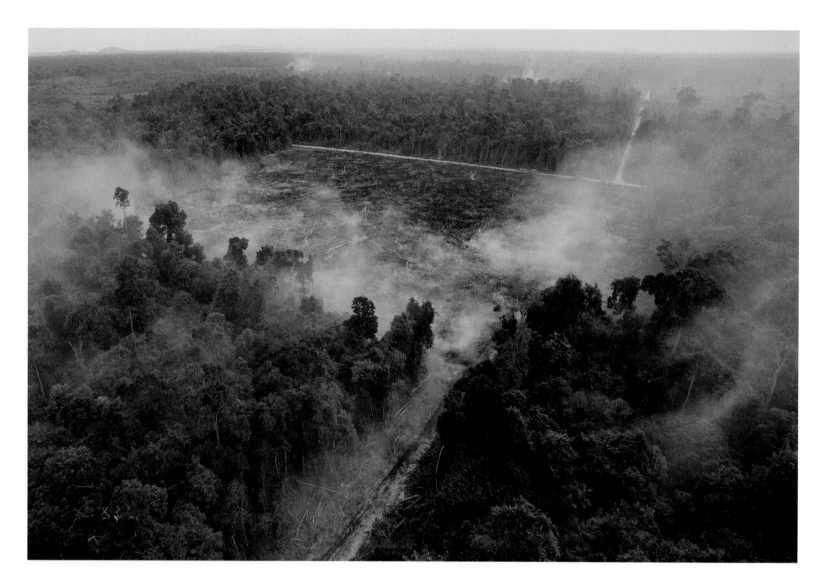

Road to destruction

In Indonesian Borneo and Sumatra, the El Niño weather event turned the 2015 dry season into a drought, and extensive fires spiralled out of control, sending heat and smoke across the region. Orangutan habitats within protected reserves, as well as those outside, were decimated, as more than 21,000 square kilometres (8,110 square miles) of forest burned. Tim used a drone to explore the forest destruction in the buffer zone around Gunung Palung National Park, West Kalimantan. The forest had probably been burned to clear space for planting oil palms to produce palm oil, an export crop. And it is rainforest clearance for oil palms that continues to destroy habitat for orangutans. 'Every single one of the thousands of fires that tore through Sumatra and Borneo last year was started by people – mostly deliberately. Every single one could have been prevented through education, better fire control, better law enforcement and will,' says Tim.

DJI Phantom 3 Pro drone + DJI FC300X camera; 1/640 sec at f2.8; ISO 200.

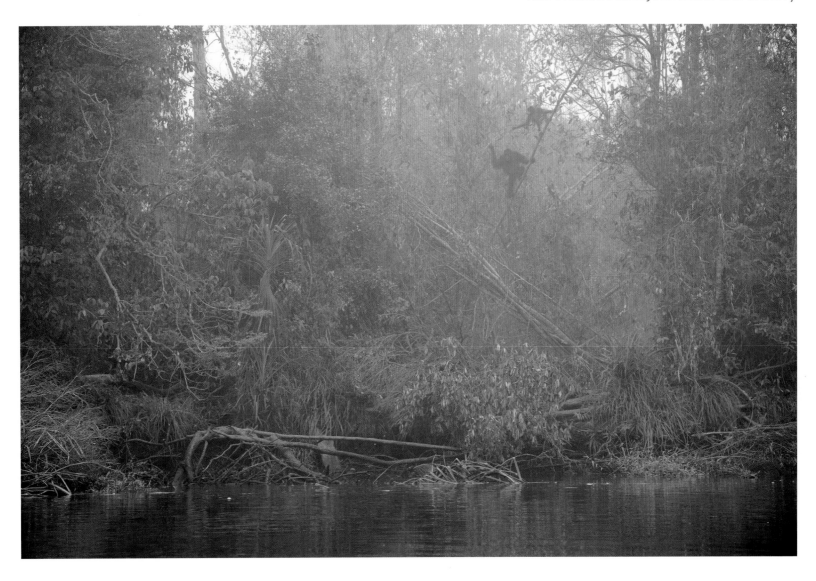

Pursued by fire

On the riverbank, an orangutan and her youngster seek refuge from the burning forest. Tim photographed them through thick smoke from a boat on the Mangkutup River in Central Kalimantan, Indonesian Borneo. Though he wore a face mask throughout his time in the region, he suffered lung irritation for weeks after. The fires that affected much of Indonesia in 2015 damaged or destroyed vast tracts of habitat, putting the critically endangered Bornean orangutans and the even-rarer Sumatran orangutans (population 6,600) in an ever more precarious situation. In some areas, the peaty soil of the forest ignited and burned for days or weeks. The heat and disruption drove large numbers of orangutans out of the forest, increasing their conflict with humans. Meanwhile others are gradually starving, trapped in pockets of forest that have been reduced in size through clearance for oil palms and are already too small to support them.

Canon EOS 5D Mark III + 24–105mm f4 lens; 1/750 sec at f4.5; ISO 1250.

End of the line?

Rescue centres such as this one at the International Animal Rescue facility in Ketapang, West Kalimantan, in Indonesian Borneo, reported a huge influx of orphan orangutans as a result of the fires in 2015. The caretakers do a magnificent job, here taking a barrow-full of one- and two-year-old Bornean orangutans to play in the forest, where they will learn some of the basic skills of survival. Each orangutan represents a female killed by poachers. The loss of these mature females has a devastating impact on wild populations, and so each youngster also symbolizes loss of future generations. These infants are lucky to be alive. Their chances of ever living wild again are remote – of the thousands of rescued orangutans, only a small proportion have ever been released successfully. Captivity may save individuals, even preserve gene pools, but these babies lack the cultural knowledge they should have gained from their mothers. Without that, even if they can go back to the forest, their survival is uncertain.

Canon EOS 5D Mark III + 24–105mm f4 lens; 1/1000 at f4; ISO 2500.

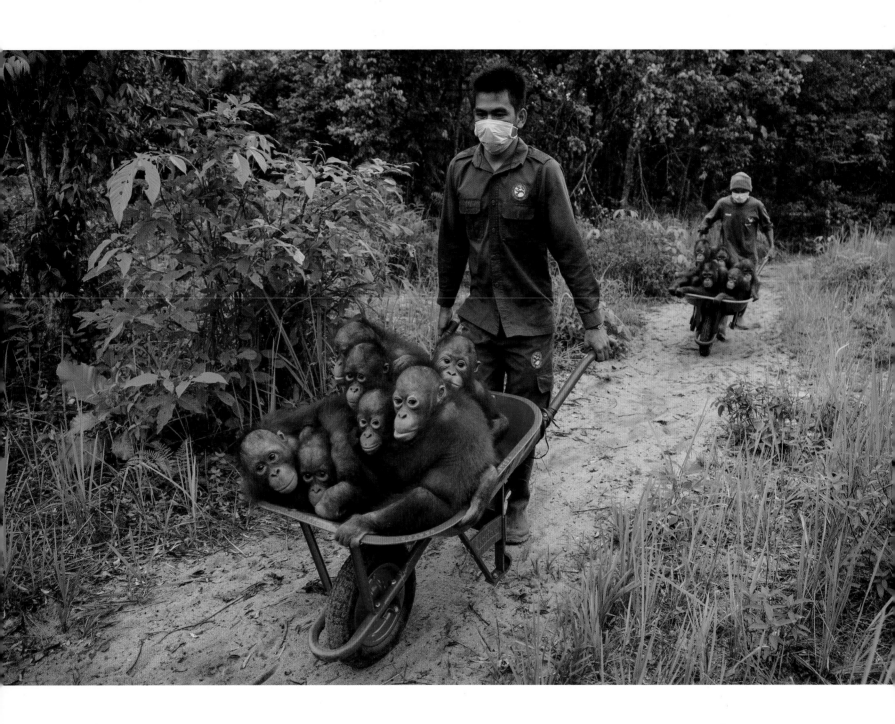

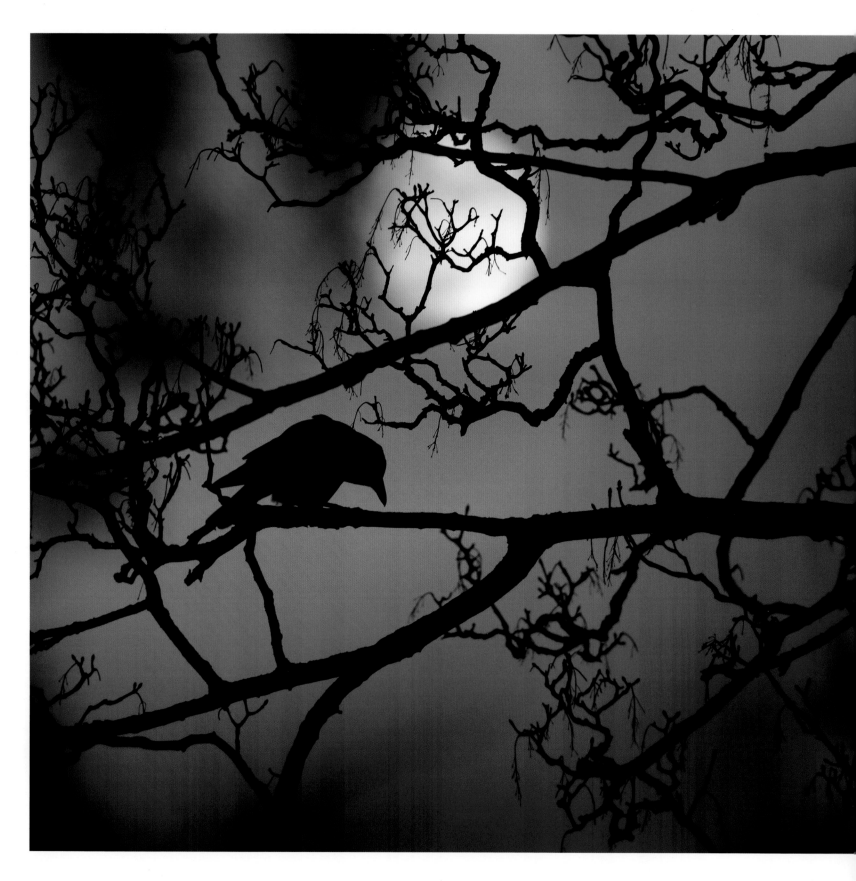

The Young Wildlife Photographer of the Year 2016

The Young Wildlife Photographer of the Year 2016 is **Gideon Knight** – the winning photographer whose picture has been judged to be the most memorable of all the pictures by photographers aged 17 or under.

Gideon Knight

UK

Aged 16, Gideon has been taking wildlife photographs for the past three years, most of them in the park close to his home or in other parks in London. A keen naturalist, he is planning to study applied science at college and continue with his photography in his spare time, both as an art and as a way to observe his local wildlife.

WINNER (15–17 YEARS OLD)

The moon and the crow

A crow in a tree in a park: a common enough scene. It was one that Gideon had seen many times near his home in London's Valentines Park, which he visits regularly to take photographs. But as the blue light of dusk crept in and the full moon rose, the scene transformed. The spindly twigs of the sycamore tree silhouetted against the sky 'made it feel almost supernatural, like something out of a fairy tale,' says Gideon. Positioning himself on a slope opposite, he tried to capture the perfect composition. But the crow kept moving along the branch and turning its head away, and so getting a silhouette of it with the moon in the frame meant Gideon had to keep moving, too. Then, just as the light was about to fade beyond the point that photography was possible, his wish came true, and an ordinary London scene turned into something magical.

Canon EOS 7D Mark I + 400mm f5.6 lens; 1/250 sec at f6.3; ISO 500.

Sand-napping

Destin Wernicke

USA

Destin was captivated by the Galápagos sea lions he saw on the island of Floreana – especially their 'fun-loving, playful nature'. He enjoyed watching their behaviour, gliding through the surf, waddling along the beach or clustering on the sand or rocks to socialize and dry off, barking at visitors 'as if owners of the island'. Though sea lions are usually highly gregarious, this young male was dozing alone on the beach. Lying down on the sand, Destin watched him from relatively close quarters and took his portrait as the sea lion rolled over and opened his eyes for a moment: 'I love the innocent look of the animal and the way the light reflects off his back and contrasts with the texture of the sand.'

Canon Powershot G9; 1/30 sec at f4.8; ISO 80.

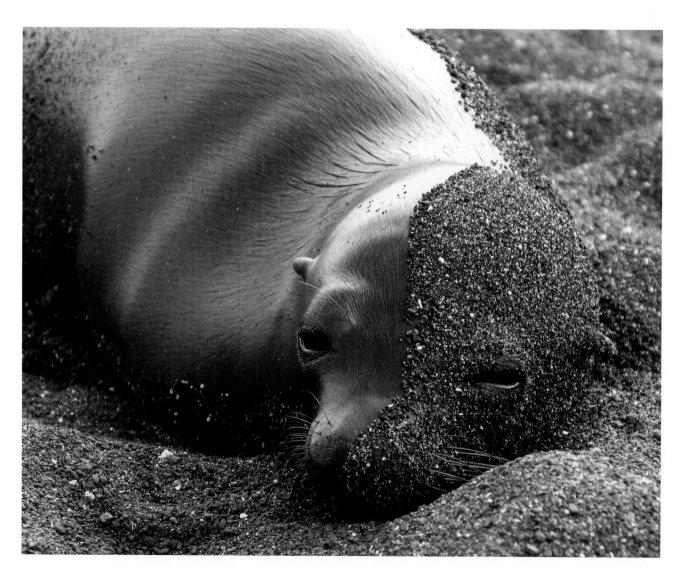

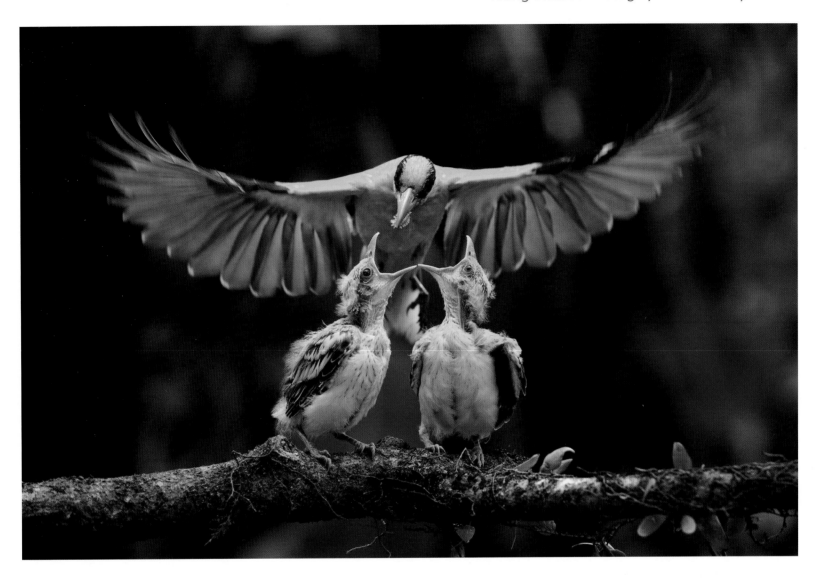

Grub time

Kim Hui Yu

MALAYSIA

In parks and gardens in many parts of Asia, the loud, fluty whistles and striking plumage of black-naped orioles are familiar to suburban residents. While on a morning jog in the Malaysian town of Sungai Petani, Kim spotted an oriole nest high up in a mango tree in a fruit orchard. Keeping watch on the tree every morning for 10 days, she finally saw that the two partially fledged chicks had fluttered down from their small hammock-like nest and were perched on a branch. Returning with a hide, she set it up with a view straight to the branch, which was almost at eye-level, and then waited. Her reward came when one of the adults flew in with a beakful of food at the perfect angle, providing the perfect composition.

Nikon D4 + 70–200mm f2.8 lens at 200mm; 1/1000 sec at f5.6; ISO 640.

Beware a mother bear
Mikhail Shatenev

RUSSIA

It was his second night without sleep, and Mikhail had to force himself to keep his eyes open and fixed on the swampy coniferous taiga around the hide. He was in bear-watching country, a remote region of Kainuu, Finland, and the hide was just a few hundred metres from the Russian border. The chances of seeing a brown bear were mixed. On the one hand, bait had been placed near the hide, and there are 20–25 bears that forage in the region. But it was April, and not all the bears would have left their dens, most of which are in Russia. But Mikhail was lucky, and his vigilance paid off. A female with two cubs came by to check out the hide. She was jittery and had reason to be. In the spring, males emerging from hibernation will kill small cubs. When a raven landed too close to a cub, she roared and lunged at it, giving Mikhail the dynamic shot he was after.

Canon EOS 60D + 300mm f4 lens; 1/1000 sec at f7.1; ISO 1000.

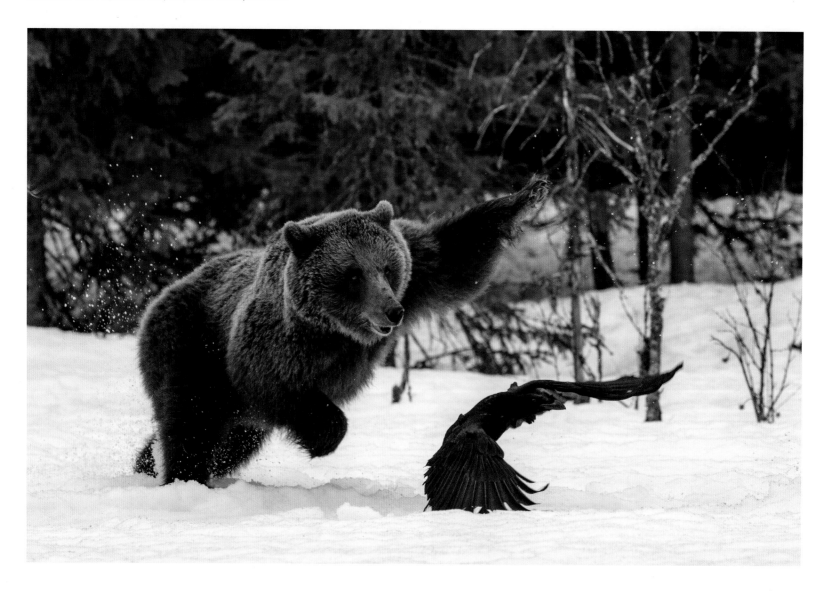

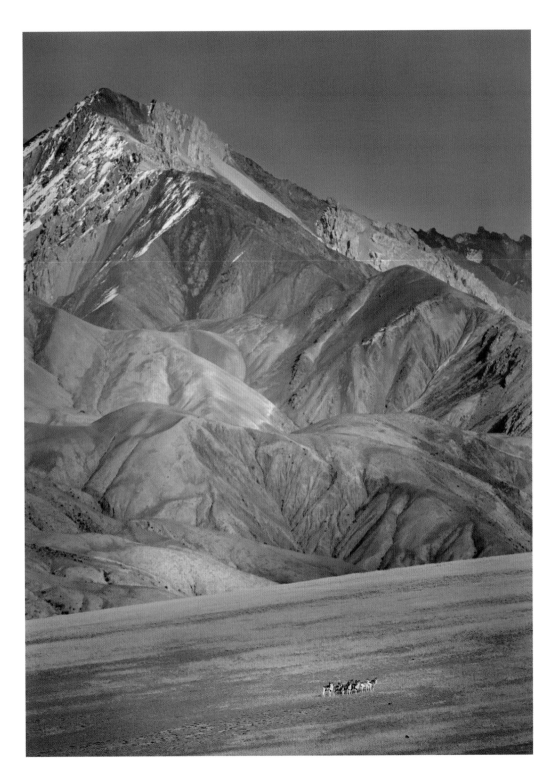

The rams of Tien Shan
Udayan Rao Pawar
INDIA

With their magnificent curling horns, the giant wild sheep – the argali – of Central Asia's remote, elevated regions, are much sought after by trophy hunters. They are also hunted for meat. So they are extremely wary of humans. Udayan was on an expedition with conservationists from the Snow Leopard Trust in the Sarychat-Ertash State Nature Reserve in Kyrgyzstan (Tien Shan argalis are the main prey of snow leopards here). Spotting this bachelor group of argali rams, alert and sensing danger, Udayan used a dry streambed as cover to try to creep closer. He got to within 700 metres (2,300 feet), close enough to make out the bright bibs of their breeding coats. But he was not the only observer. As he crept closer, he surprised a pack of six wolves just a few metres away, also watching the argali. More scared than he was (they are persecuted in the region), they fled in all directions. The rams, of course, also fled, but Udayan already had his shot, framed against the great Tien Shan range.

Canon EOS 5D Mark III + 500mm f4 lens; 1/8000 sec at f4; ISO 400.

Young Wildlife Photographers:
11–14 years old

Kid's play
Louis Pattyn
BELGIUM

For the summer holiday, Louis and his family stayed in a mountain refuge on the Niederhorn, in the Swiss Alps. Every day would be spent walking, hoping to see wildlife. The best day of all was when they encountered a herd of ibex – wild goats found in rocky areas above the tree line. (Ibex are native to the Alps but had to be reintroduced into Switzerland after being hunted to extinction in the nineteenth century.) Most in the herd were subadults or females, and they didn't seem concerned by the presence of humans and carried on grazing sometimes just 10 metres (30 feet) away. So Louis enjoyed the luxury of being able to spend a lot of time photographing his subjects. After an hour or so, he decided to try to photograph the ibex in silhouette and had just adjusted his settings when a few appeared on the crest of a ridge above him. To his delight, one of the kids then began to play, all stubby horns, pompom tail and high spirits, giving Louis the perfect chance to capture the joyful moment.

Canon EOS 7D + 100–400mm f4.5–5.6 lens at 120mm; 1/5000 sec at f7.1 (–1 e/v); ISO 400.

Bird's-eye view
Louis Pattyn

BELGIUM

The rush of wind through feathers was the only sound to break the silence as the lammergeier glided by just a few metres from where Louis stood – on the Gemmi Pass, overlooking the Swiss town of Leukerbad. It was scanning the mountainside for possible carrion, in particular, bones. In the Alps, the entire population of these massive birds, also known as bearded vultures, was exterminated in the nineteenth century, but they have been gradually recolonizing following the start of reintroductions in 1986. In Switzerland, where the first pair bred in the wild only in 2007, there are now at least nine pairs resident. In February, Louis and his father waited for hours in the bitter cold high up on the Gemmi Pass, hoping to see one from the viewing point where the previous winter they had been successful. When this lammergeier soared past, it was so close that Louis could make out every detail through his lens. Rather than photograph it against an Alpine background, he decided to take a picture illustrating the contrast between the soaring symbol of wilderness and the ski resort far below.

Canon EOS 7D + 100–400mm f4.5–5.6 lens at 210mm; 1/640 sec at f6.3; ISO 800.

Thistle-plucker

Isaac Aylward

UK

Try keeping a flying linnet in sight while scrambling down rocky embankments holding a telephoto lens. Isaac did, for 20 minutes. He was determined to keep pace with the linnet that he spotted while hiking in Bulgaria's Rila Mountains, finally catching up with the tiny bird when it settled to feed on a thistle flowerhead. From the florets that were ripening, it pulled out the little seed parachutes one by one, deftly nipped off the seeds and discarded the feathery down. Isaac composed this alpine-meadow tableau with the sea of soft purple knapweed behind, accentuating the clashing red of the linnet's plumage.

Canon EOS 1200D + 75–300mm f5.6 lens; 1/640 sec at f5.6; ISO 400.

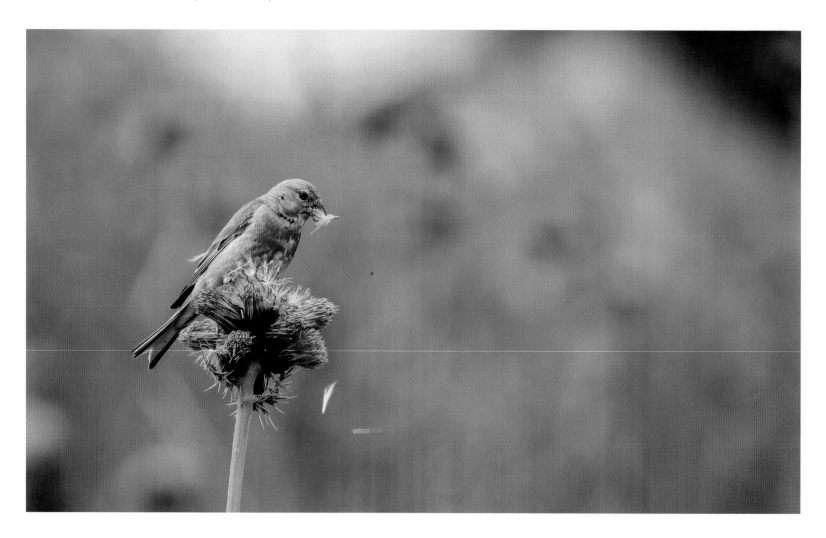

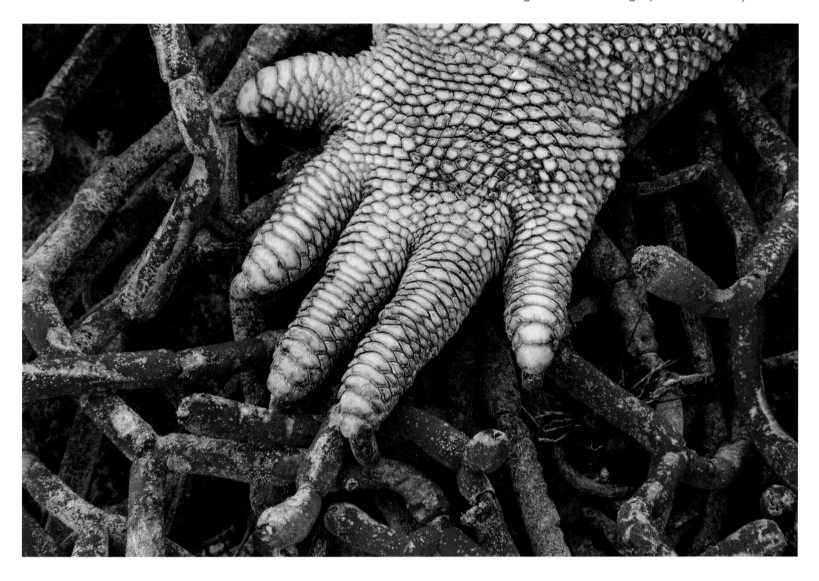

Hand of gold
Leon Petrinos
GREECE/SWITZERLAND

It would have been so easy for Leon to go for a classic portrait of a basking land iguana, as most of the others in his Galápagos tour group were doing. He also considered framing the iconic dragon-like reptile against a backdrop of the dramatic volcanic landscape of Isabela Island, as his dad had suggested. But when using the necessary wide-angle lens, it was almost impossible not to include other tourists in the shot. So he decided to change lens and portray an iguana from a very different angle. It was the contrast of 'the yellow "hand" against the red plant' (sea purslane) that caught his eye. Focusing in tight on the foot, he used detail to create a powerful and original composition.

Nikon 1 V3 + 70–300mm f4.5–5.6 lens at 215.5mm; 1/400 sec at f16 (+0.3 e/v); ISO 800.

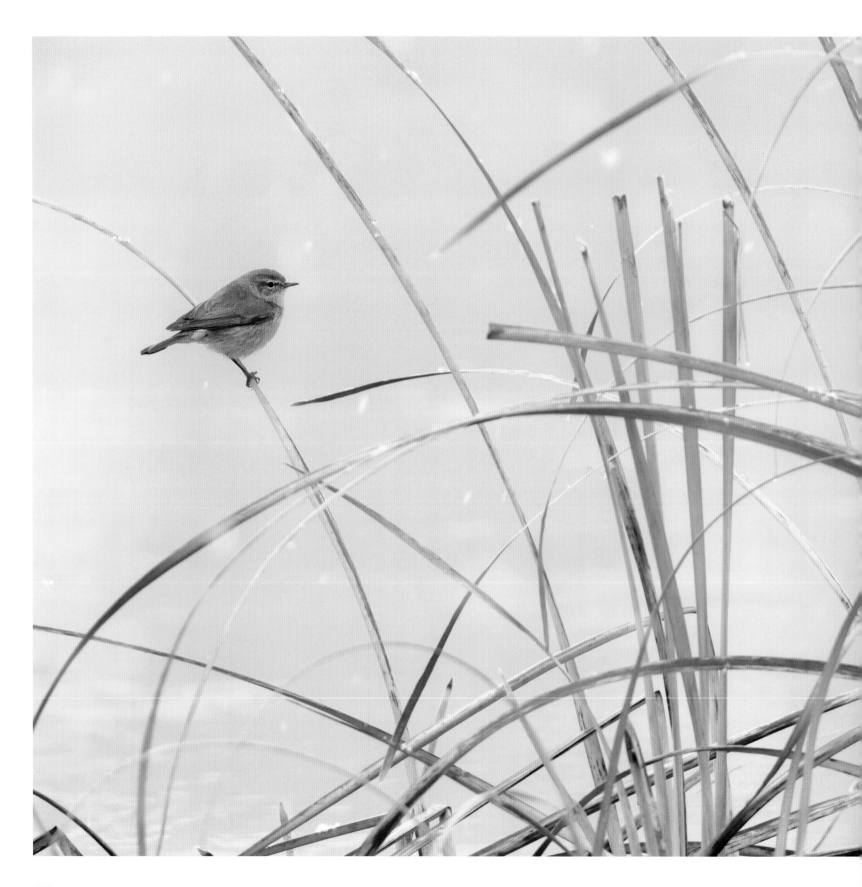

Young Wildlife Photographers: 10 years and under

WINNER

A delicate balance

Carlos Perez Naval

SPAIN

Using the family car as a hide, Carlos scanned the reeds through his camera, looking for migrant birds. The Spanish wetland of Lechago is close to his home in Calamocha. Here winters are cold, and it had just started to snow. Spotting movement, Carlos followed the little bird as it flitted among the stems, waiting for it to show itself. It was a chiffchaff. Finally, just as the light changed, it paused for a second, side-on, at the edge of the reeds – a fast-focus, composition challenge, says Carlos, 'to catch the bird off-centre, but also with a hint of the snowflakes'. A serious photographer since the age of six and a past winner in the competition, his skill paid off. 'The light, the geometric shapes of the reeds and the snowfall' came together to make it the perfect composition.

Nikon 7100 + 200–400mm f4 lens + 1.4x extender at 500mm; 1/200 sec at f5.6; ISO 640.

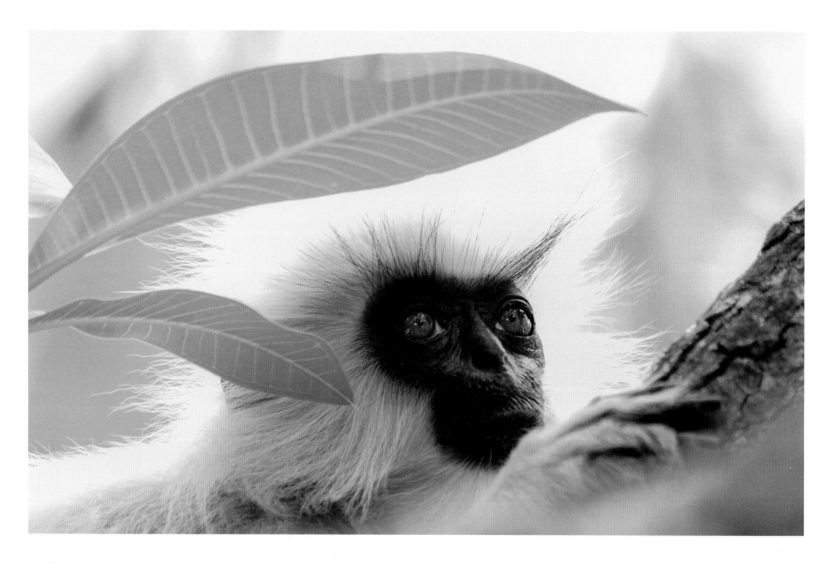

Golden relic
Dhyey Shah
INDIA

With fewer than 2,500 mature adults left in the wild, in fragmented pockets of forest in northeastern India (Assam) and Bhutan, Gee's golden langurs are endangered. Living high in the trees, they are also difficult to observe. But, on the tiny man-made island of Umananda, in Assam's Brahmaputra River, you are guaranteed to see one. Site of a temple dedicated to the Hindu god Shiva, the island is equally famous for its introduced golden langurs. Within moments of stepping off the boat, Dhyey spotted the golden coat of a langur high up in a tree. The monkey briefly made eye contact and then slipped away. Today, there are just six left on the island, and, with much of the vegetation having been cleared, the leaf-eating monkeys are forced to depend mainly on junk food from visitors.

Canon EOS 500D + 55–250mm f5.6 lens; 1/250 sec at f5.6; ISO 1250.

Peck and peek
Carlos Perez Naval
SPAIN

The haunting cry of the black woodpecker rang out through the Finnish forest – not a sound Carlos had heard before. He silently willed the bird to come closer to the hide, where there were fat feeders. The call got louder and louder until Carlos suddenly saw it fly to a tree near the hide and then to another trunk right in front of him. It landed on the far side, then hopped down the tree, poking its head out every so often, presumably to check if it was safe to fly to the feeders. So Carlos had to guess where to focus the camera before it popped it out again. 'I just love its funny expression,' he says.

Nikon 7100 + 150–500mm f5–6.3 Sigma lens at 500mm; 1/250 sec at f6.3; ISO 640.

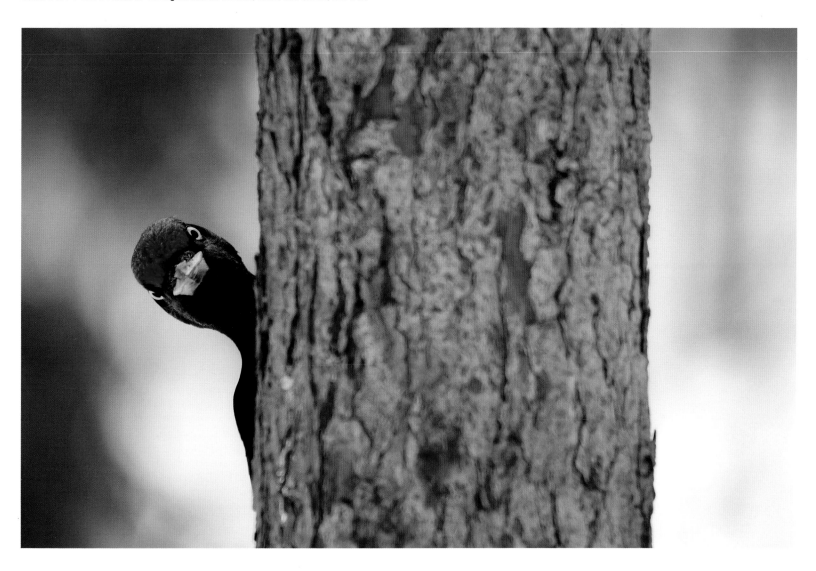

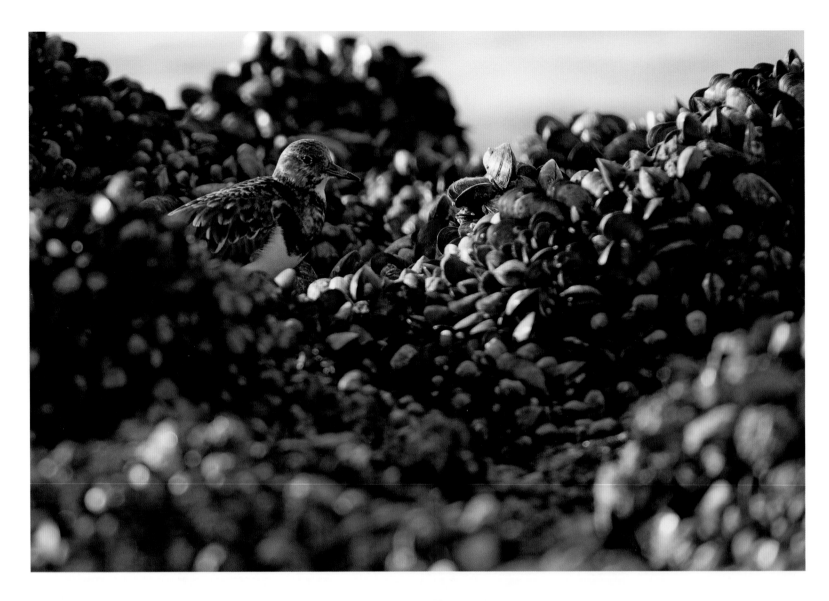

Turnstoning
Dirk Hoogenstein

THE NETHERLANDS

Dirk was fascinated by the camouflage of the ruddy turnstones he and his parents spotted on the shore of the Brouwersdam, on the Netherlands' coast. They were rummaging on a bed of mussels, turning over rocks and shells in search of insects and other invertebrates. Dirk was desperate to get closer, but this meant scrambling quite a distance across rocks recently exposed by the tide. His father was worried that Dirk would slip on the seaweed and fall, but his mother reasoned that nature photographers have to take calculated risks. His father relented, and Dirk slowly slithered across the rocks following the fast-moving turnstones until he was close enough to kneel down and focus at eye-level. When he finally clambered back, his father was relieved to see that there were no scratches... on the camera.

Canon EOS 5D Mark II + 70–200mm f2.8 lens + 2x extender at 360mm; 1/500 sec at f5.6; ISO 400; Manfrotto monopod.

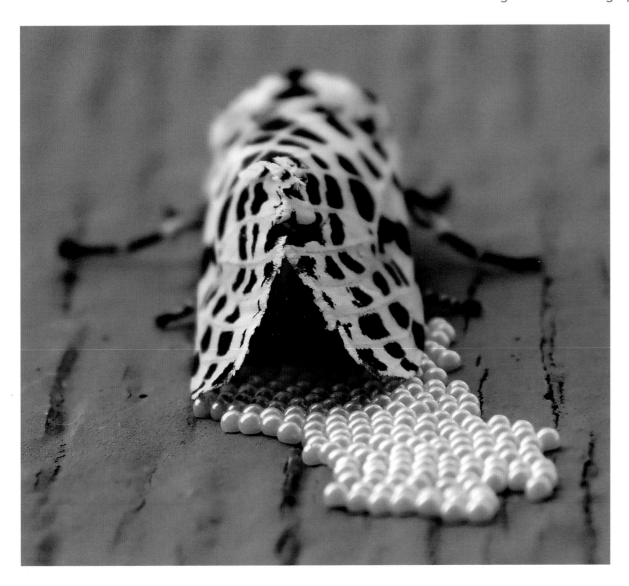

Tiger pearls
Morgan Wolfers

USA

Morgan discovered the many-spotted tiger moth on the wall just outside his front door and watched fascinated as she began to lay her eggs. They stuck to the wall as they were laid but looked almost as if they were rolling out from beneath her chequerboard wings. But to photograph them was a challenge. First, summer storms had started to rage around Morgan's home in Colorado's Rocky Mountains, and he had to protect the moth by leaning a board against the wall. The spot was also close to the ground. So he had to lie down and point the lens almost straight up. 'I had to adjust and tilt the screen on my camera so that I could see what it was pointing at and hold my hand very still.' The tiger moth sat tight for a week before flying away, and it was another three weeks before the caterpillars hatched and crawled away.

Nikon Coolpix L840; 1/60 sec at f5.4; ISO 125.

Index of Photographers

52
Saud Alenezi
KUWAIT
saudphotos@gmail.com
www.saudphotos.com

71
Stefano Baglioni
ITALY
saba7276@gmail.com
www.viverelanatura.com

54
Guillaume Bily
FRANCE
guillaume.bily@wanadoo.fr
www.guillaumebily.com

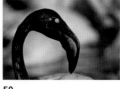

50
Laurent Chagnard
FRANCE
laurent.chagnard@wanadoo.fr
www.laurentchagnard.com

62
Alexandre Deschaumes
FRANCE
alexandre.deschaumes@gmail.com
www.alexandredeschaumes.com

103
Theo Allofs
GERMANY
theo@theoallofs.com
www.theoallofs.com

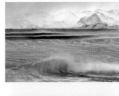

60, 70
Sandra Bartocha
GERMANY
info@bartocha-photography.com
www.bartocha-photography.com
Agent
www.naturepl.com

66
Valter Binotto
ITALY
binoval@alice.it
www.valterbinotto.it

20
Jordi Chias Pujol
SPAIN
jordi@uwaterphoto.com
www.uwaterphoto.com
Agent
www.naturepl.com

88
Nicola Di Sario
ITALY
nicoladisario@me.com
www.nicoladisario.it

82
Mats Andersson
SWEDEN
mats@concret.se
www.matsandersson.nu

26
Walter Bassi
ITALY
martellosub@gmail.com
www.flickr.com/photos/
63751255@N07/

68
Roberto Bueno
SPAIN
info@robertobueno.com
www.robertobueno.com

92
Geo Cloete
SOUTH AFRICA
geo@wwx.co.za
www.geocloete.com

34
Jasper Doest
THE NETHERLANDS
info@jasperdoest.com
www.jasperdoest.com
Agent
www.mindenpictures.com

148
Isaac Aylward
UK
isaacjaylward@hotmail.co.uk

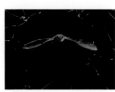

77
Mario Cea
SPAIN
mariocea100@gmail.com

12
Marco Colombo
ITALY
oryctes@libero.it
www.calosoma.it

44, 118
Ronan Donovan
USA
ronmdon@gmail.com
www.ronandonovan.com

107
Lars Andreas Dybvik
NORWAY
kaffelars@uskarp.no
www.uskarp.no

22
Angel Fitor
SPAIN
seaframes@seaframes.com
www.seaframes.com

61
Fortunato Gatto
ITALY
fortunato.gatto@gmail.com
www.fortunatophotography.com

112
Douglas Gimesy
AUSTRALIA
doug@gimesy.com
www.gimesy.com

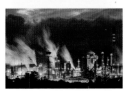

27, 80
Juan Jesús González Ahumada
SPAIN
ahumada585@hotmail.com
www.jjgahumada.com

121
Jennifer Guyton
GERMANY/USA
jen.guyton@gmail.com
www.jenguyton.com

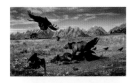

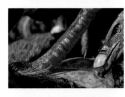

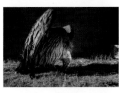

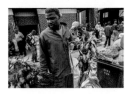

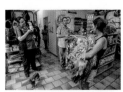

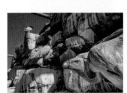

36, 122–129
Charlie Hamilton James
UK
www.charliehamiltonjames.co.uk

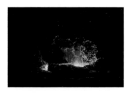

64
Alexandre Hec
FRANCE
hecalexandre@gmail.com
www.alexandrehec.com

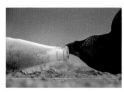

51
José Juan Hernández Martínez
SPAIN
jj.hndez@hotmail.com
www.josejuanhernandez.com

110
Paul Hilton
UK/AUSTRALIA
mail@paulhiltonphotography.com
www.paulhiltonphotography.com

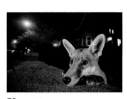

78
Sam Hobson
UK
samhobsonphoto@gmail.com
www.samhobson.co.uk

154
Dirk Hoogenstein
THE NETHERLANDS
dirk.hoogenstein@xs4all.nl

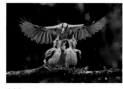

141
Kim Hui Yu
MALAYSIA
kim.hui.yu@gmail.com

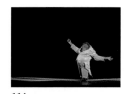

114
Britta Jaschinski
GERMANY/UK
info@brittaphotography.com
www.brittaphotography.com

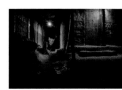

72
Nayan Khanolkar
INDIA
nayankhanolkar@gmail.com
www.nayankhanolkar.com

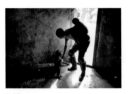

113
Dan Kitwood
UK
dan.kitwood@gettyimages.com
www.dankitwood.com
Agent
Getty Images

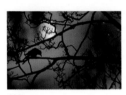

138
Gideon Knight
UK
gidknight@hotmail.com
www.gideonknightphotography.com

56
Willem Kruger
SOUTH AFRICA
whk139@gmail.com
www.willemkruger.wordpress.com

10, 130–137
Tim Laman
USA
tim@timlaman.com
www.timlaman.com
Agents
www.natgeocreative.com
www.naturepl.com

96
Greg Lecoeur
FRANCE
greglecoeur@hotmail.com
www.greglecoeur.com

109
Joanna Lentini
USA
joanna@deepfocusimages.com
www.deepfocusimages.com

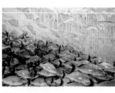

16
Iago Leonardo
SPAIN
iagoleonardo@yahoo.es
www.iagoleonardo.com

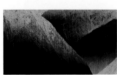

65
Enrique López-Tapia de Inés
SPAIN
quiquediapo@hotmail.com
www.enriquelopeztapia.com

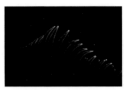

101
Quentin Martinez
FRANCE
quentinmartinezphoto@gmail.com
www.quentinmartinez.com

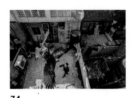

74
Luke Massey
UK
lmassey91@hotmail.co.uk
www.lmasseyimages.com

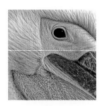

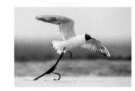

102, 120
Bence Máté
HUNGARY
photocompetitions@matebence.hu
www.bencemate.com
Agent
Andrea Reichenberger
office@matebence.hu

55
Eric Médard
FRANCE
eric.medard@gmail.com
www.ericmedard.com

48
Alexander Mustard
UK
alex@amustard.com
www.amustard.com
Agent
www.naturepl.com

100
Bruce Omori
USA
bruce@extremeexposure.com
www.extremeexposure.com

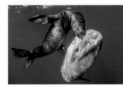

97
Ralph Pace
USA
ralphpace@gmail.com
www.ralphpace.com

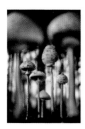

86
Agorastos Papatsanis
GREECE
agorastospap@yahoo.gr
www.agorastosphotography.com

40
Andrew Parkinson
UK
andy@andrewparkinson.com
www.andrewparkinson.com
Agents
www.naturepl.com
www.gettyimages.com
www.rspb-images.com
www.flpa-images.co.uk

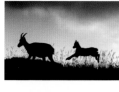

144, 146
Louis Pattyn
BELGIUM
louispattyn1@hotmail.com

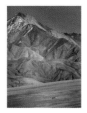

143
Udayan Rao Pawar
INDIA
udayanraopawar17@gmail.com

150, 153
Carlos Perez Naval
SPAIN
enavalsu@gmail.com
www.carlospereznaval.wordpress.com

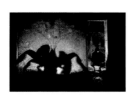

28
Thomas P Peschak
GERMANY/SOUTH AFRICA
thomas@thomaspeschak.com
www.thomaspeschak.com
Agent
www.natgeocreative.com

106
José Pesquero
SPAIN
jose.pesquero@jpgbirding.com
www.jpgbirding.com

149
Leon Petrinos
GREECE/SWITZERLAND
petrinoss@yahoo.com
Agent
www.naturepl.com

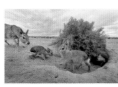

42
Darío Podestá
ARGENTINA
dhpodesta@yahoo.com.ar
www.dariopodesta.com

24
Scott Portelli
AUSTRALIA
scott.portelli@gmail.com
www.scottportelli.com

30, 108
Imre Potyó
HUNGARY
poimre@gmail.com

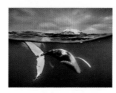

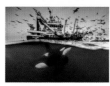

38, 94, 116
Audun Rikardsen
NORWAY
audun.rikardsen@uit.no
www.audunrikardsen.com

14, 15
Cyril Ruoso
FRANCE
cyril.ruoso@wanadoo.fr
www.cyrilruoso.com

18
Christophe Salin
FRANCE
info@christophesalin.com
www.christophesalin.com

104
Luis Javier Sandoval
MEXICO
javier_uyuyuy@yahoo.com
www.ljs.mx

98
Rudi Sebastian
GERMANY
info@rudisebastian.de
www.rudisebastian.de

84
Dániel Selmeczi
HUNGARY
selmeczi.daniel@gmail.com
www.selmeczidaniel.com

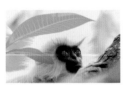

152
Dhyey Shah
INDIA
ketanrinku@yahoo.com

46
Ganesh H Shankar
INDIA
ganesh@naturelyrics.com
www.naturelyrics.com

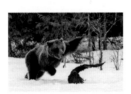

142
Mikhail Shatenev
RUSSIA
shatenev-2018@mail.ru
www.michaelshatenev.com

32
Simon Stafford
UK
simon@simonstafford.co.uk
www.simonstafford.co.uk

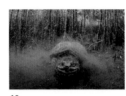

19
Mac Stone
USA
macstonephoto@gmail.com
www.macstonephoto.com

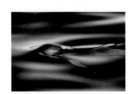

89
Christopher Swann
UK
swannyc@hotmail.com
www.cswannphotography.com

58
Stefano Unterthiner
ITALY
info@stefanounterthiner.com
www.stefanounterthiner.com

93
Joris van Alphen
THE NETHERLANDS
joris@jorisvanalphen.com
www.jorisvanalphen.com

85
Lance van de Vyver
NEW ZEALAND/SOUTH AFRICA
lancevandevyver@gmail.com
www.lancevandevyver.com

76
Hugo Wassermann
ITALY
hugo.wassermann@gmail.com
www.hugo-wassermann.it

140
Destin Wernicke
USA
destindude@netnet.net

155
Morgan Wolfers
USA
heatherwolfers@gmail.com
www.morganwolfers.com

90
Tony Wu
USA
tony@tony-wu.com
www.tonywublog.com